Foundation and Form in Jungian Sandplay

of related interest

Sand, Water, Silence – The Embodiment of Spirit
Explorations in Matter and Psyche
Mary Jane Markell
ISBN 1 84310 078 9

The Revealing Image
Analytical Art Psychotherapy in Theory and Practice
Joy Shaverien
ISBN 1 85302 821 5

Spirituality and Art Therapy
Living the Connection
Edited by Mimi Farrelly-Hansen
Foreword by Deborah Bowman
ISBN 1 85302 952 1

The Metaphoric Body
Guide to Expressive Therapy Through Images and Archetypes
Leah Bartal and Nira Ne'eman
Foreword by Professor Harris Chaiklin
ISBN 1 85302 152 0

Poiesis
The Language of Psychology and the Speech of the Soul
Stephen K. Levine
Foreword by Paolo Knill
ISBN 1 85302 488 0

Inner Journeying Through Art-Journaling
Learning to See and Record your Life as a Work of Art
Marianne Hieb
ISBN 1 84310 794 5

Foundation and Form in Jungian Sandplay
An Art Therapy Approach

Lenore Steinhardt

Jessica Kingsley Publishers
London and Philadelphia

First published in the United Kingdom in 2000
by Jessica Kingsley Publishers
116 Pentonville Road
London N1 9JB, UK
and
400 Market Street, Suite 400
Philadelphia, PA 19106, USA

www.jkp.com

Library of Congress Cataloging in Publication Data
Steinhardt, Lenore, 1938–
 Foundation and form in jungian sandplay / Lenore Steinhardt.
 p. cm.
 ISBN 1-85302-841-X (pbk. : alk. paper)
 1. Sandplay. 2. Jungian psychology. 3. Art therapy. I. Title

RC489.S25 S74 2000
616.89'1656--dc21
 99-056611

British Library Cataloguing in Publication Data
A CIP catalogue record for this book is available from the British Library

ISBN-13: 978 1 85302 841 0
ISBN-10: 1 85302 841 X pb

Contents

List of plates

List of figures

Acknowledgments

The spirit of a certain sandy beach in an inlet connected to the Atlantic Ocean has remained with me and continued to guide my involvement with sand in the art therapy setting. Many people, in brief or enduring relationships, have left an imprint on the primordial mud in my deep psyche. These include teachers and friends made at the Cooper Union Art School where I studied art, and others who were of great influence in my studies of creative expressive therapy. Rina Porat and Dr Bert Meltzer were my teachers of Jungian sandplay, and Dr Nehama Baum and Maggie Baron were additional mentors in helping to understand the process. Carole Proudfoot-Edgar has been an important teacher, and I thank her for the myth she told for the Preface of this book. I wish to thank Marise Hannanel for reading and commenting on the case study. I owe an especial debt of gratitude to Dr Joy Schaverien, who has been most instrumental in the formation of the entire project of writing this book. Her constant encouragement and reading of the manuscript at early and late stages has proved an invaluable help, and has served to sharpen the ideas presented. I thank my husband Fred who has always encouraged me to write, and given unending technical support. I have had the trust of many people seeking art therapy and sandplay, and learned from them about sand as foundation. I am extremely grateful to those who permitted me to illustrate the text with their work, and to Wanda whose sandplay process enriches this book.

Excerpts of articles that were originally published in *Art Therapy: Journal of the American Art Therapy Association 12*, 3 (1995), and *15*, 4 (1998) have been reprinted in this book. These excerpts were reprinted with permission from the American Art Therapy Association, Inc. All rights reserved. Permission granted to reprint:

Steinhardt, L. (1998) 'Sand, water, and universal form in sandplay and art therapy.' *Art Therapy: Journal of the American Art Therapy Association 15*, 4, 252–260.

Steinhardt, L. (1995) 'The base and the mark: a primary dialogue in artmaking behavior.' *Art Therapy: Journal of the American Art Therapy Association 12*, 3, 191–192.

Excerpts from the following articles have been reprinted in this book with permission of Elsevier Science:

Reprinted from *The Arts in Psychotherapy 21*, 3, Steinhardt, L. 'Creating the autonomous image through puppet theatre and art therapy.' pp.205–218, 1994, with permission from Elsevier Science.

Reprinted from *The Arts in Psychotherapy 24*, 5, Steinhardt, L. 'Beyond blue: the implications of blue as the color of the inner surface of the sandtray in sandplay.' pp.455–469, 1997, with permission from Elsevier Science.

Preface

This book presents a view of Jungian sandplay in the context of the art therapy setting. Ongoing imagery created by a client with materials is at the heart of art therapy. The art therapist provides a wide range of materials, each of which has innate qualities suitable for different forms of graphic expression. Most conventional materials are manufactured rather than natural, and they may be manipulated through the use of intermediary objects such as brushes or carving tools without direct hand contact.

The blue-bottomed sandtray, sand, water and miniatures contribute to the art therapy setting an additional, unique method of making images. Art making behavior in the sandtray begins with direct body contact with natural materials as a dialogue between the hands and sand. Ensuing hand movements include smoothing, marking, gathering, imprinting, digging, forming, or any combination of them. The final image may be left as textured or formed sand.

Natural objects and miniatures may be instinctively chosen and placed, providing further definition of the visual image and its internal counterpart in the psyche. This primal creative method recalls early building with sand and water in beach play, and choosing of objects in childhood play, to form transient structures, while the materials are repeatedly reused to accommodate new visions for making images. The ease of execution of sandplay and its transience contrast with a certain amount of skill needed to make paintings and sculptures, and their permanence. In art, the materials become an integral part of the finished artwork, which will not be taken apart, nor will its materials be reused.

Thus sandplay offers the art therapy client a manner of creating a picture whose materials and forms will return to their initial unformed state, while the immediate sandworld has been photographed and later dismantled by the therapist, unseen by the client. This momentary existence, the truly primal and natural sand and water, and the direct play involved in forming,

make a sandworld a symbolic visual statement that may touch an emotional depth not always experienced through the use of other art materials. Donald Sander, in his foreword to Ammann (1991, p.xi) says: 'The kingdom of childhood is opened once more by sandplay, and with it the door to the deep unconscious and its mysteries.'

Acknowledgment of the sand in a tactile encounter at the start of work, leading to a minimal or complex resolution of a created sand foundation, is seen to be an important move towards building one's own inner foundations. The sandplayer creates a world, often beginning by combining sand and water in proportions that produce a sturdy mud suitable for forming. In many creation myths primal mud from the bottom of a body of water is brought up by animals to the surface, and fashioned into forms. These forms begin to grow and live and populate the world (Sproul 1979).

Carole Proudfoot-Edgar, in a personal communication to the author, has related a Native American Lakota Sioux creation myth about a turtle that dives deep and brings up mud to make a base and support the forms of life. The myth is most appropriate to introduce this book, dealing as it does with the creation of form and the world from mud. This turtle myth continues almost as a metaphor for the disruptive life processes that occur among humans, leading to the personal and cultural fragmentation which often bring people to therapy. In therapy, these fragmented pieces will have to be reconstructed into a workable and wiser whole. Surprisingly, the myth is relevant to the case study which brings this book to a close.

Bradway et al. (1997) have observed that turtles often appear in the final sandworld of clients when they terminate therapy. The client whose sandplay process is described in Part 6 had never in three years used a turtle. Yet she did use one in her final sandworld, just as Bradway describes. So this creation myth ties together mud, the creation of forms, the therapeutic process, and the autonomy of the turtle, navigating the ocean alone, after leaving the safe coast of the therapist/mother.

Turtle

By Carole Proudfoot-Edgar

As a child I remember holding Turtles and the reverence with which my people would speak of Turtle. Later I discovered that many tribal peoples in the United States carried oral traditions that included Turtle as the Creator of North America, and especially what is now called the United States or Turtle Island. Turtle is considered not only the Creator but also the animal that symbolizes our brokenness as One People and our call to bring together all the pieces again. To bring together those who scattered in different directions and became the mosaic that is Turtle's shell.

We know that long ago before there were humans water covered the planet, covered the mud that lay deep below the surface. This is how it was in the Beginning when people lived beyond the Sky. One day a pregnant woman fell from the Sky World towards the water. As she fell all the water animals including Muskrat, Otter, and Turtle saw her fall mirrored in the water. They thought she was coming from the world below the water, but the birds knew she was falling from the World beyond the Sky. Taking turns, Eagle, Geese and Ducks flapped their wings, made circles below her, and eased her falling to the water. As they flew they cried loudly to all the water creatures to gather and support her as she fell towards the water.

Turtle commanded the birds to keep circling beneath her while Turtle dove to the mud at the bottom of the water. As Turtle gathered mud, creating a large island on his back, he commanded the other water creatures to also gather mud in their paws.

As Turtle surfaced, all the other water creatures gathered the mud they had retrieved and packed it, too, onto the mound Turtle had formed from the water world. The birds then flew lower and the woman landed on Turtle's mound of mud. As she landed, she was told to dance on this magic Earth in a sunwise fashion. As she danced, Turtle began to grow into a great, great island.

From First Woman came First Daughter and from First Daughter came twin sons and from them came the rest of the children of Earth. All together the world of people and other animals was created from and lived upon the land that grew from the mud that is the back of Great Turtle. This was the Time when there was plenty for everyone and all

lived in harmony together. Every being took just what was needed and gave to others of what they had.

No one knows for sure why things changed. Some people say it was Coyote watching the humans start getting greedy and not sharing. Some people say it was the humans' deep curiosity that got them in trouble just like Coyote gets in trouble. But everyone knows that what happened is that some people started going East; some people West; some people South and some people North. When they moved away they began taking with them parts of the magical Earth from Turtle's back. Eventually the land broke up and became fragmented, and so did the People, who began fighting among themselves and doing wrong to the Animals. Turtle started trembling; the whole Earth shook. Many people drowned in that time. A few people came together from the four directions and among themselves agreed to bring back together the scattered groups of the people and live in harmony with all.

People in the Southwest, they say that at this time long ago Coyote ate Turtle. When he did, all the ponds and streams dried up because Turtle was the Keeper of the Water. The Animals went to Coyote and begged him to bring Turtle back. Coyote thought about this and then brought Turtle back up. But Turtle was all in pieces and the animals had to put Her back together again.

So now we see Turtle and we know we are still trying to bring all the pieces together again and that more of what we are is waiting to be reborn from the deep waters, from the mud.

May we bring all the pieces back together again and be the Mosaic One.

PART 1

Introduction

Sandplay Therapy
and the Art Therapy Setting

This book inquires into the appropriateness of integrating Jungian sandplay into the art therapy setting, to the advantage of both. Jungian sandplay and art therapy are both therapies concerned with visual image making, but they have not widely met in the therapy room until recently due to their historically different origins.

Sandplay, developed over the past 70 years within traditional therapeutic settings, has served as an intermittent non-verbal method adjunct to an analytical process. Sandplay utilizes a shallow tray painted blue inside to represent water or sky, and filled with sand, measuring approximately 50 × 70 × 7 cm. On nearby shelves is a large collection of miniature objects with which to build a picture on the sand, which may be worked or untouched. In contrast to traditional analysis, the completed sandworld is observed by client and therapist with little or no interpretation (Bradway and McCoard 1997; Weinrib 1983). It is photographed and dismantled by the therapist after the client leaves the session. The sand and miniatures must then be returned to their original non-intentional states and will be reused by the client and others. But the client has already gone with his/her unbroken image internalized. In this way, the sandplay client holds in memory an intact image of the work just as an art therapy client can. In art therapy, the materials used to make a picture or sculptural image are not returned to their containers for reuse, and images remain intact, providing a permanent record of a client's art therapy process. The transience of the sandplay image and the repetitive use of sand, water and miniatures within a constant format infuse the momentary sandworld image with an almost ritual power at times. Making a sandworld is a creative event existing for a brief shared moment in the therapy room, in contrast to the unchanging permanence of an artwork. This difference will be discussed in later chapters.

Doing a sandplay requires no special skill. A sandworld may be simple in construction, but may also be intricate and complicated. As in art, there is no scale that can grant sophisticated advanced art more value than primitive art. The prime criterion is the image's inner authenticity, expressed by a balance of form, color and symbol, activating an empathetic reverberation in the viewer. Jung's development of the technique of 'active imagination' provided a creative base for expressive use of the arts as therapy, and for the technique of sandplay as a supplement to traditional therapy. Storr (1983) describes how Jung:

> encouraged his patients to enter a state of reverie in which judgment was suspended but consciousness preserved. They were then enjoined to note what fantasies occurred to them, and to let these fantasies go their own way without interference. Jung encouraged his patients to draw and paint their fantasies, finding that this technique both helped the patient to rediscover hidden parts of himself and also portrayed the psychological journey upon which he was embarked. (Storr 1983, p.21)

Weinrib defines sandplay as 'a nonverbal, nonrational form of therapy that reaches a profound preverbal level of the psyche' (1983, p.1). She adds that 'deep in the unconscious there is an autonomous tendency, given the proper conditions, for the psyche to heal itself' and that the sandplay process 'encourages a creative *regression* that enables healing' (1983, pp.1–2). Bradway sees sandplay as 'a form of active imagination, but the images used in sandplay are concrete and tangible rather than invisible and intangible' (Bradway and McCoard 1997, p.6). She likens the sandworld to a dream unfolding within the defined boundaries of the therapy hour, seen simultaneously by both patient and therapist.

Understanding of sandplay has evolved through its inclusion into psychotherapy. Literature describing sandplay theory and process has been written primarily by Jungian analysts, beginning with Jungian sandplay's founder Dora Kalff, rather than by therapists trained in the visual arts. Processes described in the literature often focus on developmental stages, and symbolism of the miniature objects used. Mention is made of the importance of tactile experience and playing with the sand (Ammann 1991; Bradway and McCoard 1997). It is acknowledged that use of sand and miniatures sometimes produces forms that resemble specific inner organs of the body (Ammann 1991; Margoliash 1998). Kalff 'began to believe that the material elements of sandplay acted as a kind of metaphor for the body' (Weinrib 1983, p.40). But in comparison to the commonplace study of the symbolism

of objects, there is little attempt in sandplay literature to see symbolism in the sand forms created beyond the basic mound and pool. There is also little discussion of the sandplayer's relationship to the sand surface, penetration of the sand and the use of water. Classification of the forms that a sand base/foundation may take is a main topic in this book. An artist or art therapist might instinctively focus on the relationship between sand and miniatures, noticing the balance between spontaneously created form and ready-made form. The artist's visual training would also lead to notice of the color contrast between the blue base and the sand, in a figure–ground relationship. In the literature there is little explanation of the implications of the blue-colored interior of the sandtray beyond its use as a representation of water or sky, a fact that led this author to write about the impact of the color blue on the sandplayer's work (Steinhardt 1997).

Sandplay has been compared only briefly to other visual creative forms of therapy such as painting, drawing and sculpture (Weinrib 1983). Bradway (Bradway and McCoard 1997) gives an encompassing visual description of the sandplay setting, including thoughts about the position and heights of the trays, the therapist's seating position, numerous natural materials, clay, paint and paper nearby. Her respect for tactile non-verbal experience resembles that of an experienced artist or art therapist. Yet she compares the sandplay process to the use of a musical instrument, whose range must be learned (p.29). While this is also true, sandplay is obviously a silent, creative concrete method done with materials by one's hands. This is the province of art, or art therapy. A wider artistic view of sandplay has not yet been explored, probably due to sandplay's historical alliance with traditional analysis as a compatible active method.

The creative–expressive therapies, and art therapy in particular, began their history primarily after World War I through artists working with populations in psychiatric, medical and corrective institutions. The original orientation of art therapy and its place as adjunct therapy began to expand in the 1980s. Art therapy became more accepted as primary therapy and a wider appreciation of imagery began to include Jungian theory. This introduced Jungian sandplay into art therapy as another option for creating a visual image.

The art therapy milieu is defined by the continual creation of visual imagery with various materials, often with little or no interpretation. In fact, in art therapy an entire process may take place through creating imagery, or playing in art together of therapist and client, without much analysis. In the

case of children this is especially so. With adults, there may be many art therapy or sandplay sessions that have little or no verbalization, or where words are used for describing what one sees and giving voice to the images themselves. Verbalization of conscious states of awareness occurs in later stages, often released after a long art-making process. Thus the essential delayed interpretation of sandplay therapy is a traditional aspect of art therapy.

The art therapist deals with experiential creativity arising from formless matter. Each successive image often contains partial resolution of issues brought up in previous images. This approach places trust in the image and advocates as much image making as possible rather than more verbalization. This differs from the long intervals between sandplay sessions described by some sandplay therapists who are analysts.

Each art medium, such as oil pastels, gouache paint or clay, has intrinsic qualities that elicit specific connections to the body, emotions, control or spontaneity. Sand and water as primal natural materials will have unique qualities and contact sources of inner imagery that other materials do not. In art therapy perception of sand as creative material may encourage the sculptural dialogue of the hands with sand and water. Frequent sandplays may stimulate a dynamic, ongoing development of forms as a base for identifiable miniatures. A sculpted sandworld, with or without miniatures, may radiate a presence that no words can describe.

Foundation and form

In essence, the premise of this book rests on the relationship between the two basic concepts: *foundation* and *form*. In the art therapy setting, a client's ongoing engagement with concrete tactile materials must inevitably influence his/her attitude to using sand as a material, perhaps more so than if the therapist was not visually oriented. In art therapy, the creative use of sand seems to become a typical option in forming a sandworld rather than reliance on choice and placement of miniatures on an unworked flat surface. Therefore, the foundation or formation of the base of a sandworld is often essential for the final image, with or without miniatures. The language of art, as utilized in art therapy, is to transcribe feelings, internal images and concepts into forms that communicate their being. Art enables a metamorphosis of intangible forms into actual concrete forms, further defined by texture, color, and size. Of the many definitions of *form*, several apply to the concrete nature of art-making: 'The outward or visible shape of a body as distinguished from

its substance or color; a mold or frame for shaping; a specific structure, condition, or appearance' (*Funk and Wagnall's Standard Dictionary* 1961).

In the sandtray, sand is a constant base or foundation, whether it is taken notice of or not. Some definitions of the word *foundation* may clarify this:

> That on which anything is founded and by which it is supported or sustained; a structure upon which a building or a machine is erected; that part of a building below the surface of the ground, or that which constitutes a base; sometimes, a platform, on which the upper portions rest. (*Funk and Wagnall Standard Dictionary* 1961).

The concept of foundation is also applicable to non-physical structures. Whitmont (1991), writing about the Self, quotes this passage from Jung:

> The psyche of the child in its preconscious state is anything but a tabula rasa; it is already preformed in a recognizably individual way, and is moreover equipped with all specifically human instincts, as well as with the a priori foundations of the higher functions. On this complicated base, the ego arises. Throughout life the ego is sustained by this base. When the base does not function, stasis ensues and then death. Its life and reality are of vital importance. Compared to it, even the external world is secondary, for what does the world matter if the endogenous impulse to grasp it and manipulate it is lacking? In the long run no conscious will can ever replace the life instinct. (Jung 1961, pp.348–349)

A client whose hands grasp and manipulate the sand in the sandtray may be engaged in an instinctual struggle to form a concrete manifestation of one's own psychic *base–foundation* in the sandtray. This creative struggle may resolve when the form that evolves in the sand is sensed as sufficient in itself for that moment, as is, or used as a foundation upon which objects are placed. When sand is touched it becomes finite and personal. Untouched, it is without limits, anonymous, as if some part of one's own inner pre-verbal structural foundation remains unacknowledged. It may indicate a subtle dependency on the therapist, whose sand it is, to be the base for the client's content. Forming the base or foundation of a sandworld may be an act of responsibility to oneself, the creation of a surface upon which all subsequent development stands.

In art, the base–foundation is the paper, or a material such as clay, used to form with and make marks on, whether two-dimensional or three-dimensional. The relation between a base and the marks made on it begins with the need to leave a mark on the surface of things: on food, dust, vapor, earth,

sand, using parts of our body. Early markmaking combines curiosity and a validation of one's existence. Increased skill and control of markmaking becomes artmaking. Art, as a surface with marks, may become a metaphor for ourselves, as a surface or base upon which life has left marks. We make the image feel as we feel and create a mirror of our experiences (Steinhardt 1995). Doing a sandplay or choosing art therapy over other forms of therapy is voluntary. Some people will not use the sandtray although they may complete an art therapy process. Sand may be felt as threatening and can cause revulsion. Aversion to using sandplay is presented and illustrated with case examples in Chapter 16. However, the primary focus in this text is on those who use sandplay, assuming that among these clients the potential exists for building a base and forms with the sand. A therapist's perception of sand's potential in the sandtray as either a *foundation*, supporting chosen miniatures, or as spontaneously created *form* standing alone, may enhance a client's use of sand. For art therapists, the acknowledgment of sand and water as sculptural material may confirm the importance of phenomena observed in their practice but not described in current literature.

An outline of Jungian concepts relevant to sandplay

At the age of 83, Jung wrote in the prologue to his autobiography: 'Everything in the unconscious seeks outward manifestation, and the personality too desires to evolve out of its unconscious conditions and to experience itself as a whole' (Jung 1961, p.17). Jung comprehended the existence of a 'myth producing level of mind which was common to all men' early in his professional career, while deeply involved in both mythological studies and in his work with schizophrenic patients (Storr 1983). His own dreams as a child and young man also revealed to him the existence of a collective unconscious that could be expressed by myth rather than by science. Jung distinguished between:

> three psychic levels: (1) consciousness, (2) the personal unconscious, and (3) the collective unconscious. The personal unconscious consists firstly of all those contents that became unconscious either because they lost their intensity and were forgotten or because consciousness was withdrawn from them (repression), and secondly of contents, some of them sense-impressions, which never had sufficient intensity to reach consciousness but have somehow entered the psyche. The collective unconscious, however, as the ancestral heritage of possibilities of representation, is not individual but common to all men, and perhaps even to

all animals, and is the true basis of the individual psyche. (Jung 1927/1931, par. 320)

The relevance to psychology of evolutionary processes, and comprehensive human cultural experience, created an amplified understanding of contemporary human life and behavior.

Jung was able to heal himself during a period of disorientation after his decisive break with Freud in 1912 to 1913 through the use of symbolic play, constructing a village using stones, mud and water on the banks of a lake, just as he had done as a child (Jung 1962/1995, p.76). In his building games, the creation of concrete spontaneous imagery helped clarify his thoughts and released streams of fantasies. He later experimented by consciously entering into a dialogue between himself and the fantasy figures he encountered. The emerging unconscious material could then be expressed by painting, drawing, sculpture or writing (Edinger 1968). He termed this process Active Imagination, a procedure for engaging the world of the objective psyche. Storr states:

> Jung described the collective unconscious as consisting of mythological motifs or primordial images to which he gave the name 'archetypes.' Archetypes are not inborn ideas, but 'typical forms of behaviour which, once they become conscious, naturally present themselves as ideas and images, like everything else that becomes a content of consciousness. (CW8,par.435) Archetypes have an organizing influence on images and ideas. Archetypes are not themselves conscious, but seem to be like underlying ground themes upon which conscious manifestations are sets of variations. Their presence is felt as 'numinous'; that is, of profound spiritual significance. (Storr 1983, p.16)

Edinger (1968) writes that 'archetypes are perceived and experienced subjectively through certain universal, typical, recurring mythological motifs and images'. He lists four broad categories of archetypal imagery:

1. The Archetype of the Great Mother, containing both the nourishing and devouring attributes of the feminine principle.

2. The Archetype of the Spiritual Father, personifying the masculine principle of consciousness and spirit, as opposed to matter.

3. The Archetype of Transformation, which contains themes of journey, descent into dark places in search of hidden treasure, themes of death and rebirth, degradation and redemption, and the theme of hero or wonder-child.

4. The Central Archetype, The Self, a symbol of totality or wholeness, that often manifests as a circle together with a fourfold image such as a square or cross, and holds the union of opposites.

Jung defines the Self as being at once the center and the circumference of the psyche. It is the central organizing factor of the personality and includes both the collective unconscious, personal unconscious and consciousness of which the ego is the center.

Jung explained the different attitudes of different people towards the same material as stemming from the fact that there are different psychological types. He coined the terms 'extrovert' and 'introvert' to broadly distinguish between those whose energy flow is directed towards outer objects and the environment, and those who tend to turn inward in their search for fulfillment. Jung also distinguished between four conscious behavioral functions: thinking, feeling, sensation and intuition. All the functions are present in all individuals, but a person's predominant attitude of functioning usually tends toward one function, while its opposite may be neglected. Thus a thinking person may mistrust solving problems by feeling, or the opposite. Focus on one function creates an imbalance in the psyche. Edinger (1968) states that it is 'one of the goals of Jungian psychotherapy to bring into consciousness and to aid the development of the inferior undeveloped functions in order to approach psychic wholeness'. Jung's perception of the psyche as a self-regulating system led to the understanding that, whatever the conscious attitude, it will be compensated by the unconscious attitude. The unconscious may cause disturbance not just as pathology but as a way for the psyche to demonstrate the imbalance in its functioning and the lack of interplay between complementary functions. Jung wrote:

> The repressed content must be made conscious so as to produce a tension of opposites, without which no forward movement is possible. The conscious mind is on top, the shadow underneath, and just as high always longs for low and hot for cold, so all consciousness, perhaps without being aware of it, seeks its unconscious opposite, lacking which it is doomed to stagnation, congestion, and ossification. Life is born only of the spark of opposites. (Jung 1917, par.76)

Jung termed the developmental process which begins in an adult individual *individuation*. Edinger explains this as 'the discovery of and the extended dialogue with the objective psyche of which the Self is the comprehensive expression. It begins with one or more decisive experiences challenging

egocentricity and producing an awareness that the ego is subject to a more comprehensive psychic entity' (1968, p.10).

Sandplay

Sandplay is an activity that integrates play with sand, and choice and inclusion of miniature objects. It is a means of activating fantasy and embodying it through expressive means. An unplanned ongoing dialogue with one's inner world becomes crystallized as a created concrete image, felt to be appropriate by the sandplayer. 'Image and meaning are identical; and as the first takes shape so the latter becomes clear. Actually the patterns need no interpretation; it portrays its own meaning' (Jung 1960, p.204). Images heal by bringing the contents of the unconscious to consciousness, thus enhancing ego contact with this source of psychic life.

An often heard statement from an art therapy or sandplay client in early stages of the process is, 'I don't know what to do.' An expectation that one must produce an idea, an image from a conscious source, can generate anxiety. However, when control is relaxed and the colors or materials are allowed to go their own way, surprising and relevant images do result. Arising from the archetypal basis of the Self – 'central archetype of unity and totality of the whole person to which the ego is subordinated' (Ammann 1991, p.127) – the ego becomes a mediator between the inner and outer worlds. It is then that unconscious levels are reached, and made conscious by creating form. Jung wrote:

> Inasmuch as the ego is only the centrum of my field of consciousness, it is not identical with the totality of my psyche, being merely a complex among other complexes. Hence I discriminate between the ego and the Self, since the ego is only the subject of my consciousness, while the Self is the subject of my totality; hence it also includes the unconscious psyche. In this sense the Self would be an (ideal) factor which embraces and includes the ego. In unconscious fantasy the Self often appears as a superordinated or ideal personality. (Jung 1923, p.540)

Through sand and water in the blue-bottomed sandtray, the sandplayer encounters ancient nature, perhaps activating a primordial evolutionary knowledge in the psyche. Through the miniature object collection the sandplayer meets representatives of natural life, diverse cultures, religions or myth, perhaps providing the framework needed to contact an a priori inborn inherited knowledge and bring to consciousness through imagery energies

conducive to healing. 'From a Jungian standpoint, sandplay mirrors the Eternal Child playing archetypal games. Over time, this can bring into consciousness a new awareness of the child within and of the child archetype' (Ryce-Menuhin, 1992, p.4).

Formation of the base and classification of forms

A client may begin a sandplay by manipulating the sand base and then adding miniatures. In response to the movement of human hands, sand transposes into specific types of form, creating essential sand images. Sandplays may also be made by placing miniatures on sand which is left untouched. Unformed sand is perhaps experienced as a surface no different from a table or floor. In the literature, a large number of sandworlds show prevalent use of miniatures placed on fairly unworked sand. The sand form may encompass rudimentary rivers, pools or mounds, but little or no discussion of sand as form is offered. More complex aesthetically resolved sand formations appear in some cases of Bradway and McCoard (1997), Dundas (1993), Kalff (1980), Margoliash (1998), Markell (1994), Ryce-Menuhin (1992), and Weinrib (1983). However, noticeably prevalent sculptural sand imagery is found in a majority of the case illustrations of Ammann (1991), a trained architect and Jungian analyst who states that she has always loved images and three-dimensional forms. She allows sandplay to be used as much as the analysand seems to choose, and flexibly weaves it into her analytical work. Her deep respect for nature and the constancy of natural processes is a clear foundation of her approach to sandplay. Thus, it is possible that the sculptural sand imagery in her clients' work resonates in some way to her artistic and aesthetic–visual sense. It may also reveal a tendency to view sandplay as primary therapy rather than as a supportive activity alongside a predominantly analytical process.

Work with sand can be organized into three categories based on universally recurrent forms created spontaneously by children in beach play as they go through developmental stages. The first category deals with working the sand surface. Children's sand activities begin with filling a mold, drawing lines, impressing, and gathering sand and making mounds. The second category deals with penetration of the sand surface, digging holes and tunnels, or burying and uncovering something. The third category involves the use of water, in a controlled manner for dripping, or for uncontrolled flooding. Combinations of these activities lead to more complex forms.

In therapy children and adults spontaneously create these forms in the sandtray. Meaning may then link to the form itself, and to the phase of therapy in which it occurs, becoming a concrete manifestation and symbol of issues which emerge during the interactional process. Jung wrote: 'A symbol always presupposes that the chosen expression is the best possible description or formulation of a relatively unknown fact, which is nonetheless known to exist or is postulated as existing' (Jung 1921, CW vol.6, par.814). As sand forms become symbolically significant they shed their simplicity. A line in the sand may become a manifestation of the archetype of 'The Way' (Neumann 1983, p.8), and an invitation to Hermes, guardian of the roads, to 'be with us whenever we are willing to venture into new territory with an attitude of exploration and openness' (Bolen 1989, p.171).

A hand imprint in the sand may symbolize one's existence and also a request for protection and justice from a divine power (Cooper 1978). Releasing a 'pie' into the sandworld from a filled mold may be like the birth of a new world with some external support still needed (Neumann 1988, p.10). The mound or mountain may be experienced as a breast, belly or womb, a container of feminine nurturance. It could also be a Tel – an ancient tomb, or a world center, an omphalos, connecting earth and heaven (Cooper 1978).

A cave scooped out of the sand's depths may be sensed as womb or tomb, a place of hidden treasure, a spirit guide or oracle's residence. A tunnel may provide a passage for transformation similar to a birth (Steinhardt 1998). Controlled sand drips create lacy spires reaching towards spiritual realms. Flooding dissolves all forms, a mini-deluge that enables later reconstruction of the world with new forms. The ten forms, comprising three categories, are presented theoretically, with case examples in Part 5.

Factors influencing formation of the base

Given the obvious presence of sand in the sandtray and its possible significance, it might be of value to identify factors that influence active engagement with sand. First, the shallow structure of the sandtray container limits construction into depth, although building upwards is technically achievable. At one sandplay workshop led by the author, participants had to bring their own sandtray containers. Most containers were considerably deeper and smaller than the standard dimensions. The forms created within these containers utilized real depth in a way not seen in the standard shallow sandtray, where depiction of depth is symbolic. This allowed an expansion of

the concept of meaningful form according to the sandplayer's inner need. The presence of the color blue as the sandtray's interior is another physical factor that is discussed in Chapter 2.

The therapist's attitude about the importance of sand and the frequency of doing a sandplay may influence instruction given for beginning a sandplay. Some texts relate an invitation to touch and manipulate the sand first, followed by a subtle instruction to take objects and begin placing them. The words that convey this might hint at choosing objects as the work's focus. Developing a tactile–visual relationship to sand form might not be a clear option.

Another factor influencing sand form might be the therapist's own visual training. On the training of the sandplay therapist Weinrib (1983, p.12) says: 'The therapist listens, observes, and participates empathically and cognitively, with as little verbalization as possible.' She adds that the therapist:

> should have had a deep analysis himself and adequate clinical training, including extensive knowledge of archetypal symbolism. He should have had a meaningful personal experience doing sandplay as a patient himself. He should be familiar with the states of development as they manifest in the process, and he should have studied and compared many sand pictures, which is the only way to learn to read them. As the carrier of the process, he should have achieved rootedness in himself. (Weinrib 1983, p.29)

This passage does not include art training as providing additional visual skill for reading a sandplay. Training does include doing a personal sandplay process, an opportunity that could be used to expand one's visual creativity. Many people do not attempt to draw or paint because they are deeply convinced that they have no artistic talent. If sandplay was viewed as a primary art form, this might free innate visual imagery for the sandplay therapist in a more experiential way. There might be increased use of sand form by that therapist's clients. Art therapists have benefited greatly by receiving Jungian sandplay as an established method resting firmly on considerable theoretical expertise. However, the art therapy setting and sandplay phenomena occurring in it remain to be validated in sandplay literature.

The author's personal experience in sandplay and art

As a child I was involved in art-making behavior. It manifested as a response to an inner need to make visual marks whenever and wherever possible. This was a serious playful behavior that seemed to have no name and no apparent purpose. Drawing paper and colors were unaffordable or unattainable luxuries during the early 1940s. Therefore my early drawings and sculptures were done with any available material or surface such as snow, dust, steam vapor, the margins of newspapers, chalk, earth or sand. During the winter the schoolroom blackboard could be drawn on with chalk during the breaks. In summer the nearby Atlantic Ocean provided a sandy beach, limitless space and natural objects for drawing and forming. I observed my own forms and the forms that other people created with sand and water. I also became aware of the forms and minute details created by wind, water and natural processes acting on the sand or the rock formations. I later attempted to record these observations graphically and became a painter and potter. I never questioned my interest in making art, or what purpose it served. Many years later I began to teach art. As I facilitated art-making behavior in others, I realized its inherent therapeutic value. There is an authentic artmaking behavior in which time vanishes, and fundamental needs and ideas arise, personal sources of creativity are activated and given form in the visual image. In 1980 my discovery of the art therapy profession accessed for me another level of art. As an art therapist I could see how the visual image became a bridge between inner and outer worlds.

In 1987, while teaching an art therapy course in a training program, another workshop in the curriculum entitled 'Sandplay Therapy' caught my eye. Sand and water at the beach had been my childhood canvas and my studio. I attended the workshop in a large gymnasium. The group leader, a dance-movement therapist, asked the 60 participants to lie with all heads towards center, forming a large circle. She directed the group to relax, breathe and emit spontaneous sounds for quite some time, until the sounds merged in harmonious accord and slowly faded away. Along a wall were little random piles of miniature objects and some sand. One could take a small piece of paper, place sand and any chosen objects on it and play around with them. Then the experience or story could be written up. The simplicity and depth of this experience was enchanting and overwhelming. My primary relationship with art had become my profession. Now sand and water in nature, the tools of my first 'environmental art', could join the art materials in my studio as a distinguished mode of making images therapeutically. Thus

the primal image-making tools of my childhood merged with art therapy, my current profession.

The merger of sand, water, art and art therapy revived sensory memories of a time when there was no separate word for art and play, and where art therapy and sandplay were not historically separate therapeutic methods. This retrieved memories of knowing the seashore and landscape well, by living in them and observing constantly, guided by nature itself. During the countless days and years invested in sand and water play at the beach, an intuitive knowledge grew in me that sand, water and the color blue was an essential place. This knowledge is the foundation upon which my professional training in art, art therapy and sandplay rests. The issues that I will introduce here are perhaps an attempt to pay respect to this foundation, and to confirm the importance of spontaneously created sand form in the sandtray as an essential component of sandplay therapy.

An outline of the text

Part 2 of the book reviews the sandplay literature, keeping sight of issues that impact directly on formation of a sand base. Beginning with a brief description of the evolution of sandplay as therapy, guidelines for practice will be reviewed, as well as attitudes towards the physical attributes of the sandtray, such as its shape, dimensions and blue interior. Styles of introducing sandplay to a client, the accepted frequency of doing sandplays and the importance of sand itself, and requirements for training the sandplay therapist are also reviewed.

Part 3 serves to support the perception of sandplay as integral to the art therapy setting by centralizing a common focus through which both may be viewed. A brief history of art therapy (Junge and Asawa 1994; Waller 1991) and the Jungian trend in art therapy (McNiff 1986, 1989; Robinson 1984; Schaverien 1992) are first presented. Jungian sandplay is viewed in the literature as concrete 'active imagination', a role painting and sculpture could not always fulfill, perhaps because shaping formless materials demands some skill. Sandplay combines sand, water and ready-made objects and is quick. But still it is a concrete method of forming an image with materials and can be compared to other art forms such as drawing, sculptural relief, collage and assemblage. Connections will be made between art forms and sandplay, enabling a perception of sandplay as a unique form of image making in art therapy. Use of objects in sandplay will be compared with the use of objects in art, beginning with the Cubists. Art and art therapy theory provide sources

of information and comparison. Several possible classifications of materials will be presented, according to their physical qualities, the ways they may be used, and the type of imagery they elicit. The properties of art materials, and of sand and water as materials will be defined. In addition, the miniature objects used for populating the sandtray are also made of distinct materials such as wood, glass, stone, metal and plastic. The qualities of these materials need definition as they may influence a client's choice of an object. Finally, color is discussed as a presence in itself.

Part 4 is devoted to aspects underlying visual expression, which contribute to creation of form in art, and to building sand foundations as a psychological and artistic concept. The evolution of markmaking into art forms identifies the common starting point of sandplay and art. Individual visual expression in therapy may be understood as a concrete culmination of the complex interplay between the therapeutic environment, materials, and the individual psyche. Created form and illusion have always been partners in the realm of art. Aspects of artistic illusion may also extend to sandplay in the art therapy setting, together with other illusory aspects of sandplay. Mapping the sandtray, individual and collective process and form, and the influence of group work on the sandplay image close Part 4.

Part 5 describes the primary modes of play with sand and water. Underlying motifs attached to use of the sand surface, penetration of the surface, and the use of water as dripped form or as aiding in the dissolution of form, are presented theoretically and through case examples. All the manifestations of sand form (molding, gathering, drawing, imprinting, digging holes, tunnels, burying, uncovering, dripping and flooding) are familiar in spontaneous beach play, and all appear in sandtray work of children and adults. In the sandtray, the symbolic meaning of these forms may be as pertinent as understanding the symbolism of objects. Each type of sand form is illustrated with examples from clients' work. Inability to engage in tactile communication with sand is also discussed and illustrated with case examples.

In Part 6, one client's sandplay process is presented, with attention to the use of sand, space, materials and color in the healing process. Some comparison will be made between the art and sandplay imagery of this single client within the total process. This may elucidate the client's choice of painting, drawing, sculpture or sandplay in different phases of the therapeutic process, as a need of the psyche for different levels of imagery at different stages.

A Review of Sandplay Literature in Relation to Form

History and Description
of Sandplay Therapy

History

Sandplay originated in 1929 as a form of play therapy with children in the clinic of English child psychotherapist Margaret Lowenfeld (Lowenfeld 1935, 1979). Lowenfeld especially valued the tactile experience of sand and water in addition to projective play with toys. The children added real water to the sand and placed miniature toys in it, thus originating the 'World Technique'. In 1935 Lowenfeld published her first book, *Play in Childhood*. Educational psychologist Ruth Bowyer studied, used and researched Lowenfeld's sandplay method, the 'World Technique' (Mitchell and Friedman 1994). In 1970 Bowyer wrote *The Lowenfeld World Technique*, summarizing 40 years of research based on Lowenfeld's approach to working with children. Her research included the use of sand in children's play. Other early child psychotherapists such as Melanie Klein, Anna Freud and D.W. Winnicott valued play as the child's non-verbal communication about his feeling and life. Their clinics contained small toys and miniatures but excluded sand (Mitchell and Friedman 1994).

Jungian sandplay was developed by Swiss Jungian child psychotherapist Dora Kalff, after Jung encouraged her to study sandplay in London with Lowenfeld in 1956 (Ryce-Menuhin 1992). Kalff had studied at the Jung Institute in Zurich for six years. She added to Lowenfeld's basic tenets her own rich background in Eastern philosophy and her knowledge of Jungian theory. Jung's belief that image making is an alternate method of therapy, described in 'The Transcendent Function' (1916/1958, vol.8 CW, pp.82–83), expanded on Freudian interpretations of the creative act and deepened the relationship between the artmaker and his/her images. Jung's technique of 'active imagination' introduced the notion that one's inner life is rich with feelings and thoughts of which one is not aware, and by allowing fantasy free

rein, while observing, these hidden parts can be made conscious. Kalff's approach to sandplay integrated these precepts. Kalff (1980) created 'a free and protected space' for her clients, an accepting, holding environment where they could engage in sandplay. Her approach rested on the 'basic hypothesis postulated by Jung, that there is a fundamental drive toward wholeness and healing in the human psyche' (Weinrib 1983, p.7). Kalff stated that observations made during her clients' sandplay processes were 'in agreement with the psychological experience that the Self directs the psychic developmental process from the time of birth' (Kalff 1980, p.23). In her clients' sandworlds, she noted, in accordance with Jung, how circular forms appear, 'particularly as a "symbol of perfection and of the perfect being", and the square as a form that 'appears when wholeness is developing' (Kalff 1980, p.24). Kalff's recognition of stages of development in a sandplay process found theoretical confirmation in the ideas of Jungian analyst Erich Neumann regarding psychological development in early childhood (Weinrib 1983). Kalff saw the applicability of sandplay for adults as well as for children and found that the same developmental stages were present in adult sandworlds (Kalff 1980). Through Kalff's teachings, sandplay developed within analytic frameworks and came to be seen as a concrete form of Jungian 'active imagination' (Bradway and McCoard 1997; Stewart 1990; Weinrib 1983).

Jungian sandplay utilizes two rectangular trays painted blue on the inside, one filled with dry sand and the other with moist sand. Kalff slightly changed the measurement of her trays (49.5 cm × 72.5 cm × 7 cm) from that of Lowenfeld, and achieved geometric proportions in which the diagonal of a square made by the rectangle's vertical measure is equal to the length of the base, or horizontal measure (Jackson-Bashinsky 1995). Her trays were not placed on the floor, but stood separately at table level. A large selection of miniature objects representing everything in the natural and human world should be available on nearby shelves. Natural objects, fabric, string, paper and other materials are also accessible. Kalff's miniature object collection encompassed symbolic, ethnic and religious objects from all over the world, enabling representation of the psyche's connection to the collective unconscious in addition to representation of familiar phenomena.

In addition to the Jungian analysts trained in sandplay by Kalff, other therapists from backgrounds in psychiatry, psychology and social work increasingly used sandplay as an adjunct therapy. 'Kalffian' sandplay has flourished as a valuable but intermittent image-making event supporting a

verbal therapeutic process. Dora Kalff's book 'Sandspiel' (1966, translated into English in 1971), was the first published literature on Jungian sandplay (Kalff 1980). Sandplay literature since the 1970s has been written primarily by Jungian analysts with an enthusiasm for the powerful deep dialogue between sand, objects and psyche (Ammann 1991; Bradway and McCoard 1997; Bradway et al. 1990; Dundas 1978; Kalff 1980; Mitchell and Friedman 1994; Ryce-Menuhin 1988, 1992; Weinrib 1983). Sandplay has largely been understood through focus on stages of development in the individuation process according to Neumann (1988). The symbolism of miniature objects has been seen through amplification based on all psychological, anthropological, ethnic, cultural and mythological knowledge related to an object.

The triangular transference that occurs between client, therapist and image has attracted the interest of psychotherapists working with sandplay. The role of therapist as silent witness-participant is a radically different interaction for those accustomed to working with direct transference–countertransference and interpretation. They find that sandplay is less tiring than analytic work (Ammann 1991; Cunningham 1997). Bradway and McCoard (1997) use the term co-transference to refer to the complex 'mix' of the therapeutic relationship. Ammann (1994) musically describes the interactive relationship according to the principle of resonance. She sees the entire being of the therapist as an 'instrument', which he/she must play fully and well. Then the client's being responds on these same frequencies (p.58). The triangular transferential relationship is part of art therapy and has been debated by art therapists almost since the birth of their profession (Agell et al. 1981; Kramer 1971; Schaverien 1992, 1995). The art therapist as silent witness is often hard at work observing the 'foundation and form' that a client creates in his/her art or sandplay, and the marks made upon it. Involvement in the transference–countertransference is concurrent with observing the making of a sandplay. The essence is not only observation of the process, but sensing the internal level on which sandplay imagery resonates, as compared to art imagery.

Aspects of sandplay impacting on the creation of sand form

Physical attributes of the sandtray

THE SANDTRAY'S DIMENSIONS, SHAPE AND GEOMETRIC PROPORTIONS

The dimensions of the sandtrays of Lowenfeld and Kalff are similar. Lowenfeld specified dimensions of $52 \times 75 \times 7$ cm and Kalff adjusted these proportions to $49.5 \times 72.5 \times 7$ cm. This slight difference is explained as creating a size easily seen without the client having to move the head, although this would seem to be possible in the Lowenfeld tray as well. Due to a misprint of Kalff's proportions in her book on sandplay (Kalff 1980), Kalff's sandtray was wrongly reproduced by sandplay therapists, although the basic shallow rectangular shape remained. Thompson wrote that proper measurements of the sandtray revealed a situation closely allied to chaos, citing Stewart's (1977, p.9) prescription of 'approximately $30 \times 20 \times 3$ inches' as a median; there is no mode (Thompson 1990). These proportions equal $51 \times 76 \times 7$ cm, much larger than Kalff's tray. Ryce-Menuhin writes:

> The average size of sandtrays used by therapists in a recent survey seems to be about 18 inches deep, 23 inches across and 3½ inches high at the sides. I use a very slightly larger-sized box as the temenos or container; the size must act as a regulating and protecting factor for the patient's non-rational expression. This expression may touch a profound pre-verbal level of consciousness without any conscious use of regression. (Ryce-Menuhin 1992, p.5)

Ryce-Menuhin's proportions are equivalent to $46 \times 58 \times 7$ cm, much smaller than Kalff's tray. Weinrib (1983) unquestioningly gives sandtray proportions as $28½ \times 191½ \times 3$ inches, and these are Kalff's proportions in inches.

These variations and inconsistencies of proportions led sandplay therapist Jackson-Bashinsky to Switzerland, tape-measure in hand, to measure the original Kalff sandtrays. She had questioned the shape of her own sandtray and remembered Kalff's comments about the symbolic meaning of 'basic geometric forms, especially as they pertain to the developing self'. Jackson-Bashinsky discovered that the true sandtray measurements were $49.5 \times 72.5 \times 7$ cm. She also realized that there was an innate geometric relationship between the diagonal of a square based on the vertical measure being equal to the length of the sandtray's horizontal measure (Jackson-Bashinsky 1995).

Questions about the shape rather than the proportions of the sandtray have also been a subject for debate. Signell (1990) wrote: 'When I am at the

beach I sometimes draw a circle in the sand, and gather my objects from the beach.' She adds in a footnote: 'Incidentally, I naturally gravitate to a circle, a feminine container, not the traditional rectangle, and would have a round sandtray in my office if it were feasible!' (Signell 1990). Thoughts about alternative sandtray shapes are discussed by Ammann (1991):

> Because of the inequality of measurements the rectangular space creates tension, unrest, and a desire for movement, a desire to go forward. The square or circular space, however, creates balance, rest, concentration toward the center. It is possible to compare the analytic process with a constant search for the center in uncentered space...the analysand works distinctly upward, or outward to the sides, until he finally finds this center, his personal circle, in the rectangle of the sand tray. (Ammann 1991, pp.17–18)

Within the variations of sandtray proportions and the debate about the possible geometric shapes for the sandtray, several points stand out. The shallow dimension of the tray, 7 cm or 3 inches, remained the same despite changes in the vertical and horizontal lengths. The basic rectangular shape has remained constant. Alternate shapes such as a circle or square have not been widely used as the containing temenos. As Jackson-Bashinsky has stated, in Kalff's sandtray there is an inner relationship between the vertical and horizontal dimensions, establishing a visual balance not immediately discerned by the eye, but perhaps felt as reassuring by the psyche.

It would seem that the importance of shape and proportions have been especially considered by Kalff and Ammann. The shallow 7 cm depth of the sandtray does not allow development of forms in depth but does allow building to the heights. Thus the depth of the sandtray and the blue 'water' interior are symbolic, almost two dimensional and imaginary. This relates the sand picture to a picture on paper, rather than to a sculptural image. This might satisfy clients for whom a symbolic depth suffices, but others more involved with creating structures may seek actual depth. As mentioned in the introduction, participants at a five-day sandplay workshop led by the author brought their own containers, many of which had considerably more depth than the standard sandtray. Sand forms of depth and complexity emerged and became part of the personal myth created in the ongoing process.

Some art therapists use paper that has been pre-shaped into various geometric forms in different sizes, such as a square, circle, oval, or very long rectangle like a Japanese scroll. It is assumed that forms, size and proportions will elicit in the client different movements, pace and content, and a client

will intuitively choose a form suitable to his/her inner need. Kalff (1980) believed in the significance of basic geometric forms, such as the square, triangle and circle: 'We accept the validity of these symbols of the wholeness of the human psyche because they have occurred everywhere, without exception from the earliest times of man.' Her sandtray was rectangular, probably because the dynamic of this form enables the sandplayer to find one's own center within it (Ammann 1991).

Sand and water sometimes seem to encourage non-symbolic behavior, such as throwing or pushing sand out of the low-framed box, or asking for much more sand than can be contained in the current low sandtray. The need for real rather than symbolic water also may manifest in placing a small container filled with real water as part of a sandworld, or in actually flooding the sandtray. Thus, it appears significant to consider the effect of proportions, shape and depth of the sandtray temenos on a client's creative behavior and work.

BLUE AS THE COLOR OF THE INNER SURFACE OF THE SANDTRAY

Blue has been designated for the sandtray's interior by Jungian sandplay's founder Dora Kalff. In her own book Kalff does not mention the blue interior, but this is stipulated by others who have studied with her or written about her work. Mitchell and Friedman describe Kalff's method of introducing the blue interior as representing sky or water when the sand is moved aside: 'After the client touched the sand, Kalff would explain that the blue background was meant to bring to mind images of water and concluded her brief introductory remarks by suggesting that the client 'put in what speaks to you' (Mitchell and Friedman 1994, p.54).

But water and sky imagery can always be indicated by blue fabric or paper placed on the sand, so the blue interior must have some additional purpose. One must understand the effect any color has on our physiological and psychological state in order to see that blue is actually conducive to the work done in the sandtray. The attributes of blue include intrinsic depth, height and continual distancing (Kandinsky 1977, p.38). A deep and strong sky-blue color is described by Walker (1991, p.52) as 'the most tranquilizing color of all'. Blue causes the brain to secrete neurotransmitters that bring calmness to the body, by slowing the pulse rate, lowering body temperature, lessening sweating and reducing appetite. Each of Jung's four function types (thinking, feeling, sensation and intuition) may be represented by a color. The feeling type may be represented by red, the sensation type by green, the

intuitive type by yellow and the thinking type by blue. Edinger noted: 'Thinking is the rational capacity to structure and synthesize discrete data by means of conceptual generalization' (1968, p.2). Steinhardt states:

> We can begin to see the role of blue as the color of the inner surface of the sandtray beyond its equivalence to water or sky. Blue like the backdrop of a stage play, spreads out and away from the sandplayer and can give distance and perspective or draw one into depth. (Steinhardt 1997, p.458)

For an artist the term blue is general rather than specific, as there are at least six major blue pigments which are not interchangeable, each with a unique aura. In the sandtray, the appearance of sand form may occur because the interior is a clear blue of a specific hue. Bradway described her early sandtray as a:

> square red tray without any sign of blue on the sides of the tray. Later I learned that it was not the official Dora Kalff size and I changed to a rectangular blond tray with the now familiar dimensions of 19.5 by 28.5 by 2.75 inches. The floor of the tray was the specified blue, but the sides were not. Still later, when I started to use trays with the sides also painted blue, I found that the scenes more frequently had a three-dimensional quality. (Bradway and McCoard 1997, p.xiii)

Bradway describes a young man's experience with sand and blue:

> He put his fingers into the sand down to the blue base And circled with them through the sand making the largest oval shape the rectangular box permitted... He spent the rest of the time smoothing and patting the oval island, sometimes with one hand and sometimes with both hands, circling it with his finger or fingers, and clearing the sand away from the blue so that there was a clear blue space around the hard central mound of sand. (Bradway and McCoard 1997, p.6)

It is likely that if the blue color were not there, in a hue having a color impact in relation to the sand's color, this form might not have manifested so clearly.

Yet many sandplay text illustrations show no blue interior, partial blue, pale blue, and sometimes an unvarying darker hue. The qualities of blue need precise definition consistent with the sandplay experience, especially so because the various blue pigments are not interchangeable and have distinct visual auras. The author has painted the dry sandtray interior cerulean blue, a strong color that has less depth than the deeper cobalt blue, which is used for the moist sandtray. Selection of moist sand often indicates readiness to cope

with emotional depth in sandplay (Kalff 1993). Thus a deeper blue would subliminally support the concept of depth. The lighter cerulean blue would be consistent with the dry sandtray, drawing the sandplayer less into depth.

Blue in nature accompanies sand as water or sky. The experience of sand is incomplete without a truly blue background. The presence of a strong cobalt blue in the sandtray contrasts with the pale sand naturally and dramatically. Three-dimensional forms may evolve as concrete physical reflections of the concept of depth felt in the deep blue color, and because of the strong contrast with it.

Attitudes to sandplay frequency, sand and instructions

THE FREQUENCY OR INFREQUENCY OF DOING A SANDPLAY

As an adjunct to analysis, sandplay as a non-verbal method accessing pre-verbal forms of psychic knowledge is used with varying frequencies, ranging from frequent use of sandplay to doing just a few sandplays over several years. Obviously, a client's willingness to do a sandplay affects the frequency, but a therapist's attitude may be equally influential. The following examples illustrate this. Kalff wrote:

> Sandplay constitutes in itself a method whereby the individuation process is lived through and expressed. I personally have never considered it an adjunct to verbal analysis, to be used only at certain points in the therapeutic process. When it is used as an adjunct to verbal analysis, it may very well further the therapeutic work, but I do not think it will lead to the same types of experience that I have seen to be possible through a continuing use of Sandplay as the main emphasis of the therapy. (Kalff 1980, cited in Bradway *et al.* 1990, p.ix)

Mitchell and Friedman add: 'Kalff emphasized the nonverbal techniques of Sandplay and play therapy at the earlier stages of therapy, while seeing the value of verbal and analytical approaches in later therapy stages' (1994, p.59). The type of experience Kalff refers to is not visually illustrated or verbally explained except for indication that sandplay is primary therapy. The sandworld photographs in Kalff's own book (1980) show very invested sculptural imagery. Kalff had an extensive background in music, art, and Eastern philosophy. Her richness of attitude seems to have non-verbally reverberated in her clients' work.

Jungian analyst and sandplay therapist Weinrib (1983) presents sandplay as integrated into the analytic process with long intervals between sandplay sessions:

> Pictures are not necessarily made at every meeting. Sometimes weeks, more rarely even months, go by between the making of sand pictures because the image, coming out of the depths of the psyche and concretized in a creative act, needs to develop and move on in its own time. When no pictures are made, a regular Jungian verbal analysis proceeds, including the interpretation of dreams, work on typological problems, interpersonal relations, and other issues... In sandplay – a ruminative, contemplative process – understanding is less important than the healing process itself. (Weinrib 1983, p.23)

Bradway states:

> I, too, have found that verbal analysis and sandplay usually occur concurrently, but sometimes one is emphasized more than the other and sometimes they are done with different therapists. Often verbal analysis takes center stage and sandplay remains an adjunct to the verbal analysis. At other times, sandplay is the main mode of therapy and verbal analysis is clearly an adjunct to the sandplay, which is how Dora Kalff used sandplay. And occasionally, analysts who do not use sandplay themselves have referred their patients to me for sandplay which went on in tandem with their regular verbal analysis. (Bradway and McCoard 1997, p.18)

Bradway continues later: 'Most analysts use sandplay in the first way, as an adjunct to verbal analysis. Some see it as a parallel to, or even sometimes as a substitute for, dream analysis (Bradway and McCoard 1997, p.27). Ryce-Menuhin (1992, p.33) prefers to 'use sandplay in conjunction with a long, deep verbal Jungian analysis of many years'.

Ammann (1991) uses verbal analysis and sandplay simultaneously or alternately, and as intensively as the analysand chooses. Ammann does not mention the frequency of her analysands' work with sandplay, but the work she presents shows intense awareness of light and shadow, knowledge of form and texture, an investment of time, producing art and sandplay combined.

Sandplays allied with a verbal process may be done rarely but the images do show intrinsic visual continuity manifested in the recurring use of miniatures, patterns of placement, or created sand forms. This continuity presents the psyche as a consistent maker of images, with its own memory, trusting that imagery as an ongoing consistent language. The art therapist

knows that there is never too much making of imagery. Form and material may change, but the non-verbal process resolves itself as images press to be revealed. In the art therapy setting, sandplay may be used weekly for many consecutive sessions, or used for two or three sessions, alternating with artwork and returning to sandplay, or done just once or twice a year. Each art therapy client determines by choice the frequency of art imagery or sandplay imagery, controlling the balance between them. Thus, in the art therapy setting, therapy oscillates between two types of concrete expression, rather than between sandplay and verbal expression.

An art therapy framework for sandplay is an option not mentioned in recent books, as those of Mitchell and Friedman (1994) or Bradway and McCoard (1997). However, articles linking sandplay with psychodrama (Toscani 1998, Winn 1995), music (Hale 1988), dance-movement therapy (Lewis 1988), and art therapy (Case 1987; Steinhardt 1995, 1997, 1998) have appeared in various publications.

THE STARTING POINT OF A SANDPLAY .

Margaret Lowenfeld, the originator of the 'World Technique' (Bowyer 1970) introduced children to sandplay through somewhat explicit instructions for creating a scene. She might explain that pictures could say things that words could not. Mitchell and Friedman describe Lowenfeld's approach:

> Attention was then directed to the sand tray, as she explained that the sand could be left spread out for placing things on it or it could be heaped into masses; and the blue base of the tray could be used to represent sea, lakes, or rivers. Next the child was shown the content of the cabinet of toys and asked to 'make a picture in the sand,' using any or none of the objects in the cabinet. (Mitchell and Friedman 1994, pp.11–12)

Lowenfeld wrote that 'once started on the work, introduction becomes superfluous; the interest of the creation itself is its own explanation' (Lowenfeld 1979, p.5). Her instructions lead to choosing and placing objects but they also do emphasize play with sand.

Bradway, after years of experience, has no fixed set of instructions but lets them 'evolve out of the circumstances'. She compares this to instructions she used with clients when she was studying with Dora Kalff. Kalff would say: 'Look over the shelves until you find something that speaks to you and put it in the tray and then add to it as you wish' (Bradway and McCoard 1997, p.52).

Mitchell and Friedman provide an introduction to doing a sandplay similar to Kalff's: 'After the therapist has introduced the procedure and given the client an opportunity to engage (touch, manipulate) the sand, miniatures on nearby shelves are selected by the client and placed in one of the trays to form a scene' (1994, p.xix). Kalff's precise instructions and those of Mitchell and Friedman seem to skip quickly over the preliminary stage with sand and may cause a client to leave the sand untouched or secondary to placing miniatures. Weinrib (1983) leaves things open:

> No instructions are given. The patient is simply encouraged to create whatever he or she wishes in the sand tray. The patient may choose to make a landscape or any other kind of picture, or decide to sculpt or just play with the sand. Using the sand tray, the patient is free to play out his fantasies, to externalize and make concrete in three dimensions his inner world. (Weinrib 1983, p.12)

Weinrib describes the first sandplay experience of a man with a history of psychiatric disturbance:

> He stood staring at the tray for a while and then ran his hands into the sand. He caressed it, felt it, ran his hands through it as though discovering the texture of sand for the first time in his life. Just having his hands in it seemed to satisfy some hunger. (Weinrib 1983, p.45)

For Weinrib, sandplay can be like meditation: 'One stands before the empty sand tray or the full shelves of figures and waits for an idea or an image' (p.69).

Ammann has a similar approach:

> The analysand expresses in the sand what is spontaneously constellated in him during that hour. He is completely free to play or not to play with the sand, just as he likes. The analyst gives him no instructions. Figures can be used if it seems necessary but some adults only sculpt with the sand. (Ammann 1991, p.17)

Ammann shares her basic premise: 'Often the structure of the sand, as foundational element, is just as expressive as the figures which might be placed upon it' (p.24). Although Ammann does not elaborate on this premise, the photographs presented illustrate that her patients understood this option well. The premise of sand structure as foundation and expressive form is elaborated on in this book.

The introductions of Weinrib, Bradway and Ammann resemble an art therapy starting point. The art therapist often prepares the setting before a

patient enters the room. Materials for drawing or painting, the visibility of paper on a table or easel or clay on a wooden board all convey messages as to what may be done in the room. There may be little need for instruction, beyond ascertaining the patient's right to choose the materials with which he will work.

ATTITUDES TOWARDS THE IMPORTANCE OF SAND IN SANDPLAY

Ruth Bowyer, a psychologist who researched Lowenfeld's 'World Technique', contributed much to sandplay by insisting on researching the use of sand. Influenced by the 'World Technique', psychologists such as Charlotte Buhler, Hedda Bolgar and Liselotte Fischer developed diagnostic methods based on play with prescribed sets of miniatures. They considered sand peripheral and discarded it (Mitchell and Friedman 1994). Contrary to this, Mitchell and Friedman describe Bowyer's work with 50 children and 26 adults, aged 2 to 50. Bowyer (1970a) found:

> that the constructive use of sand (i.e., the movement of sand by the client in order to build a creative product) added important dimensions: increased the richness of expression, expanded available information for analysis of the production, and gave added depth to the experience of creating the World. The medium of sand provided the opportunity for subjects to experience and express a large range of emotion through pouring, burying, and hitting the sand. Making their own constructions of hills, valleys, roads, rivers, waves, furrows, etc., deepened and enriched both the experience and interpretation. In a later study, Bowyer (1959a) also found that the constructive use of sand suggested average or above-average intelligence (most often after the age of twelve), as well as the availability of inner imaginative resources. (Bowyer 1970a, cited in Mitchell and Friedman 1994, pp.68–69)

Jones (1986) demonstrated in her research that: 'The structure of children's creative expression in Sandplay is consistent with Piaget's principles and chronological stages of cognitive development. Structural complexity of the sand worlds increased with age in accordance with Piaget's developmental sequences.' Jones reported on the use of sand according to age groups: 'Children aged 0–1 dropped and threw sand in and outside of the tray. Figures are plunged in and out of it.' From aged 2 to 4, 'Sand is used primarily for burying and unburying figures, which may result in a vague sense of boundary through this simple dramatic play.' From age 5 to 7, 'Sand is used to create permanent structures and clear, though diffuse boundaries.' From

age 8 to 12, 'There is some simple sand construction, although sand is generally left untouched.' From age 13 to 18, 'Sand is extensively used to create land and water form, as well as boundaries' (Mitchell and Friedman 1994, pp.91–93).

Thompson (1990) quotes Eickhoff (1952):

> The most therapeutically exciting and satisfying medium in my experience is the sandtray with its equipment. Here is plastic material in the shape of sand and water by means of which gross feelings can be expressed, for it can be thrown, tossed, molded, plastered, dug and smoothed; and on this basis concrete symbols can be placed so that a situation is very easily presented to the gazer. (Eickhoff 1952, p.235, cited in Thompson 1990)

Bradway states:

> For me the power of sandplay has to do with the coagulative potential of working with actual sand and water and miniatures, and with the freedom to do whatever one wants with these media while feeling protected by a non-intruding, wise therapist whom one trusts. (Bradway and McCoard 1997, pp.7–9)

She refers to Edinger (1985, p.100):

> Concepts and abstractions don't coagulate... The images of dreams and active imagination do coagulate. They connect the outer world with the inner world...and thus coagulate soul-stuff. Moods and affects toss us about wildly until they coagulate into something visible and tangible; then we can relate to them objectively.

Bradway reiterates:

> Sandplay offers an opportunity for such coagulation. Emotions and moods are experienced concretely in the use of sand and water with, or even without, miniatures... It is the experiencing of molding the sand, of adding water in sprinkles or by cupfuls, of placing the objects, of burying them, of letting something happen, be it felt as creative or destructive, and of honoring whatever process takes over, that is healing.

These attitudes confirm the importance of play with sand and its presence in the sandtray. Sand is linked to developmental stages, and to coagulation of self-expression in form. In Part 5, classification of sand forms and their therapeutic meanings may take this one step further.

The therapist, transference, co-transference and resonance

Within the sandplay establishment there has been ongoing debate regarding transference and countertransference in the client–therapist relationship. Sandplay's originator Margaret Lowenfeld (1935) believed that a child involved in play with sand, water and miniatures developed a transference to the tray itself, rather than to the therapist. This was a radical approach in comparison to belief in the importance of transference to the therapist proposed by contemporary members of the psychoanalytic community Melanie Klein, Anna Freud, Susan Isaacs and D.W. Winnicott (Mitchell and Friedman 1994). In Jungian sandplay from Kalff onwards one can find variations on the theme of transference–countertransference. These are directly connected to the therapist's orientation, training and personal background, the personal tools which a therapist brings to sandplay as non-verbal therapy.

Mitchell and Friedman (1994, pp.79–81) review attitudes to transference in sandplay by focusing on the approaches of five sandplay therapists: Lowenfeld, Kalff, Weinrib, Bradway and Ammann. Kalff, combining Jungian principles and her own creative knowledge, reasoned that there was:

> a two-way interaction in which the therapist could not come from a position of authority for she or he was 'in' treatment just as was the client.
> It was the therapist's development as a person, rather than of their knowledge, that would ultimately be decisive in the treatment. (Mitchell and Friedman 1994, p.79)

For Kalff transference was the ability of the therapist to create a 'free and protected space' which would enable a positive transference to the therapist, eventually enabling the constellation of the client's Self.

Weinrib sees the sandtray as part transitional object, evidenced by a client's ability to internalize the sandtray worlds rather than just the therapist (Weinrib 1983, p.52).

Bradway notes the use of choice and placement of miniatures in the sandtray to manifest transference to the therapist. She also speaks of co-transference (Bradway and McCoard 1997, pp.31–34). 'I use the term co-transference to designate the therapeutic feeling relationship between therapist and patient. These inter-feelings seem to take place almost simultaneously, rather than sequentially as the composite term transference-countertransference suggests.' In addition, Bradway sees the therapist's training as comprising not only a personal process, but learned knowledge in

archetypal symbolism, pathology and clinical knowledge and family dynamics, in addition to understanding the transferential feelings of past and present between client and therapist. As a therapist coming from a verbal orientation, she emphasizes the difficulty of learning *not* to speak, but to understand and observe with deep empathy. This empathy fosters the activity of self-healing powers in the patient. Bradway has explained the way things work in the sandplay process with empathy. Yet the author believes that visual comprehension of the creative act in the presence of an art therapist holds additional facets.

Ammann (1994) describes the client–therapist–sandworld relationship metaphorically. She defines the transferential 'mix' in terms of 'resonance' and likens the creation of a sandplay to gardening, the sandtray as 'Garden of the Soul'. The therapist has given a little plot of sand to the analysand in which to allow a world to sprout up, through his hands and his choices. The particular symbolic garden and its tools are owned, assembled and organized by the gardener-therapist. In the interactive field between client and therapist there is a dream garden, 'a place where conscious and unconscious parts of the therapist's and client's personalities meet and interact' (p.54). Ammann claims that the therapist's personality can be seen in the sandworlds of their clients. As a garden metaphor, knowledge of natural processes of gardening, growth and nature is essential. The gardener has formal learning, but personal experience is imperative and must be ongoing. If one relates this to the sandplay therapist who is also a trained art therapist, the therapist's knowledge of creativity stemming from dialogue with formless material will resonate in the client's work. Ammann (1994) writes:

> The analyst or therapist enters the therapeutic process of his analysand or client by resonance. The principle of resonance is very simple. If you have in your hands a violin with four strings and another violin with four strings lying on the table beside you, the strings on the violin on the table will start to vibrate as soon as you start to play your violin. If you are a poor violinist and you have an instrument with only two strings, only two strings of the violin on the table will start to move. If you have a miraculous violin with ten strings, then not only will the violin on the table pick up all the vibrations, but perhaps a lute hanging on the wall or a magic harp somewhere in the room will also begin to quiver. By playing the violin, the therapist can bring the client's violin to life, thus awakening it. (Ammann 1994, p.58)

This points to the therapist with his entire knowledge and being awakening unused energies and potential in a client, through reverberation, or resonance. Ammann asks 'who would teach cooking, without ever having cooked?' (1994, p.59). She describes nature and form as only a person involved herself would. She is an architect, but does not state that the sandplay therapist must be trained in the visual arts or have knowledge of concrete creative processes. She uses a musical example, as does Bradway, in defining the sandplay process. Yet Ammann's analysands present the most artistic, sculptural and aesthetically resolved examples of form in sandplay found in today's literature. So this author asks whether one can teach sandplay, acknowledging it as a visual art form, without having had some personal involvement in the visual arts.

The trained art therapist must have substantial experience of making art, knowledge of materials and art history, and knowledge of psychological and graphic developmental stages. He/she must understand the process of construction of images, the forms created, the colors and materials used, the areas of intensity or openness, content and the accompanying story. Jungian art therapists may incorporate dreamwork, active imagination and amplification of symbolism together with art making. The relationship between client, created image and therapist is a keystone in the art therapy process. All this creative and visual knowledge for facilitating a non-verbal process could apply to sandplay. There remains to be explored a comparison of sandplay imagery with art therapy imagery.

Discussion

This chapter has presented a brief history and discussion of sandplay and has tried to demonstrate the appropriateness of sandplay in the art therapy setting. Most literature on Jungian sandplay today defines its use and how it works through its inclusion in the verbal therapeutic setting where it originated. However, it is a visual concrete method and merges well into the art therapy setting. Because the art therapy milieu enables continuous, self-created visual imagery, sandplay within this setting becomes an image-making method among others. Drawing, painting, sculpture, collage and sandplay each possess intrinsic expressive potential or limitations as formless creative materials. Sandplay's possibilities as a boundaried three-dimensional picture, a type of sculptural bas-relief or movable collage are augmented in this setting. This may result in more frequent use for some clients, and more spontaneously created sand form. In the art therapy setting, sandplay is not

an isolated image-making event within a verbal therapeutic process, but an available and unique method among other visual opportunities. Missing in current sandplay literature is the understanding of sandplay's potential for forming foundations, and relevant symbolism, a phenomenon that emerges when it is included into the art therapy setting. Creating sand form may be an act of responsibility to oneself, in laying foundations upon which to base further content, represented by miniatures. The miniatures themselves may contain the seeds of growth, but the ground upon which they grow will be more fertile when cared for by the client. Art therapy clients using sandplay may benefit by struggling to create their own foundation, supported by an art therapy mode of understanding foundation, form and visual imagery.

The Art Therapy Setting and Jungian Sandplay

An Art Therapy Approach to Self-Expression through Materials

The early foundations of art therapy as a profession have been decisively strengthened over time through the determined belief of its founders in the healing attributes of non-verbal creative activity. This ongoing process has widened perceptions of the goals and means of art therapy. Compared with its limited beginnings as non-verbal adjunct therapy, art therapy today is a therapeutic context which is used for providing primary therapy, has to its credit art-therapy-based assessments, and has expanded into research. A multiplicity of art therapy training programs exists today not only in the USA and Great Britain, but also in Italy, Germany, Holland, Israel, some Scandinavian, eastern European and South American countries, and Australia. Many other countries are on the verge of forming their own training programs and invite guest lecturers of international repute in addition to their own art therapists who have trained abroad.

It is inevitable that innovators of art therapy training programs will base their philosophy on their personal experience in the arts, education or in psychology and on the culture in which they live. Thus art therapists from different training backgrounds and countries will espouse diverse approaches. The constant common denominator of the various approaches to art therapy has always been the belief in artmaking with concrete materials as the foundation upon which this form of non-verbal therapy stands. The American Art Therapy Association begins its definition of the art therapy profession: 'Art therapy is a human service profession that utilizes art media, images, the creative art process, and patient/client responses to the created products as reflections of an individual's development, abilities, personality, interests, concerns, and conflicts' (*AATA Newsletter* 1998).

Art therapy approaches have ranged from the use of only visual art media (Kramer 1971) embracing art as therapy, to a creative multi-modal arts

approach (McNiff 1981; Robbins 1994). These integrate into art therapy any other art form such as music, movement or poetry when most appropriate for a patient's immediate need for authentic expression. Sandplay has been included by art therapists working with adults (Gray 1983), children (Case 1987) or integrated arts and play therapists (Oaklander 1978). The inclusion of Jungian sandplay in the art therapy setting may enhance its use as a creative art-making medium incorporating aesthetic considerations in the work of many adults and some children.

Sandplay, when perceived as a form of artmaking, can be defined by some of the visual criteria applied to painting or sculpture. This in no way conflicts with the value of sandplay as narrative projective play either in the creative arts environment or in traditional psychotherapeutic settings.

The development of art therapy as a profession rests on the twentieth-century perception of art as a conveyor of inner states of feeling, rather than a portrayer of outer realism. This designates to the artmaker an unbounded freedom of choice of materials, and their formal use in form, line and color. The sandplayer has been granted unlimited choice as well, within the boundaries of allotted materials. Collage and assemblage, two art forms originating in this century, have a process of construction outwardly resembling that of constructing a sandplay. The use of the objet trouvé or found object is integral to collage and assemblage. The objects on the shelf of the sandplay miniature collection are 'found' by the sandplayer and placed in his/her sandworld, just as the artist may arrange objects in a collage or assemblage. The ancient art of sculptural relief, a projection of forms from a ground, is a concept that is also applicable to understanding a sandplay. The connections between art therapy, perceptions of art and forms of artmaking will be related to making sandworlds.

The structure of basic art materials has been defined by art therapists with the understanding that each material elicits a unique artmaking behavior and imagery (Betensky 1982; Robbins 1994). However, the emotional freedom of artmaking and art therapy today permits almost anything meaningful to the artmaker to be called 'material for art making'. A practical classification of today's multitude of material choices may add to understanding the need for the symbolic content of a specific choice of material. In the same line, the few materials of sandplay – sand, water, a rectangular shallow sandtray with a blue interior and a collection of miniatures – also need definition. It is precisely in the overlapping area of classifying materials that sand, water and the color blue of the sandtray's interior can be defined with an art-informed

approach. Objects are chosen for placement in a sandworld from the many miniatures in a sandplay collection, not just for their identity, size and color, but also for the material they are made of, perhaps wood, glass, stone, metal or plastic.

Art materials have natural or manufactured origins. Their hardness and resistance or their malleability and flow due to the presence of water comprise basic categories for classification. Other factors determining their use with certain clients and populations are their two-dimensionality or three-dimensionality, and the physical strength, tools or time needed to work with them. The qualities of materials may prove useful as metaphors for inner issues such as the need for boundaries and control, the right to resistance, or a need to loosen control. Different materials elicit different levels of imagery, from light dreamy fantasy, to weightier body-evoking forms. The materials of art therapy and of sandplay and the bridge between them are presented in different chapters.

Often use of the sandtray's blue interior as part of a sandworld neces-sitates seeing color as a 'material' in itself. In addition to the vital visual and psychological impact of the blue sandtray interior, color in general becomes part of a sandworld in the color of objects and in awareness and use of the different colors of dry or wet sand. Elucidation of psychological and physiological aspects of the six color families of the rainbow concludes the presentation of artistic attitudes relevant to making a sandworld and under-standing it in visual terms.

The Art Therapy Profession

The art therapy profession was established during World War II in Britain and the USA with the employment of artists in therapeutic institutions. Wood (1997) finds that during the late 1930s through the late 1950s the idea of art as therapy was first introduced into hospital settings. 'Both psychotherapy and art therapy were employed in the movements to rehabilitate people (mainly armed service personnel) traumatised by war.' She connects the perception of art as useful for healing to art's power to provide an external visual form for underlying conflict, specifically for 'the frightening dream-like preoccupations of the turn of the century. The two world wars compounded what seems to have been a general sense that an innocent understanding of the surface of human experience is not enough.' Adrian Hill was an artist convalescing from tuberculosis in an English sanatorium during World War II. Waller (1984) writes of him:

> By accident, it seems, some of the patients began to draw and paint horrifying scenes from the war, or used their painting as a vehicle to talk about their pain and their fears of illness and death. Adrian Hill found himself unwittingly an 'art therapist'. (Waller 1984, p.6)

Hill began his art therapy work by responding to these occurrences and working with his fellow patients, later writing books proposing the use of art as therapy. Edward Adamson (1984) and Rita Simon (1992) also began as British artists running art studios for psychiatric patients. In these early settings art therapy was utilized as an adjunct ongoing therapy. The patient would come to paint, but would later go to the psychiatrist or therapist assigned to treat him.

In the USA, artists such as Margaret Naumberg (1966) and Elinor Ulman (1965) began working with psychiatric institutionalized patients, while Edith Kramer (1977) worked with children in a corrective institution. Art therapy theory developed over the 1950s and 1960s in accordance with the medical outlook of the hospitals and institutions where it was practiced. The

power of art as therapy and the often visible process of healing and growth that an art therapy client could undergo caused a slow recognition of viewing art therapy as primary rather than adjunct therapy. This might be especially so in the case of non-verbal patients whose minimal trust in others would limit the possibility of direct verbal communication with a therapist. The art therapy process with a therapist–witness could ensure that some healing took place, although direct interaction with others was limited for the patient.

The first art therapists had studied and become artists in a climate of artistic experimentation that had changed creative possibilities and had gradually given over to the artist creative rights of self-expression. Public perception of what art was had changed often and radically in the hundred years before 1950. Great shifts in the Western art world had led from classical painting to impressionism, post-impressionism, expressionism, cubism, dada and abstract expressionism.

The artistic freedom of the mid-twentieth century owed much to concepts developed in the Bauhaus, 'a school of art and design founded by Walter Gropius in Weimar in 1919 and closed by the Nazis in 1933' (Chilvers 1996). Among the notable original teachers were Johannes Itten, Paul Klee and Wassily Kandinsky. Kandinsky's 1911 manifesto, 'Concerning the Spiritual in Art', placed the sources of art within the artist's own inner need (Kandinsky 1977). For Kandinsky art was an embodiment of the artist's inner spirit and need; the real artist was one whose painting was emotionally accurate, rather than a visually precise imitation of external reality. Kandinsky drew connections between color, form, movement, sound, the senses and emotions. Thus one might paint an emotionally accurate image of something significant by expressing it abstractly in color, form, size and placement. Kandinsky's theories provided a good framework for learning art-making behavior rather than learning how to make art. His principles are also basic to art as therapy, the creation of emotionally relevant visual imagery.

It is necessary to point out that as Western society has become more technological and specialized, so has the practice of artmaking been considerably narrowed down. Artmaking in the West today may often be limited to professionally talented people who can produce commercially saleable graphic art or to fine artists who are able to sell their work or obtain grants. Art has changed a great deal from its original status as a central component in group ritual or religious life. However, if we look around the globe, we find

many cultures where art is still connected to group ceremonial practice, serving religious purposes or expressively promoting the group cooperation necessary to cope with daily survival in a natural environment. Making ceremonial artifacts for use in group ritual takes enormous amounts of time for preparation, and even today this may still be done by non-mechanical methods. In Western society, making art in the form of painting or sculpture also demands much time, patience, and craftsmanship, an investment which really cannot be calculated in monetary equivalents. Ellen Dissanayake, a contemporary art historian, has written two books entitled *What is Art For?* (1988) and *Homo Aestheticus: Where Art Comes From and Why?* (1992). She proposes that art is a fundamental universal or biological human-species characteristic, a normal and natural behavior like language, sex, sociability, aggression, or any other characteristic of human nature. She sees art as a behavior that developed in humans as they evolved, to help them survive. Art has always existed throughout all human history, and the arts have held a significant place in every human society, conjoined with ritual ceremony essential for group survival. Art then is a psychological or emotional need and has psychological or emotional effects, says Dissanayake. She points out the human need to 'make special' those things that one cares deeply about or activities whose outcome has strong personal significance. Making an object artistically special is to create a boundary between the mundane and the extraordinary. 'Making special' heightens the significance of something and makes it more memorable. If artmaking is an essential human survival behavior, today's narrow specialization, designating artmaking to the prov-ince of a few talented professionals, has several important repercussions.

Non-artists, those considered untalented in art, remain artistically deprived in this culture with no creative vehicle for artmaking behavior through which to convey issues of special significance in their lives. The need for a creative vehicle becomes vicarious and manifests, for example, in the large attendance and high emotional levels at popular performers' concerts, or a choice to study art history rather than to make art. On the other hand, the artist is surreptitiously burdened with creating significant objects or events for an entire society, as well as for himself, and earning a living at it. This could drain the artist and his/her art of emotional vitality and obscure the original creative urge that led to this path in life.

The upsurge in art therapy frameworks of treatment in the Western world may reflect the cultural paucity of legitimate structures for personal non-verbal expression. Decoration of the body through hairstyle, makeup and

choice of fashion may be the most acceptable form of visual expression into which one can channel inner needs without awareness of the emotional source of the visual choice. Art therapy can bring a modicum of consciousness to visual creative expression of inner imagery for those who are accompanied in investing time in 'making special' their art objects.

Art therapy theory and literature slowly matured until in the 1970s and 1980s a large array of art therapy literature began to materialize, together with a number of training programs (Junge and Asawa 1994; Waller 1991). Art therapy was gradually enhanced by depth psychology, symbolism and Jungian theory as an appropriate partner for art imagery (McNiff 1986, 1989). American art therapist McNiff has proposed that images are autonomous entities, although we may have created them, and that we can dialogue with them, bringing their gifts into our art and our lives (McNiff 1989).

British art therapist Joy Schaverien examines the vitality of images and the transference and countertransference, while considering the levels of connection of a client to his/her images. She has described the magical belief invested in objects, enabling their use as a scapegoat or talisman. She states: 'My position tends more in the direction of Jung (1972), Hillman (1979), or Neumann (1970) who accept magical thinking as an innate aspect of human existence – as an irrational layer of the psyche which harbors the seeds of self-healing' (Schaverien 1987, p.77).

Schaverien has also made an important differentiation between two types of imagery. The first is the 'diagrammatic picture', which maps out an idea but needs words to explain its intent. The picture may consciously try to explain an emotion but without evincing that same emotion in a viewer. This image will not be empowered and will not function as scapegoat or talisman. However, the 'embodied image' will be created with emotional investment and will cause the viewer to reverberate to the feeling it expresses. It needs no words to explain it and frequently cannot be explained. It is the thing itself, and there are no words for it at that moment (Schaverien 1992).

The distinction between a diagrammatic image and an embodied image also applies to sandplay. There are instances when objects are placed on almost untouched sand by a client who may then explain the image and the objects chosen as if they were a diagram of one's thoughts. At other times an embodied image is created. A powerful numinosity may project from a sandworld whose sand has taken shape by spontaneous unplanned action of the client's hands, and cannot be otherwise. Then perhaps, and suddenly, a few miniatures are chosen and placed. Here the sandplayer frequently

comments: 'I have no idea what this is or what I've done.' Attention will be paid to observing and learning the sandworld rather than explaining it.

Within the Jungian trend in art therapy, Jungian sandplay became another small bridge between art therapy and Jungian thought, as it attracted creative expressive therapists who began to include it in their clinical work (Case 1987; Lewis 1988). Gray (1983) considered the many links between art therapy and sandplay in an extensive and laudatory review of Weinrib's book, *Images of the Self: The Sandplay Therapy Process* (Weinrib 1983). Gray, a Jungian art therapist and analyst-in-training at the time, recognized the importance for art therapists of Weinrib's emphasis on 'the primacy of the autonomous, healing, symbolic process within the psyche – a process that involves minimum direction, interpretation, or interference on the part of the therapist'. As an art therapist she confirms 'Weinrib's emphasis on the psyche's continuing quest for wholeness and its capacity to heal itself through the constellation of symbols'. She adds: 'The failure to appreciate the psyche's capacity for self-healing often results in a kind of art therapy practice greatly dependent on a directive approach and an overuse of 'techniques' – even gimmicks' (Gray 1983, p.36).

The Jungian sandplay process has been described by Weinrib as being like 'a prolonged dream or active imagination that needs to work itself out' (Weinrib 1983, p.14). Only the dreamer can dream his dream, and the art-maker make his art, which usually does need to work itself out. Belief in the evolving creative process that is experienced, and the ability to wait for creative solutions to happen, confirm the existence of inner resources and the desire of the psyche to become whole. Weinrib and other Jungian analysts include sandplay in their practice in addition to dream analysis and traditional Jungian verbal therapy. Gray adds that just as Weinrib's 'client's dreams confirmed the process going on in the sandplay', she uses sandplay, dream analysis and art therapy and also finds 'a remarkable interplay between dreams and pictures – one interpreting the other' (Gray 1983, p.38).

Forms of Artmaking
Related to Sandplay

Relief, Collage, Assemblage, Objet Trouvé

The sandtray extends an opportunity to combine three different types of artmaking activity in one sandworld: sculpture, markmaking and strategic incorporation of objects. Sand mixed with water offers a plastic sculptural material suitable for creating three-dimensional form. Sand is receptive to markmaking with the hands or tools, enabling a wide array of surface textures, each a primal image of some form of touch. Natural or manufactured already formed objects are 'found' in the sandplay miniature collection and placed in the sandworld. These three activities together form one sandworld, contained and framed in the open shallow sandtray. The sandworld may contain forms projecting from, but attached to a ground like the relief or rilievo in art. The process of construction may resemble creation of collage and assemblage in art.

The relief in art consists of elevated forms physically connected to a ground, in contrast to sculpture which is disengaged from a ground and can be seen from all sides. Elevation of form may be low (bas-relief) or high (alto rilievo). The *Encyclopedia Britannica* (1962) defines relief:

> Modes of representation and composition in relief are always determined by their dependence on the ground plane from which the forms emerge, or on which they are superimposed. In this important respect reliefs are more nearly related to painting than to the detached roundness of statuary. (vol.19, p.101)

A sandworld is built on a sand base enclosed in a shallow rectangular tray. Sculpted forms and objects project upwards from it, giving it the quality of a relief or rilievo. In the sandtray, sand may be intentionally left to cover the entire inner surface without revealing the blue-colored bottom of the tray.

This creates an unruptured horizontal earth–sand surface or ground, providing tangible support for whatever objects are placed on it. Any exposed blue area suggests depth and water, or height and sky, both infinite vertical movements whose meanings tend more towards a search for understanding rather than a need for the stability provided by a ground.

Reliefs exist in art from ancient times and usually tell an important story having something to do with the structure to which they are attached. Carved stone reliefs on Mesopotamian, Egyptian and Greek temples and cast metal reliefs on Renaissance church doors attest to the artful integration of form and story (Janson 1974). The sandworld structure is fairly shallow, but it is a constructed base upon which attached forms and objects tell an important story, related to the structure of the base.

Collage and assemblage are art techniques in which combinations of natural or pre-formed materials are used to make an artwork. Collage is defined as a 'composition of flat objects, as newspaper, cloth, cardboard, etc., pasted together on a surface and often combined with related lines and color for artistic effect' (*Funk and Wagnall's Standard Dictionary* 1961). Some artists find a flat surface too limiting and combine three-dimensional objects in their collage constructions, creating an 'assemblage' (Janson 1974). Assemblage is a term invented by Jean Dubuffet in 1953 which is usually used to define three-dimensional found material combined into one artwork. The use of ready-made objects, or part objects, was introduced into art by the Cubists, primarily Picasso, Braque and Gris, from 1907 to 1914. Old newspapers, tickets, parts of furniture and larger objects were incorporated into works of art creating a tension between their real identity and their role as an integrated part of the picture image. Dadaists such as Marcel Duchamp, between the years 1915 and 1922, adopted the use of ready-made objects but claimed to do so at random, without deliberate choice. The objet trouvé or found object is:

> an object found by an artist and displayed with no, or minimal alteration
> as a work of art. It may be a natural object, such as a pebble, a shell, or a
> curiously contorted branch, or a man-made object such as a piece of
> pottery or old piece of ironwork or machinery. (Chilvers 1996, p.375)

Real objects increasingly appeared as part of paintings and sculptures, until in the 1960s very large found objects appeared in the combine paintings of Robert Rauschenberg, and very small exquisite objects populated the glass-fronted assemblage boxes of Joseph Cornell (Chilvers 1996). The sandplay miniature collection offers a client innumerable objects to 'find' and place on

the ground of his/her sandworld collage or assemblage, within the safety of the therapy room.

Frequently, quite visually stunning sandworlds are created by children and adults with great care, integrating formation of the sand and addition of miniature objects. The emotional investment and care expended in making these sandworlds may be equated to the careful involvement of making an artwork or a ritual object. When objects are used as part of an integrated sandworld, they may be understood as magical immediate 'drawings'. Objects as 'vicarious' or magical drawings created by choice and placement on the sand rather than by drawing or sculpting may be compared to the immediacy of use of objects as a material in the art world. Perception of the sandplay object as material in a total artwork places importance on the physical material of an object, in addition to the psychic material it represents.

Objects in sandplay literature are often described in historical, biological, cultural and symbolic detail, with little or no emphasis placed on the material of which it is made. In a sandplay process there may be sandworlds whose objects are predominantly of one material such as metal, glass, wood or ceramic. The meaning of the sandworld must then be linked to the material, as well as to an object's identity, color and location.

The Art Therapy
Setting and Materials

The setting

The presence of materials in the art therapy environment may have irresistible lure for many children and adults. An extensive assortment of papers, paints, oil pastels and other colors are available for painting and drawing. This may be done on a table, floor, easel, or a wall for larger works done while standing, so that the whole body participates. Modeling may be done on a table or floor with clay, plasticine or plaster of Paris. A play area may contain a sandtray and miniatures, toys, a puppet theatre and puppets. There may be materials for collage and tactile experience such as scraps of fabric and wool, buttons, and natural objects. These materials and other basic equipment, such as brushes, tools for clay and carving, easels, boards and recording equipment, may stimulate by their presence patterns of artmaking behavior (Steinhardt 1989).

The space and materials will be organized according to the art therapist's personal preference, emphasizing the presence of certain materials, understating others. But whatever the organization, the visual impact of this environment can often convey to a client the primacy of creating visual images with the available materials (Case 1987; Rubin 1984).

Three groupings of materials for art-making

Material is defined as 'that of which anything is composed or may be constructed; matter considered as a component part of something' (*Funk and Wagnall's Standard Dictionary* 1961). A material useable for art-making could be any concrete substance whose unique properties can be described in terms of weight, density, flow, malleability, texture, form and color. Art therapists must understand the properties inherent in different art materials and when

their use is appropriate or contraindicated. Actual descriptions of materials in the literature are often brief. More is written about their efficacy and potential for use with different populations, perhaps because the properties of materials may seem obvious to the art therapist, as if the name of a material is self-explanatory. In considering the unlimited sources of materials used for creating art objects, it may be helpful to place them within three main affiliations:

- unformed materials suitable for creating form
- formed identifiable materials
- formed identifiable objects as materials

Unformed materials suitable for creating form

Both soft and hard formable materials can be manipulated and changed to produce form different from that of the material itself. The actual concrete creation of an idea does depend on the qualities of the material used to form it, but the material also conveys an idea about itself through its qualities and formation. Soft materials such as paints, drawing equipment, clay and sand mixed with water have no particular form and can be played with as substances or made into art objects, paintings or sculptural forms. Hard materials such as stone, metal and wood can also be carved or formed into an art object. The artmaker's level of development and skill will determine the visual form and level of artistic achievement whether softer or harder materials are used. On the highest artistic and technical level, great sculptures made of metal or stone combine the hard durability of these materials with sculptural movement, and even softness and transparency, so that stone and metal evoke flesh and fabric.

The qualities of materials can become metaphors for inner states of being, mirrored in the artmaker's relation to them. For example, transparent or opaque use of paint, rough or smooth surfaces of wood or clay will reflect some inner feeling of the artmaker. One unmarried woman aged 42, in art therapy, used oil pastels and very thick acrylic paint but refused to use clay at all. It disgusted her, she said, as anyone could push it around, and do with it as they willed. Although she would not sculpt with any other material, she thought wood was a material to be respected for its resistance, as one would have to consider its hardness and grain in order to form it.

Formed identifiable materials

Materials may be incorporated into an artwork because of their innate qualities, without changing their appearance in the finished artwork, comparable to materials used for collage. The substance and qualities of certain materials may be easily associated with expression of emotional states, accurately representing for the artmaker inner perceptions of experience without interpretation or naming. For example, transparent cellophane, fragile translucent tissue paper, smooth silk or coarse burlap, sand, gravel, or sawdust could be incorporated into an artwork unchanged and elicit feelings in the viewer corresponding to their substance: lightness, fantasy, gentle or coarse sensuality, or roughness of different degrees.

Even sand could be regarded as a 'found' already formed material by a sandplayer, leaving it untouched in the sandtray as a base, without contacting it. It could represent infinite energy or possibility that is still unachieved. It could indicate inability to use this potential. It could also show resistance to touching something as connected to body and touch as sand can be.

Formed identifiable objects as materials

Natural or manufactured, ready-made identifiable objects or part-objects may be incorporated as material into an artwork while retaining their own historical identities. Old buttons, or parts from the inner mechanism of wristwatches are sometimes chosen for embedding in clay, either imprinting them or leaving them like mosaic pieces. Instant meaning is conferred on objects by the role, color and material of the object in addition to any association and memory the artmaker connects to them. But as part of an artwork their meaning is also ambivalent, oscillating between their original purpose, the artmaker's associations, and their role in the context of the finished work. The sandplay object's use is less abstract, more a part of a story scene.

Criteria for classification of materials

The concrete properties of materials, the ways they may be used and the level of imagery and emotion they elicit are the general criteria used for classification of art therapy materials and sandplay materials. The subdivisions of these categories discussed below highlight the particular potentials of each material. Good quality art materials often require higher budgets than what may be available in an institution. The art therapist may be met with disbelief

when he/she presents administrators with an order for 20 boxes of 45 color oil pastels, 20 packages of plasticine, 100 kilos of clay, 500 sheets of paper of various sizes and kinds, or good bristle brushes from the smallest to largest sizes. It may appear extravagantly wasteful to those not making art to use materials in amounts larger than a pencil and paper. It also may appear wasteful to give small children or children with emotional problems expensive materials when the results are sometimes irrational spilling and mixing rather than producing controlled art. Yet there are no substitutes for the basic, good quality materials necessary for artmaking, and for the sense of value they bequeath to the artmaker. Many inexpensive or found materials can be part of the art therapy materials repertoire, providing that there remains a balance between long lasting, good quality basic equipment and other inexpensive or found materials.

In sandplay, sand and water may cost nothing and miniatures can be found in cast-off toy collections of grown children, besides those items that are specially made or bought. However, the sandtray itself should be made of wood, painted with high quality blue paint inside. It is possible to improvise a sandtray with a simple plastic container, but synthetic material, thin containing boundaries and non-specific proportions will not be experienced with the therapeutic force of the well-proportioned wood sandtray.

Natural or manufactured materials

Art materials today are considerably more varied than the basic materials of fifty years ago. The introduction of chemical based colors and mediums has made available colorful, quick drying types of paints based on acrylic, and hybrids such as water soluble oil colors, oil paint sticks, phosphorescent colors, synthetic charcoal and chalk, combinations of plastic glue and gouache, synthetic clays that need no firing or can be fired in a home oven, etc. The ease of use may be counteracted by an artificial quality or by a sometimes harsh or lifeless visual countenance of the finished dry work. For example, acrylic based gouache paints are shiny when wet, but when dry they leave a rather airless opaque matte surface. In addition, the paint cannot be rewet and changed after it dries.

High quality tempera or oil paints have a quality of 'breathing' or letting light filter through the layers after drying. In general, media based on natural ingredients may radiate more sense of 'life.' Plasticine is colorful and playful but loses its luster some time after use, becoming crumbly and leaving oil stains on any paper or cardboard base. Synthetic charcoal and chalks may

appear harsh and are not easily mixed or erased. Thus, inexpensive, easy-to-use materials may lack the innate feel of natural reality that art materials based on natural products have.

Natural materials that were once commonly found in the art studio may project a less exciting presence and may require certain skills for use. Still, potter's clay, dough made of salt, flour and water, wood charcoal, India ink, watercolors or tempera paint from natural sources with gum arabic filler, oil paints and printing inks based on natural pigments should be part of the art therapy room. Drawing boards or boards for clay work should be of plywood rather than synthetic wood, plastic or formica. Nature should be a consistently represented presence in the art therapy setting.

The natural developmental sequence of human psychological and physical growth resolves successfully when a person can become what he is, using his inborn potential to live fully. In psychological testing, the 'draw a tree' projective test is often used for ascertaining the organic developmental growth pattern of a person, his connections to the base (roots), his ego structure (trunk) and relationship to the environment (branches) (Hammer 1980). The tree metaphor emphasizes the intrinsic human connection to nature and natural processes. Natural materials may activate in us the deep connection to being part of nature, and thus to naturally fulfilling our healthy potential. When clay is chosen over plasticine, wood instead of plastic, tempera paint over acrylic, it may signify metaphorically some natural aspect of ourselves that calls to be acknowledged if we are to be healthy.

The sandplay client has sand and water to touch and play with, both ancient natural substances which literally date back to the dawn of life on earth. The object collection is divided between natural objects, such as stones, shells, wood, or crystals, and manufactured miniatures made of either natural or synthetic materials. Choosing between the natural or synthetic occurs when, for example, a ceramic dog is chosen rather than a plastic dog, a wooden carved musician rather than a cartoon character musician, a brass set of utensils rather than plastic tea cups, a realistic baby miniature over a cute cartoon baby, a realistic lion rather than an animated cartoon version.

Boundaried, resistive, malleable and flowing materials

The art therapy client is faced with a continuum between polarities of control and lack of control in relation to materials. Often clients begin trapped at one end or the other and cannot yield to the movement possible between the extremes. At one end are clients who maintain cautious control of the

forthcoming imagery by working on small formats and trying for precision. At the other end are those who lose control and relax their boundaries until the entire room is in danger of being splattered with paint and clay. The need to be in control could be reflected by choosing lead or colored pencils, oil pastels or plasticine which are resistive and can be used to craft precise boundaries. Materials that contain water and possess flow, such as gouache or watercolor, could cause discomfort in a client who feels uneasy with movement that may not always be controlled. If gouache and watercolor are chosen by this client, they are likely to be applied to paper with a very small brush, using short strokes of dry or diluted color to build up an area. This client might refrain from clay which also contains water because of its soft malleability, letting anyone 'push it around'. Or there might be an attempt to shape the clay precisely with cutting tools and a ruler. Thus, the movement towards using flowing materials would take a controlled form at first. Boundaries should be loosened gradually with some enjoyment in gradually letting go. Otherwise, a longing to relinquish control may become overly destructive and chaotic. The therapist can respect rigid control as a wary defense, perhaps a resistance to frightening urges to let inner rage and chaos loose on the environment. The use of an interim technique such as collage, putting fragmentation back in order, can be a method of control by choosing and assembling, deciding what materials will be used and how the world can be fitted together.

The opposite behavior, an uncontrolled use of materials and disintegration of boundaries, might manifest by mixing colors into a muddy mess, spilling, pouring, flooding and splashing with paint or with water in the sandtray, smearing paint on the body and throwing clay or sand. Lack of boundaries given visual form by chaotic use of material may occur at the onset of therapy, before trust has been formed in the relationship, as the client tests the therapist's limits and supposed unconditional acceptance. Although this happens more often with children it does also happen with adults. With both children and adults there may be controlled spilling and muddying of paint, after a trusting relationship has been formed. Loosening of control releases imagery resembling body fluids and excretions, such as blood, urine, vomit and excrement.

In the therapy room the boundary between exploratory manipulation of a gooey substance and being bad or destructive may be unclear for a client. Guilt connected to urges of 'not being able to hold it in' or wanting to play with excrement or mud may arise. Adults may be shocked and embarrassed at

their strong need to flood the paper with muddy color, scratch and claw at it sometimes, and watch it move and drip off the paper. This behavior may express uncontainable anguish, pain and anger that has no words. It may continue for a few sessions, until some calm is achieved and a more structured need for form is felt.

In the sandtray, very watery imagery may destroy old structures, until eventually the client 'dries up' and produces new forms, or other ways of imaging death and destruction. The therapist may be tested in having to contain this messy, aggressive behavior. Aside from a possible feeling of annoyance at the mess, inconsiderateness and wastefulness of the client, it may be important not to permit a client to leave the therapeutic setting perceiving him/herself as a destructive hopeless person. Some sort of containment can be provided by working within trays, boxes, tubs or areas which are physically separated from other parts of the room.

Kramer (1971, p.54) differentiates between behavior focused on enjoyment of manipulating and smearing materials and 'chaotic discharge' with materials which may become violent and destructive. One can imagine children playing in a natural environment such as the beach, in much the same ways, ranging from enjoyment of building in mud, to hurling mud and destroying other people's constructions. For Kramer, the most integrated use of materials is for 'formed expression, or art in the full sense of the word; the production of symbolic configurations that successfully serve both self-expression and communication' (1971, pp.54–55). Formed expression is not measured by neatness or messiness, but rather by an ability to utilize the continuum of materials, from resistive to flowing, according to their nature. An authentic dialogue evolves between inner states pushing to be formed and the materials.

Skill, strength, tools and time

Materials may be classified according to the ease or complex skill needed for their use. This in turn may determine the satisfaction or frustration felt when a material is used and a 'mistake' made seems to be reversible or irrevocable. A common but fallacious belief for many children and certain adults is that it is safer to work with pencil, which can always be erased and corrected, eventually achieving perfection. Pencils require no skill, but they are formal and thin. They are reminiscent of the ascension from kindergarten into the serious status of first grade, separating the child from his playful kindergarten self. Those who use pencil may find themselves mostly erasing it and never

finishing their drawings. Paradoxically, choosing pencil for the greatest safety creates the greatest demand for perfection, with consequent frustration. A soft, yet controllable material such as oil pastel requires little skill and can be used quickly in a wide choice of colors. Any frustration felt during the use of oil pastel would probably not emanate from use of the material itself, but be connected to the gap between what was imagined and what actually is created on the paper. Many pictures are crumpled or torn up in anger because the 'mistake' is perceived as terrible and irreversible. A light oil pastel color may be used to sketch, until a desired form is obtained and then emphasized in a darker color, circumventing the 'mistake'. Clean-up is quick and easy, which may be important.

The skill required for work with gouache paint or watercolor is contingent upon the age of the client and the demands he makes of himself. Gouache and watercolors may become muddy, drip and continue to 'move' uncontrollably, causing either interest or dismay. Acceptance of the 'mistake' and relinquishment of control may lead to creative spontaneous solutions and surprises, turning it into something else. Thus these two media can be great promoters of spontaneity. Materials such as wood, stone, plaster for carving and oil paints need tools, certain skill and knowledge about the materials, longer time for execution and sometimes physical strength. Frustration and a sense of defeat may accompany every mishap with these, as often mistakes are irrevocable.

In contrast to the less alterable surfaces of wood, stone, painting or drawing, media such as clay, collage and sandplay allow a constant change of form in the search for the image, without change being considered a mistake. Sandplay also provides a fairly quick image-creating activity requiring no more skill than the client wishes, since it is based on simply choosing and placing 'found' objects on the sand, which may have been worked or left untouched. In Jungian sandplay the client is not allowed to 'clean up' – replace the miniatures – after creating his sandworld, leaving the total image intact in the psyche. An interesting result of this rule of not having to clean up may be a client's interpretation of it as an opportunity to test therapeutic boundaries and relinquish all attempts at skilled use of materials. The client, either child or adult, may freely throw sand, flood with water or throw unlimited objects in the sandtray. Nevertheless there is usually an inner direction in the choice of materials used, or even in the choice of objects thrown into the tray. Therefore this can be considered the final image and, as

is done at the conclusion of all sandworlds, it will be photographed and dismantled later by the therapist.

For example, one 48-year-old woman during three years in art therapy always made a point of brushing off 'dust' from the sofa and pillows in the author's studio before she sat down. She prided herself on being an excellent homemaker and had once commented that the art therapist may have been a good painter but did not keep a very ordered house. Her oil pastel artwork and her sandplays were neat and aesthetic. One day she asked what would happen if she dumped all the miniatures off the shelves into the sandtray. She knew that the therapist would have to put the sandtray back in order after she left. When she received confirmation that she could use the sandplay equipment as she wished, she grabbed several boxes of miniatures – marbles, babies, houses, snakes and lizards, bats, mice, bones and skeletons – as if spontaneously and overturned them into the sand. She arranged rodents, bugs and reptiles in all the corners and a skeleton on the lower edge. She then threw in a box of small brass objects and small translucent pieces of turquoise glass. She observed the jumble for a long time and noticed that a lot was buried there so 'there's more than you can see, like the leftovers of a civilization'. 'There are insects crawling over the baby like he's part of the rubble. Sad, these houses all thrown around, and the skeleton that can't get straight.' She realized that she had not taken many other kinds of objects and that her choice had reason to it. It seemed to reveal deep feelings of chaos and neglect as an infant born during wartime in her country of origin. Some time after this she began for the first time to paint on very large paper, developing a colorful layered use of paint for the next two years. When she concluded art therapy she began to study painting seriously.

Another sphere of dialogue between an artmaker and materials is based on elimination of tools, using direct contact between the material and the hands. Direct touch is most intimate, reminiscent of touch between mother and child, the surface skin of the fingers sensing and absorbing tactile communication. Hand movements of patting and smearing with finger paint or gouache usually leave a visually imprecise surface, an unclear form and paint sticking to the hands. With clay or plasticine many forms of movement and touch may be applied. Direct touch results in two phenomena: a shaped visual image comes into existence; the sensation of the material sticking to the sandplayer's skin remains. Both gouache and clay adhere to the body through direct touch. This may produce distress and be perceived as dirt sticking to the hands or, as Foster (1997, p.55) describes: 'One psychotic

patient screamed that his "hands were cracking up". Another was frightened by "the sticky stuff getting under his skin".'

Some distance is created by an intermediate substance such as the wrapping on an oil pastel or the wood or plastic case of a pencil or marker. A tool such as a brush or scissors can provide a sense of emotional control of material use. Coordination may be necessary but strength is not required. Hard tools like a hammer, chisel and cutting tools needed for resistive surfaces invite more aggressive movements and may require strength, coordination, precision and time.

Time is a variable factor. Issues surrounding time in art therapy pertain to the time demands of materials, the concentration span, skill and planning of a client, or to a client's physical and mental health or infirmity. An art therapy session for clients with normal concentration ability should be scheduled for one full 60-minute hour, although there are frameworks that consider 45 or 50 minutes as an hour. Art-making can be very quick, but art as 'formed expression, or art in the full sense of the word' (Kramer 1971, pp.54–55) usually requires time and focus, in conditions of detachment from the outside world. More time is necessary for any concluding verbalization. When working with a single client or with groups in art therapy, an hour may be short, especially if the image making is intense. A creatively involved client may enter a state of boundaryless internal time, unaware of linear external time. The transition from the imagery to verbalization with the therapist and then to the outside world may be abrupt in the space of an hour. The unobtainable wish for endless time in therapy may become an issue in the interactive relationship, exposing deep frustration and anger in the client. As such, time in art therapy is an elemental part of a session, may impact on the success of therapy and warrants consideration according to specific clients' needs.

Two-dimensionality or three-dimensionality of materials

Classification of materials as two-dimensional or three-dimensional contrasts the physical attributes of materials with the way they are used by a client. Painting and drawing or collage are usually done on a flat surface and remain two-dimensional. But at times paint may be layered so thickly that there seems to be a striving towards three-dimensionality. Clay and plasticine are solid three-dimensional materials and can be formed as independent structures. But there are instances when clay and plasticine are smeared onto a flat paper surface like a drawing or painting, denying their potential for

independent form. Foster refers to the fear of three-dimensionality in psychotic patients and their reticence to work with clay. She states: 'Whatever one does with it, one cannot fully get rid of the three-dimensional quality and an awareness that there is an inside, a rearside and a front' (1997, p.54). Foster suggests that clay, as independent three-dimensional form, has a lifelike presence and invites physical touch. One's finger can actually enter into the soft clay, as if entering and exiting from a body. Soft three-dimensionality is then connected to intimacy, the fact of the body and independence. This may evoke unequivocally sexual feelings, pleasure or revulsion and fear.

The threat of three-dimensionality or intimate touch may impact on the creation of sand form in sandplay. When sand is even minimally touched or molded it bursts into three-dimensional life. If sand is experienced as overly sensuous it may remain untouched even though miniatures are placed on it. In this case sand functions almost as two-dimensionally as a piece of paper. The obvious three-dimensional presence of miniatures and objects, with their finite constant shapes and clear boundaries, may also be negated when they are placed lying down as in a drawing. Schaverien (1987, 1992) describes the 'diagrammatic image' that needs some verbal explanation, in contrast to the 'embodied image' that cannot be described in words, but speaks for itself. The 'flat' sandplay may have a diagrammatic quality, while the sandworld using the sand base as an important formed foundation for miniatures could be an embodied sandplay image.

Classification of the Materials of Art Therapy

This chapter introduces a classification of the materials commonly used in art therapy based on the criteria discussed in Chapter 6. Classification is divided into two sections. The first presents basic unstructured materials having no formed identity, on a continuum from wet, flexible, soft and uncontrolled, to dry, resistive, hard and controlled (Landgarten 1987). These include clay, gouache, watercolor, markers of different widths, oil pastels, chalk and charcoal, playdough, plasticine, collage, colored pencils and lead pencils.

The second section presents materials that have innate form, texture and color. Their intrinsic qualities relate to their purpose, or to their original identities. This section has four subgroups. In the first subgroup are various types of manufactured paper for artmaking. The second subgroup encompasses used paper or fabric, wallpaper, newspapers, magazines, photos, ticket stubs, wool, string, etc. In the third subgroup are identifiable objects and part-objects. The fourth subgroup contains various connecting materials. The qualities of any of these may be experienced as representing aspects of the psyche. Their power may reside in the material, its color, size, identity and use, or in their reference to the artmaker's history.

Unstructured formable materials of art therapy

- Natural or manufactured
- 2-D or 3-D
- Soft, wet, flowing, or resistive, dry, controlled
- Use of hands or tools
- Physical effort needed
- Time needed

- Possible symbolism
- Type of imagery

1. **Clay**: natural; 3-D; flowing; hands and tools; some physical effort; time flexible; symbol of body, feces, mud; imagery concrete, visceral, physical.

2. **Gouache**: manufactured; 2-D; flowing; hands, brushes and tools; minimal physical effort; time flexible; may be used transparently for fantasy, mixed with water for solid color surfaces, to thick and visceral mixing and pouring, suggesting blood and excrement.

3. **Watercolor**: manufactured, either synthetic or professional quality natural pigments; 2-D; flowing, uncontrolled; brushes and sponges; little physical effort needed; time is flexible; light, ephemeral airy fantasy, dreams, urine.

4. **Markers**: manufactured, synthetic; 2-D; flow and control; a tool in itself; no effort but may entail many short wrist movements for filling in; time is flexible; imagery may be diagrammatic, cute and stereotype, light, fantasy, but may also reveal difficult issues in a controlled fashion.

5. **Oil pastels**: manufactured; 2-D; flow and control; direct hand use; physical effort varies from lightness to heavy texture; time flexible; imagery light and airy to heavy and physical.

6. **Pastel and charcoal**: natural compacted pigment or charred wood; 2-D; flow and control, precision and softness; direct hand use for drawing and smearing; no effort required; time flexible; imagery ranges from light and dreamy to mysterious inaccessible images.

7. **Playdough**: manufactured synthetic, 3-D; loose control; direct hand use for manipulating; no effort required; time flexible; may be fragmented and reconnected again; imaginative simple subject matter, if wanted.

8. **Plasticine**: manufactured synthetic, 3-D; control and precision; direct hand use for manipulating; may be used two-dimensionally for drawing by smearing; effort required; time flexible; concrete, sometimes diagrammatic imagery, cute color which lends itself to whimsy or fantasy; all possible subject matter.

9. **Collage**: combines natural and manufactured materials; 2-D and 3-D; control; precision; soft or hard imagery; direct hand use for placing and pasting, tools for cutting and applying color; little effort required; time needed for organization and execution; imagery may reflect states ranging from fragmentation to integration; high personal choice of materials.

10. **Colored pencils**: combines natural wood holder and pigments but is manufactured; 2-D; controlled; precise; soft quality to imagery as colors can never be very strong; direct hand use; little effort required, but many hand movements may be needed for filling in; imagery ranges from neat controlled work to dreamy fantasy.

11. **Lead pencils**: manufactured from natural wood and graphite; 2-D; controlled, hard, precise, but can be smeared or erased; direct hand use; little effort required but many hand movements needed for filling in; imagery may be precise, detailed and endlessly erased in a quest for perfection. The need to be perfect may connect to the introduction of the pencil in the first grade of school, representing the transition from kindergarten play to the demands of authority.

Formed identifiable materials of art therapy

1. **Manufactured paper**: paper may be used flat, two-dimensionally and attached with various glues, staples or tape, or may be folded into three-dimensional forms.

 • *White drawing paper*: should be sturdy; white as a base for drawing or painting does not interfere with the colors used on it; white paper may be experienced as glaring, harsh or empty at times. Having no color of its own, all color added to it moves towards darkness. Unused areas of the paper may be experienced as 'dead' when they are not well integrated into the artwork.

 • *Cellophane*: delicate; transparent; shiny; forms a boundary between the viewer and what is visible under the cellophane; lightness, air, mystery. Available in a range of colors.

 • *Tissue paper*: delicate; translucent; matte; useful for layering; lightness, air; available in large range of colors.

- *Brown paper:* sturdy, warm, matte; seems receptively to absorb color; provides a median base color from which to work towards light or towards dark colors.

- *Colored Bristol:* sturdy, pliable; available in many colors; color may be based on synthetic dyes that fade quickly when exposed to light. Good for collage, construction.

2. **Useful two-dimensional odds and ends**: this category may consist of just about any material that an art maker can use safely, from personal to found items.

 - *Old tickets, memos, notes, magazines, newspapers, stamps, wrapping paper, wallpaper:* items such as these may allude to personal and intimate issues.

 - *Fabric, wool, cord, string, thread:* soft and flexible, textured and colored, these materials may allude to personal and intimate memories. They may be metaphors for inner qualities. Attachable with glue, staples, string or by sewing.

3. **Objects and part-objects**: in the art therapy setting it is useful to have a collection of small objects and part-objects for use in collage or assemblage. Objects will inevitably bear traces of their original identities. Their form, material and the wear and tear of their existence may be of interest to the artmaker choosing them. Commercial stickers, such as movable eyes, stars and animals may also be in the object collection.

 - *Buttons, nails, matches, toothpicks, ice cream sticks, etc.:* all these are useful for gluing, or building with.

4. **Connecting materials**: the type of connecting material that a client chooses and the way it is used, loosely or intensively, may refer to an inner concept of relationship and trust or mistrust.

 - *Scotch tape, masking tape, staples, glues, wire, string:* connection of surfaces or materials and objects can be made loosely, or in an inseparable manner. Means of connecting can be sharp, metallic and aggressive or through a gentle adherence of surfaces.

Sandplay in the Art Therapy Setting

Sandplay: Method, material, and movement

Sandplay as method and material blends well into the art therapy setting as an image-making activity chosen by children or adults. It may be used weekly or interspersed with sessions of drawing, painting, clay sculpture or play. Rubin (1984) meticulously describes a complete art therapy setting, its areas and contents, but does not include sandplay. Case (1987), Gray (1983) and Halliday (1987) see the sandtray and miniatures as a part of the art therapy setting, a medium that bridges play and art. Case attempts to place sand and the sandtray in the realm of art media and describes some tactile qualities of sand and the process of initial play until a direction works itself through. Play with sand and water seems to evoke distinctive physical–tactile sensations that are not experienced through play with other materials of art therapy.

Sandplay is an immediate form of image making and in the Jungian approach is considered a form of active imagination, made by a client in the presence of a therapist. Chodorow points out that 'active imagination is most often done alone, away from the analyst. But some forms, particularly Sandplay and Movement usually include the analyst as witness' (Chodorow 1997, p.17). Art may be done at home in privacy and is sometimes brought to a verbal therapy session. In art therapy, art-making, like sandplay, is usually part of the session with the therapist present. The experience of being witnessed entails revealing the uncertainty and struggle in the process of creation, well before a final product is conceived. An important benefit for a client on the way to achieving the completed image is the therapist's approval of the experimentation involved in the creative search. The art therapist, having been personally involved in his/her own creative process over time, has knowledge of creative risk taking and finding solutions. This art-informed awareness may be sensed as creative permission and reverberate in the images created by his/her client.

The art therapist will tend to view materials as unformed, unorganized substances. He/she may focus on the client's relation to sand, water and the inner blue color of the sandtray before the introduction of miniatures. Then the colors and materials of chosen objects may be noticed in addition to the objects' identities and placement. Markmaking on sand uses the movements of drawing. Sculpting with sand and water may use movements related to those used in molding clay. But the sandtray itself differs from paper or board as it is a permanent walled enclosure containing the sculptural material – sand and water. Another difference is the primeval transience of sand, returning always to its indifferent undeveloped state. Impermanence may be unsettling as may other qualities of sand discussed later. When the sand-player feels comfortable with sand, there is usually an intuitive search for the movement that will give the sand its specific form. With repeated use, the three-dimensional potential of moist sand becomes familiar. A relaxed acceptance of the uncertainty inherent in creative process allows the sand-player to relinquish control. At this point inner movement guides the hands, choreographing the hand dance with the sand. The movement creates its mirror image in visible sand form. Sand, an aggregate of individual particles at first, proceeds to be moved into unified structures. The hands have pulled towards the body, and pushed away, have moved outwards to the sides and inwards, have tried to descend or have wanted to create a structure of ascent. Clients of all ages play with sand and arrive at discovery of the same basic movements that create forms in sand in accord with an inner need. Jung said: 'Often it is necessary to clarify a vague content by giving it a visible form. This can be done by drawing, painting or modeling. Often the hands know how to solve a riddle with which the intellect has wrestled in vain' (1916/1958, CW 8, par.180).

Sandplay, art and mud

One can use sand as a base for drawing or a material for forming, but it is not manufactured like paper or processed and packaged like clay. It remains a primal natural substance. In therapy it can be played with in ways reminiscent of beach play, from simple markmaking to creation of complex forms, within the limitations of size and amount. The immediate spontaneous construction of a sandworld in the sandtray restores early unselfconscious outdoor experience of play with sand, earth, water and objects, the child's first 'environmental art'.

Years ago, when manufacture of art materials was geared more towards artists than towards general creativity, children made do with anything at hand for creative activity. Messiness may once have been relatively permissible in areas where modern plumbing and water were less accessible. As our civilization becomes removed from nature, learning and creative activity tend to occur more often in controlled settings, sometimes by way of a computer rather than a human teacher. Parents may equate dirt with worthlessness or badness and add guilt to the simple and natural tendency to be playful within nature. Art-making linked to spontaneous play behavior in natural surroundings is more of a rare behavior today. Art materials today are varied and sometimes artificial. While it is true that artists often love nothing more than 'hanging out' around expensive art materials, it is a distortion to believe that legitimate artmaking depends only on bought materials or learned techniques of creativity.

In the art therapy setting a *longing for mud* may be perceived in some child or adult 'captives of culture'. This may be enacted through watery indiscriminate paint mixing, by dissolving clay in water or flooding sand with water. The simplicity of sandplay and the fact that sand or earth and water are the most natural of materials may help to recapture some sense of primary creative activity.

C.G. Jung himself returned to the art-making play behavior of his childhood after he was 40 years old. During a time of stress after his break with Freud in 1912–13, he recalled with emotion how as a child he had built towns with earth and stones at the edge of a lake. He resumed this building activity daily, letting fantasies arise in spontaneous play like the child he had been who needed a way of self-calming and working things out (Jung 1961). In 'The Tavistock Lectures', Jung said: 'Active imagination, as the term denotes, means that the images have a life of their own and that the symbolic events develop according to their own logic – that is, of course, if your conscious reason does not interfere' (1935/1976, vol.18, par.397). Jung's childhood memory and his adult use of it supports two ideas: the use of spontaneous play to arrive at mental well-being and the use of natural materials. His building activity was done with earth and stone near water, actual ancient primeval materials and a source from which life forms evolve. Mud symbolizes 'the receptive earth impregnated by the fertilizing waters; the source and potential of fertility and growth. It also represents primitive and unregenerate man' (Cooper 1978).

On the banks of the Dead Sea in Israel, there is an ancient black mud formed from decomposed plant matter and the dissolved minerals in the thick salty water. There is great popular belief in the healing powers of this mud. It is known to stimulate internal organs and cure certain physical diseases. An entire day or more may be spent by children and adults of all ages alternately smearing black mud on every part of the body except the eyes, and later showering it off or bathing in the sea. People enjoy photographing each other in this muddy black state. The hands directly apply thick muddy marks and draw designs on the human body using it as a base, perhaps activating a primitive creative urge and sense of enjoyment.

On ocean beaches, ordinary sand and water also provide occasion to roll in the mud, be buried in it and create structures of all kinds. At times the body is the base for markmaking and at times the coastal sand surface is the base. All will be soon washed away. Water will remove the mud from people's bodies leaving no sign of the personal markmaking they briefly enjoyed. High tides and wind will eradicate that day's coastal markmaking activity, leaving a clean surface for the next day. The physical healing properties of the Dead Sea mud and playful activity with coastal sand and water are the apparent justifications for being covered with mud. It would also seem that the enjoyable body painting and play with mud, sand and water in nature is a primitive ritual act having a life-giving force. In the concentrated and symbolic therapeutic context, it may be essential for a client to recapture some sense of this natural primal life-giving force through spontaneous creative play with primary materials and some direct use of the body.

The art therapist often contends with two types of fear related to artmaking. There may be an actual fear of art for those who believe that art-making is for the talented few. There may be a fear of messiness connected to badness and body excretions, as opposed to morality and goodness, some-times joined to a conviction that one will produce vile visual monstrosities. Both these attitudes prevent and devalue primitive graphic markmaking needs.

The therapeutic setting may restore permission to be playful and take playful risks. Art therapy cannot replace the freedom of the natural setting, but the act of creating in the natural setting has no art therapist to witness and support its importance. In therapy the smallest movement turned into a mark or form or the integration of an object in a collage, assemblage or sandplay is witnessed. The witnessed therapeutic creative experience sinks into the psyche when a client leaves the session. There, it continues to resolve within

until the next session, as part of a process shared with the therapist but regulated by the psyche's support of the individuation process. In 'The Transcendent Function' Jung states: 'Directedness is absolutely necessary for the conscious process, but as we have seen it entails an unavoidable one-sidedness. Since the psyche is a self-regulating system, just as the body is, the regulating counteraction will always develop in the unconscious' (Jung 1916/1958, CW 8, par.159).

Markmaking

Markmaking is a primary human tendency beginning with food smearing in the first year of life. An awareness develops that certain body movements produce changes in the appearance of a surface. The ongoing graphic dialogue with the environment continues as children and adults consciously leave footprints on earth or sand, move a finger through dust on furniture, or vapor on a window. Children gradually realize that their motor movement can control these marks and leave them as proof of their existence. Young boys will direct their urination on earth to create a dark wet line on the lighter dry earth color like calligraphy. Deeper marks are incised with sticks, stones and knives. Hearts and names are engraved on trees and park benches, graffiti are sprayed on stone walls. Markmaking continues as a personal form of permanent or temporary 'environmental art'. Footprints in the sand, sand-castles and other interactions with sand in nature are soon obliterated by wind and water. Scribbles on the classroom blackboard during the break will usually be erased before the lesson starts. We often pass by someone else's mark on a dirty car window, on a wall, or in an ancient stone site in the middle of the desert. We come upon marks made by humans in remote mountain caves 25,000 years ago or more, validating their belonging to the land and the continuity of their life on it. In these places we also find more recent graffiti, names and dates incised by tourists within the last century. We are both markmakers and spectators.

Children enter into markmaking with curiosity, as a form of spontaneous play. They invest time and their increasing skill in making comprehensible images. The visual image becomes a non-verbal communication with others. Winnicott (1971) says it is essential for the developing child to play in order to get in touch with his own life source, or to create his own goals and satisfy his curiosity. The child who cannot play loses contact with the self and is left with a feeling of emptiness, a feeling of not being. The experience of free play builds and strengthens the ego. A sense of differentiation begins.

Gradually the child discerns between what is his own and what is external. Thus, in the process of ego building, choosing a goal in free play makes the goal special, appropriate and essential for that moment.

We would not make a mark if we did not need to create a special visual image. Of all the things that exist in our lives, we choose to draw or build something specific in which we are especially interested, and this makes the chosen image special. In making special our chosen subject we invest the time, thought and effort needed to differentiate this image from the ordinary. In much the same way tribal people decorate and prepare themselves for rituals, making them special and quite separate from ordinary daily activity. Rituals are special events shared by a group, connecting them in a common meaningful experience (Dissanayake 1992). In art therapy, a special image is created in the presence of a therapist or therapy group. The sharing of an individual image with the therapist or with the group may become a communal special event of emotional importance for everyone.

The act of making a mark is in essence an interaction between ourselves as markmakers and the surface or base chosen to receive the mark. The visual product consisting of a base and the marks we have made upon it may become a metaphor for the relationship between ourselves, as a surface or base, and the marks enacted upon us by life. Parents, relatives, friends, teachers, society and the environment have painted and engraved upon us marks of different forms, sizes and colors. Some of these are pleasant, valued and useful. Others are painful and continue to hurt. Art, as a marked surface, may be the mirror we make of our experience.

Markmaking and form in beach play and in art therapy

The natural sand environment encourages spontaneous and universal art-making behavior. Each child learns to fill molds and make 'pies', to imprint hands and feet and incise lines, to gather sand into mounds, dig holes and tunnels and control water by dripping sandcastles. Objects and our bodies are buried and uncovered. Beach play is entirely acceptable as an isolated brief vacation activity. Building intricate sand structures may develop into a repetitive and intense artistic effort, sometimes fulfilling creative needs to make something special and be noticed and admired by spectators. But a sand structure's existence has always been brief as sand must always return to its natural formlessness. Destroyed by their makers who have to go home, or left intact for a brief moment, these creative efforts in the sand await their

predictable eradication by human or natural means. Creation and destruction are inextricably linked in this form of play.

In comparing the experience of play with sand in the vast and open natural environment to that of sandplay in the protective container of the art therapy setting, several meaningful differences may be noted. The first difference is that of the intent or purpose which brings one to either containing environment. The beach welcomes all equally in a general mood of playful experimentation and concrete mastery of whatever structure is planned. The art therapy room is a protective enclosure designated for the involvement of a single person in creative processes with mostly manufactured materials, and the sandtray. The beach provides endless space, sand and water, shells and stones, but its variety is mainly limited to this. The inner space of the therapy room cannot be as physically infinite as in nature, but a large range of materials is available and, as temenos, the therapy room can hold the client's entire emotional world and infinite imagination. These give the artmaker–sandplayer unlimited symbolic means with which to create forms in art, or in sand, and unlimited specific objects to choose that distinguish one's sandworld from any other. An inner need is transformed into significant personal, symbolic imagery.

In the infinite beach space a person is relatively as small as a miniature object. In art therapy and in sandplay, the artmaker is usually larger than the images he creates. He can look down upon them at a glance, which suggests that one can be in control of images once they are externalized, putting things in proportion. At the beach, play with sand is a concrete physical activity and the entire body takes part in the work. The limited size of the art therapy room, the painting table or sandtray, restricts physical participation to use of the hands and not much more. Beach play may be carried out alone, with perhaps some notice by another person in a brief moment of validation. In therapy, the therapist is a constant witness, supporting the search for form and image from its inception, resonating with the client while observing a whole process and not just a finished product. The therapist's interested eye connotes that the evolving image is special and important. The work done will represent not only itself but also the sense of support gained in the interactive process, which eventually becomes part of the client's inner world.

The sandtray and the numerous miniature objects form an arena for symbolic enactment. The work becomes a quest for internal maturation and growth that may begin with gradual creation of form similar to that of beach

play. But the shallow sandtray with its blue symbolic water and limited sand will not provide concrete width, depth or height, or large bodies of real water. These limitations force the sandplayer into the imaginary realm, instigating a creative illusion of reality similar to a painting or relief. Once the concrete limitations of the sandtray are accepted, the potential sandworld extends in imagination well beyond the sandtray's horizontal and vertical boundaries into expanses, depths and heights with endless possibilities. The sandworld that is formed and framed within the sandtray is like a page in an ongoing myth, upon which client and therapist focus at that moment, aware that beyond the frame the myth continues.

Very often in therapy, clients use not only paper, paints, clay and sand as a base for their marks, but, in subtle ways, use the therapist as a base to make their marks on. The client does to the therapist what has been done to him/her, and makes the therapist feel as he/she feels. The art therapy client may do the same thing to his own self-created imagery, making the image 'feel' as he/she feels. Markmaking and forming in accordance with an inner need may replicate the process of one's life. This process needs a mirror in order to be seen clearly, understood and resolved. Both therapist and image become those mirrors, each contributing a unique key to understanding, growth and change. Through art and sandplay, a client can experience being both the base and the mark. He or she is the sand, dust, clay or paper that will absorb both familiar and puzzling marks, leading eventually to more understanding and more control in the journey towards individuation and health.

Materials of Sandplay

Introduction

This section presents the materials of sandplay in two parts. The first part addresses sand and water as materials. They are both natural substances and may be found in a common ecological system in nature. In sandplay they may be used separately, each retaining its unique character, or together, which changes the qualities of both and produces a third material. The second part introduces sandplay objects, their identities, categorization and some reasons for their attractiveness.

Sand and water

Sand

Sand is literally millions of years old, representing ancient geologic history. Sandy beaches exist all over the world. They take their color from rock fragments that are washed or blown down from mountains, enduring further breakage while being transported over vast distances by wind and water, abraded and polished continually. Individual grains are born and may become sedimentary rock, hardening into stone again, which once again fragments. Many beaches contain shell and skeleton fragments of marine invertebrate animals that have undergone breakage, abrasion and polishing over eons of time (Mack and Leistikow 1996). They are reminders of the life they once contained in water, as the former home of an organism.

Sand can be fine and white, yellowish or brown, even black or red. In the sandtray, white sand provides a clear neutral background upon which natural stones and shells or miniatures are clearly distinguished. On darker colored sand, the colors of natural objects and miniatures are 'swallowed' and their forms become less visually defined.

Sand is a formless collection of granules, shifting indifferently in response to external forces. Sand combined with water enables one to build strong

structures, smooth or texture its surface, enter into its depths, bury and uncover, or make lacy, fantasy drip-castles. Sand is the border between ocean and earth, and in sandplay symbolizes the element Earth, the Mother, the permanent strong base of reality, containing, nurturing and absorbing.

Particular forms of play are elicited by the nature of sand. At the beach the entire body is often involved, sparsely clothed, lying in the sand almost as a physical part of the work. Sandplay in the therapy room is symbolic, non-verbal, using only the hands. Sand in the sandtray is not chosen; it is there, a given, just as one's body is a given. Like the body it becomes sensed and known when it is touched. Sand can become the formlessness before creation, while client and therapist witness the bringing of forms into the world, in a renewal of creative birthing each session.

Usually, a constant amount of sand is confined within the sandtray. This can become a metaphor for the constant amount of matter in the universe, or the total matter or energy which constitutes a person within the boundaries of his own body. Sand, like matter and energy, is allocated differently by shifting. The sands of nature shift and travel over great distances, propelled by water and wind, yet are always part of the total matter on our planet Earth.

In therapy, the client's energies are gradually directed and distributed with clearer balance, perhaps symbolized by the sand—energy being shifted in the sandtray from session to session. A smooth sand surface is an equal distribution. Any pressure of hands on this surface causes unequal distribution which automatically forms polarities: higher and lower, more or less, horizontal or sloped, close or distant, containing and contained. The entire sand content can be moved to one area. This will create beige sand forms contrasted against the blue color of the interior of the tray, such as a central mound surrounded by a blue base, a land mass on one side of the tray leaving the opposite side blue, or an unruptured sand surface enclosing an open central blue area.

Sand can arouse associations to heat, cold water, nudity, grittiness, burying or building. Certain clients tend to avoid sand, as if unable to acknowledge its specific plastic qualities. As a base it is treated no differently from a table or floor. Consequently, this client chooses to remain uninformed of the sand's and his own three-dimensional options and tactility.

Water

Water must be present for life to exist. The planet Earth is two-thirds water as is the human body, whose functioning requires more water than most other land animals. Human life begins in the watery womb. Emotions are often expressed through release of body fluids such as saliva, mucus, sweat, tears, urine or blood. Water changes form in response to temperature and gravity by evaporating, freezing or flowing, states that may be used as metaphors for human emotions. In daily language water's qualities are often used as metaphors, for example: 'floating around', a 'shallow statement', a 'transparent action', 'murky thinking' and 'stormy personality'. Water reflects what is not part of it, supports what is on it and transparently reveals what is within it. Claude Monet, the French impressionist painter, devoted the last years of his life to painting his waterlilies within this tripartite watery environment of reflection, transparency and floating (Wildenstein 1996).

Water has many sounds, from drips, pleasant trickles and calming brooks and waves, to forceful tidal waves and roaring storms. Water that can no longer flow freely becomes a stagnant swamp. Water can dissolve or change the condition of other substances. It creates sand from rock by abrasion, transporting and depositing it on shores and riverbanks. Water cleanses and cools but also pours down in wrath from the sky, flooding and drowning. 'All waters are symbolic of the Great Mother and associated with birth, the feminine principle, the universal womb, the prima materia, the waters of fertility and refreshment and the fountain of life' (Cooper 1978, p.188).

Ryce-Menuhin (1992) compares the course of psychic development with flowing water, by referring to a translation of Hexagram 29 (K'an/The Abysmal Water) of the *I Ching* (Wilhelm 1951, p.115):

> It flows on and on, merely filling at the place it traverses; it does not shy away from any dangerous place, nor from any sudden plunge; nothing can make it lose its own intrinsic essence. It remains true to itself in all circumstances. Thus truthfulness in difficult conditions will bring about the penetration of a situation within one's heart. And once a situation is mastered from within the heart, the success of our exterior actions will come about all by itself.

Kalff relates a client's depiction of a stream with stones to a description of flowing water in the I Ching: 'The water flows uninterruptedly and reaches the goal. It flows and does not accumulate anywhere. It does not lose its reliable nature at the dangerous places either' (1980, p.79).

Sand and water

Sand and water have several potential relationships. Both are ancient, limitless and unboundaried flowing substances of nature. Alone, each shifts and flows endlessly in accordance with gravity and atmospheric conditions. Water is tangible and formless in its flowing state. Sand has concrete presence and is formless. Together, water and sand combine into sturdy structures or collapse into mud when water dominates. A person can be flooded with emotion to the point of collapse in a similar way. Art materials containing water, such as watercolors, gouache and clay, often encourage a flow of emotions when they are used freely. In the sandtray real water is present, but absorbed, in the moist sand. There may be a need to isolate water from sand in the sandtray as a response to its clarity, reflective or cleansing qualities, or its flow. Sometimes this need can be met by filling containers or plastic sheets with water.

The sandplay object

An object's identity can constitute psychic material for the sandplayer. Objects as 'psychic material' can be categorized according to their visible identities. The concrete material of which the object itself is formed consti- tutes another reason for its choice. Types of objects that compose a full range for the sandplay collection are listed below. The collection usually represents everything in the current, or historical world, from concrete reality to religion and fantasy. Natural objects formed by processes of nature alone comprise one general category. The sandplay collection would be 'lifeless' if it did not include natural objects such as stones, bones, shells, fossils, minerals and crystals, wood, straw, seed pods and dried flora, weathered glass and feathers. Manufactured objects may be made of plastic, resin, metal, fired clay, glass or synthetic stone, all of which can be cast from a mold or carved singly from wood or stone.

There is a qualitative difference between objects and substances formed by nature independent of man's control and those manufactured by man. A natural material has been formed by eons of evolutionary activity, or has grown according to nature's blueprint in darkness or nourished by sunlight, and thus may symbolize that part of human nature that can grow to be itself under benign conditions. A client may enter therapy because his/her 'genetic blueprint' has not fulfilled its potential and there is a wish to heal and change,

through the self-regulating powers of the psyche (Jung 1916/1958, CW 8, par.159).

Choosing sandplay rather than drawing or painting is in a way a choice between getting in touch with primal sources independent of man or using something closer to human culture. This may reflect the primal level of inner work with sandplay versus the more culturally personal work done with manufactured art media.

Natural objects or objects made of natural materials are used for ritual, meditation and consultation in many parts of the world. In Native American tradition, objects of stone or wood may be found, or made, in the form of animals, for use as a personal fetish for meditative consultation and healing for a range of personal or tribal problems (Bennett 1993). Close observation of animal life has given rise over centuries to teaching legends of each animal's powers, honoring the wisdom of all animals in knowing how to live on the earth. 'When you call upon the power of an animal, you are asking to be drawn into complete harmony with the strength of that creature's essence' (Sams and Carson 1988, p.13). Carved totem poles of Northwest America are believed to represent the tribal ancestors. They offer protection and guidance and demand loyalty to their kind. 'The Personal Totem Pole' is a therapeutic method discovered by transpersonal psychologist E. S. Gallegos (1990). It combines personal imagery of seven 'totem pole' animals 'within us', the principle of the seven chakras or vortices of energy positioned along the spine (Ouseley 1949), from which the animals are evoked, and Jung's theory of active imagination. Around the world, archeological finds of dolls and animal figures reveal the need to speak with and through objects. These may have been play objects or served in religious or ritual uses, 'thus becoming a transitional object between people and their Gods or between people and their emotions' (Steinhardt 1994, p.205). Thus it is possible to understand the charisma an object holds for us and the need to choose an animal or object in sandplay as a human attribute. It may illuminate an inner rationale for self-expression and healing, nourished by and drawing upon the natural wisdom attributed to the identity of the object.

Emotional attachment to an object

Among the creative expressive therapies, visual art alone enables an inner image to be transformed into a tangible object. The art object and the sandplay picture take form in the protected space between therapist and client and join in the therapeutic relationship. Both art object and sandworld

remain physically in the room at the close of the session. A child may sometimes demand to take the art product home. Obviously, the large sandtray cannot be taken, but an emotionally invested miniature object may be either requested or surreptitiously taken. For the client, the product is twice valuable. It is concrete proof of growing skill and mastery in creating the forms of the imagination. It also represents trust in the therapist, support within the therapeutic relationship and the self-esteem necessary to tolerate the uncertainty of the creative process.

In crossing the boundaries of the therapy setting to the outside, an art product may be destroyed by criticism, indifference or physical damage, and an object may be lost. This may devalue and destroy whatever joy, self-esteem and trust was acquired in the process of making an authentic image in the presence of another. When the client is able to carry an intact inner image of the artwork or sandplay, rather than a concrete image subject to external danger, the inner image may grow psychologically, unharmed. The positive aspects of the therapeutic relationship that it represents are introjected and eventually become functional in situations other than the therapeutic setting. However, the difference between a concrete and an introjected image may be imperceptible at first for the client. For a client with the need to have a concrete representation of the therapeutic relationship in the outside world, a tiny self-made object, word or symbol drawn on a piece of paper by therapist or patient may suffice to contain the art or sandplay experience and be taken away as a temporary talisman.

Manufactured miniatures

Inexpensive miniatures are usually made of plastic. They are water resistant, frequently unbreakable and can portray precise, colorful identities. Some standard items are packaged as a collection of one type, such as wild or farm animals, soldiers and military equipment, cowboys and Indians with wigwams, cacti and totem poles. Other available items may be connected to a current popular film or TV show, or to religious events. It is often difficult to find representations of girls and women in ordinary toy stores except when connected to cartoon films. Very expensive collectors' items for doll houses of certain historical periods, or replicas of military subjects, are made in porcelain or cast from heavy metal. Their value and delicacy may preclude their use in the sandtray.

Choice of a manufactured object relates healing to the object's visible identity and its symbolism. When a plastic, resin or rubber object is chosen, it

is usually not for the qualities of the material. It is the identity of the object, the content and story it represents that is chosen. Metal cast objects have a different quality of presence. Frequently, souvenirs made of metal are found around the world in markets adjacent to sites that attract great numbers of visitors. Reproductions of gods, legendary characters, buildings, revered animals or simply decorative containers and objects of varying quality can be purchased on site. Sometimes these objects are strictly local and will not be found anywhere else. Fine metal cast soldiers or doll house miniatures of high quality may be very expensive and suit collectors interested in factual history. But the sandplay collection contains objects that inexplicably awaken the interest of the sandplayer, who may suspend rational thinking when an object is chosen. It may be for its identity, size and color, some remote association with it, and also for the material of which it is made. When a material is important it will be shown in two ways. For example, a wooden dog may be the one chosen from among several dogs in the miniature collection, made of either plastic, wood, glass, metal, clay or stone. At times all the different objects in a sandworld, whether people, tools, vehicles or animals, will be made of a common material, such as metal, wood, glass or crystal. In both these examples the material's identity will have meaning.

Objects in the sandplay collection

The basic sandplay object collection contains several hundred miniatures. The basic groups have many subcategories. A collection takes years to build and is often fun to acquire. Objects should be sturdy and unbreakable, able to withstand violent treatment and water. Particularly beautiful or delicate objects might be handled with care by adults but their use with children should be carefully considered if there is a potential for damage. There is always a danger of acquiring too many objects. Immediate specific needs cannot always be satisfied. As in life, the failure of the environment to provide immediate satisfaction can be a factor for growth, causing a client to improvise and be creative.

Listed below are essential objects for the collection. The categories are arranged with different living creatures preceding objects. Their categorization has been generally organized according to the element they live in, whether earth, water or air. The category of 'fire' is not a separate one here, but could be so if one placed in it objects connected with physical fire, animals, witches, spirits, demons and ritual objects connected to the fire

element. The sandplay therapist can add to this list whatever else is important to him/her or to clients.

Types of objects used in sandplay

1. People: should be of all ages in both sexes. Babies, children, mother, father and grandparents should have several representatives each; different professions should be represented, and various types of sportsmen; tribal and ethnic groups should be present in family groups if possible; imaginary characters from films, comics, superheroes and villains, characters from legends and fairy tales, including sorcerers and witches are necessary; gods and goddesses from around the world and angels of all kinds are important.

2. Land animals: should include realistic wild animals, from the larger mammals, rodents, reptiles and snakes, and worms, from jungle to plains to desert to mountain species; farm animals and domestic animals of all kinds; prehistoric animals such as dinosaurs; cartoon animals.

3. Flying creatures: should include realistic birds related to water, land and air; wild and domesticated; cartoon birds; bats, prehistoric birds (pterodactyls, archaeopteryx); insects, from ants, flies, roaches, beetles, grasshoppers, spiders to butterflies.

4. Sea creatures: all kinds and sizes of fish, including ordinary or tropical fish, sharks and rays; whales and dolphins, walrus, seals; crustaceans; octopi and squid; sea horses.

5. Abodes, buildings, houses and inner furnishings: there should be a variety of houses and styles from around the world, from small and modest to larger and decorative; cave, tent, hospital, jail. There should be furniture for all the rooms in a house, such as the kitchen, bathroom, bedroom, living room; porch or garden furniture; hospital furniture.

6. Utensils and food: small pots and pans, plates, cups and saucers, silverware and a good quantity of small food items.

7. Trees and plants: there should be many trees of several kinds, preferably as natural looking as possible; flowers and plants. (At times real foliage can be used.)

8. Sky objects: sun, moon, stars, rainbow, clouds, lightning.

9. Vehicles: for land (bicycles, cars, trucks, tanks), sea (rowboats, sailboats, ships), or air (airplanes, helicopters, rockets, parachutes).

10. Objects of the man-made environment: fences, traffic signs and road equipment; bridges; wells; gates and portals.

11. Unique objects: masks, tools, volcano, cave, scales of justice, swing, vase, clocks, musical instruments, pyramids, eggs, campfire, marbles, gravestone, sarcophagus, religious objects, mirrors, treasure chest, boxes and bottles, weapons.

12. Accessories: fabrics, photos, wool, string, buttons, chains, nails, screws, jewelry, coins, suitcase.

13. Natural objects: crystals and minerals, stones, bones, fossils, weathered metal, wood and dried plants, acorns and seeds, shells, feathers, weathered glass, bird's nest.

Displaying the collection

Miniature objects are often displayed standing on shelves. They may be arranged into groups of people, animals, houses, etc. Some sandplay therapists place unrelated objects near each other so that the sandplayer creates his own order, by choosing and integrating objects into a sandworld of his own creation. When objects are too numerous for the shelf space available, transparent plastic containers may be used for holding objects of one kind. For example, one container will hold only fish, another only farm animals, or horses, or babies or trees. This may save space, make sense to the sandplayer looking for a specific item, and help as well in clean-up. The therapist dismantles the client's sandworld after the session, sometimes without adequate time to clean all the sand off the miniatures. Cleaning the containers of the sand that has collected is easier than dusting shelves and removing and replacing hundreds of miniatures each time.

Classification of the Materials of Sandplay

Any object or material that is used in a sandworld may have been spontaneously chosen. Yet when it is within the sandtray it becomes a symbol that can represent, among other things, specific qualities within the range of possibilities of that material or object. This brief classification of sandplay materials may enrich understanding of the unconscious knowledge conveyed by use of sand, water and the materials of which objects are made.

Sand and water

Sand

Sand is natural and ancient; malleable and flowing; flat (two-dimensional) or three-dimensional; requires little effort; hands or simple tools; requires time; soft dreamy metaphors, infinity, impermanence and change, indifference; range of imagery.

Water

Water is natural and ancient; frozen, flowing, vapor; formless; no effort; uncontrollable; metaphors from shallow, deep, calm, turbulent, clear, murky, flowing, etc.

Materials of which sandplay objects are made

Metals

In many cultures metals are considered the embryos of the earth womb. Different metals are associated with different planets or gods. Gold is associated with the sun and silver with the moon; lead is associated with

Saturn, iron with Mars, quicksilver with Mercury, copper and brass with Venus (Cooper 1978, p.105).

Stone

In many cultures stones are considered as the bones of Mother Earth. They represent indestructibility and are immortal and eternal. Stones may be used for foundations for building structures. Upright stones may be considered as phallic powers. A stone can be a world center, an omphalos, the place where heaven and earth meet (Cooper 1978, p.160).

Glass and crystals

Crystals have attained their forms deep in darkness under conditions of heat and pressure over thousands of years. Their pure essence is revealed to us when they are brought up to the light. This may symbolize the healing process of therapy. The deep internal work done in the dark of the psyche must crystallize and then it may be brought up into life as clarity and insight. Glass is manufactured but has the qualities of transparent purity and hardness. Both these substances represent purity, insight and spiritual perfection (Cooper 1978, p.48).

Gemstones

The sandplay collection should include gemstones of different colors in various stages of polishing, from natural to smooth. Some quartz crystals are inexpensive and possess something magical in their presence. Jewels may symbolize hidden treasures. The cutting and shaping of them represents revealing the beautiful essence or potential of the natural element.

Wood

Wood is considered in many cultures as prima materia, out of which all things are formed. Wood crafted with tools transforms chaos into order. Wood can become the containing cradle, coffin or marriage bed (Cooper 1978, p.194). Wood grains show the vitality of growth and chart the life of the tree, which can symbolize the organic growth of a person.

Shells

Shells of all shapes belong to the watery principle and the moon. The shape of some shells resembles female genitals. The snail emerges from its shell like a baby from the womb. Pearls grow in the oyster womb. Mollusks are influenced by phases of the moon. In general, shells are representative of sexual symbolism, fertility and birth, whether carnal or spiritual (Eliade 1991). The sandplay collection of shells should represent bivalve mollusks, and conches and snails of all kinds.

Bones

Bones represent the eternal principle of life and possible resurrection. They are also the proof of mortality and limited time. Bones in the sandplay collection may be real found bones, teeth and small animal skulls, plastic bones and miniature plastic dinosaur or human skeletons.

Feathers

Feathers represent truth, which must rise. They belong to air and wind, are light and represent flight to other realms and the knowledge of birds. Their colors and the birds they come from give them specific significance when worn or used in ceremonies (Cooper 1978, p.65).

Plastic

'Any group of synthetic or natural organic materials that may be shaped when soft and then hardened, including many types of resins, polymers, cellulose derivatives, casein materials, and proteins' (New Webster's Encyclopedic Dictionary of the English Language 1997, p.509). Plastic as a material may represent packaging and design, as an attitude of materialistic society, which sells an impression or idea of something.

Color

In art therapy, the use or non-use of certain colors are essential indicators of a client's state of being and emotions. Concentrations of one color, or certain combinations, may be spontaneous choices, yet their very presence in an artwork makes them special and requires observation and whatever understanding is possible. The color chosen to draw an object may be appropriate or inappropriate. Brown as earth or treetrunk is a usual choice. A brown sky or blue treetrunk might indicate some unresolved emotion attached to the symbolism of sky or treetrunk that may be unconsciously depicted with formless materials. In sandplay, color is limited to the difference between dry and wet sand, to the blue sandtray interior and to the already present color of objects. It is nevertheless an expressive emotional element of choice. This chapter provides a synopsis of some significant aspects of color that are useful in observing artwork and might prove useful to amplify understanding of a sandworld.

The presence of color

Organic life on earth evolved through adaptation to the presence or absence of light rays emitted by the sun's fire and adaptation to geographic location and climate. Pure sunlight contains all the colors of the world. When light rays penetrate drops of water vapor in the sky, the rays are refracted and a rainbow is revealed. The rainbow is composed of seven consecutive bands of color. The uppermost band is red, below it orange, and then yellow. This is considered the 'warm' part of the spectrum. Yellow is followed by green, blue and indigo, and violet. This is the 'cool' part of the spectrum.

Life, light and color are intertwined. Each of the six color families in the rainbow can influence by their light rays the organic growth of both plants and animals. Each color has physiological and psychological influence on humans, entering the body through the eyes and the skin, or through the

color of foods that we eat. The attributes of each color may be understood on three levels: the universal, the cultural and the personal. Universally, every color is part of light and life and therefore must have specific life-enhancing properties, regulated by nature. Cultural factors, including the geographic and socio-economic environment, can determine mass acceptance or avoid- ance of a color or combination of colors. Personal experience may determine associations to a color and need of or dislike of it (Clark 1975; Ouseley 1949; Walker 1991).

Color as pure light has no substance. The color of physical matter is due to selective absorption of light rays by pigments. Pigments are dry insoluble substances that can produce colors in the tissues of plants and animals, or can be taken from natural and synthetic substances and pulverized for drawing, or suspended in a liquid vehicle for painting. When pigments are allied with oil, plastic or water, one can prepare oil paint, acrylic paint, watercolor or gouache paint. When compacted and left pure, pigments may be made into chalk pastel. Compacted with an oil base pigment becomes oil pastel. The medium to which it is attached has its own classifiable qualities, but each color affects us with its unique aura.

In the color wheel there are six colors in fixed rainbow order: red, orange, yellow, green, blue and purple. The primary colors, red, yellow and blue, in light and in pigment, cannot be mixed by any combination of the others. The secondary colors, orange, green and purple, are the result of mixing two primary colors together. On the color wheel, in light and in paint pigment, opposite colors are complementary: red complements green; orange comple- ments blue; yellow complements purple. Opposites always consist of a primary color and a secondary color. When opposites are mixed all three pri- mary colors are present, as the secondary color contains the other two primaries. In light, such mixing creates clear white light. When the three primary colors are mixed in pigment form, brown or black colors will result. Complementary colors complete each other in the eye, forming together an entire range of light. When they appear adjacent to each other in a color field and are of equal intensities, they compete, interacting by vibrating in the eye against each other (Albers 1963).

Each color has a general aura which may evoke diverse reactions in different viewers. For example, red is generally a dramatic color, which stimulates and intensifies outgoing movement and emotion. A red pigment such as vermilion or light cadmium red may be associated with feelings of joy or love. Darker cadmium red may be associated with deep emotion, or anger.

Blue pigments may be experienced as calming, distancing one from close emotional interaction. In general, blue is the color of spiritual life and thought, but some darker hues may be experienced as leading to detachment bordering on feelings of depression or death.

A color may be avoided or desired, depending on what is associated with it. When a color is shunned because of a particular aversion, any benefit connected to the opposite aspect of the color is prevented. Correspondingly, one may enjoy wearing clothing of a certain color, or use the color in the environment, without realizing that the color also represents an unresolved issue. For example, a woman wore only red stating that this color showed her love. After a series of red paintings, she realized that she was furiously angry with people close to her, something she had not associated with red before. After working through her anger, she stopped wearing red and began to dress in other colors.

Blue pigments: Cobalt and cerulean

Color may be seen as material, an 'object' in itself both in art and in sandplay. In each color family there are specific hues and pigments that resemble each other. But they are not interchangeable and cannot be mixed to approximate each other. An artist's color chart will offer a range in each color, darker or lighter, opaque or translucent, all derived from different sources and radiating slightly different auras. For example, basic blue pigments include cerulean blue, cobalt blue, ultramarine blue, manganese blue, pthalo blue and Prussian blue. Each blue is specific, tending to be lighter or darker, or inferring a link towards green, purple, red or black.

In sandplay, blue is designated as a constant presence in the sandtray's interior. It is always somewhat visible on the inner sides of the sandtray. The sandtray's bottom is revealed if the sand is moved aside exposing the necessary amount of blue. Selecting a visible quantity of blue may be experienced as a color choice, just as an object is chosen. In considering the many blue hues available and their different auras, it is important that the blue chosen for the sandtray's interior will correspond to the need for depth indicated by choice of dry or wet sand. Water, sky and the color blue move on an axis in constant recession into infinite height, depth or distance. The choice of the moist sandtray, where water is actually present in the sand, may indicate that the work to be done leads to depth. The dry sandtray is chosen when the sandplayer's psyche is less concerned with depth. In correlating the quality of depth and blue pigments, cerulean is a light hue with less depth

than the darker cobalt. Thus the dry sandtray might be painted cerulean and the wet sandtray a cobalt blue. Each blue would be compatible with the work to be done in each sandtray.

Color as an integral element in life systems

Color as associated with emotion and behavior is today a part of psychological and art therapy diagnosis (Luscher 1969; Ulman 1965). In art, color has always been used symbolically, especially when connected to ritual and religion (Clark 1975; Walker 1991). Kandinsky's 1911 manifesto delineating the principles of modern art stressed that color and form should be used as an accurate vibration of the artist's inner need for art to be authentic. He described how each color's attributes are experienced physically and emotionally (Kandinsky 1977).

Color as one element interconnected with others in a complete round of life is part of the ancient Tibetan and Chinese philosophies of living in balance called the Law of the Five Elements. The elements in the two systems are slightly different, but the five colors representing the Elements are the same. The Five Elements of the Chinese system and their colors are: Wood – green; Fire – red; Earth – yellow; Metal – white; Water – blue. Each of these elements links to a specific color, season, body organ, time of day, direction, flavor, emotion, sound, smell, food, etc. Everything within the track of one element is interconnected. Each element creates another continually: Wood creates Fire, Fire creates Earth, Earth creates Metal, Metal creates Water, and Water creates Wood. All these elements are part of a dynamic whole and none is more important than another. Color in this system is inseparable from harmony and health (Connelly 1979).

Another integration of color into balanced living are the chakras of Hindu religion, seven locations along the spinal cord that form a system of color in our physical and etheric bodies. They are 'dynamic centres of vital force and consciousness – the generators of prana and the inlets of cosmic energy into the human system' (Ouseley 1949, p.70). In rainbow order we find: at the base of the spine the red chakra; above near the spleen the orange; in the region of the solar plexus is the yellow chakra; the green is near the heart; the blue is in the center of the throat, with indigo above the eyes, followed by violet at the crown. Each chakra is believed to absorb a particular color of vital energy from the environment which is then distributed to the body.

In Native American belief, the Full Rainbow consists of a sky rainbow and an earth rainbow creating one unending circle of color paths. Each of us is given a color at birth whose entirety we must learn well before going on to a new color (Rhinehart and Englehorn 1984, pp.37–43).

Black, white and brown are somewhat different from other colors. White as light is not a color but the presence of all rays in perfect balance. In the Chinese Law of the Five Elements it is the color of Metal. Black is the absence of light. In the Five Elements black is connected to blue, while brown is linked with yellow, the earth element. In pigment, black, white and brown are important colors, and frequently appear with other colors in the art of clients in art therapy. The use of black near other colors increases their intensity. Deep cadmium red near black may indicate imminent explosive anger. A light or medium cadmium yellow near black may signify a need for extreme caution. An ultramarine or Prussian blue near black may indicate recession into depression. The following chart is based on understanding of color as a healing force, and as a representative of emotion.

A color chart for sandplay and art therapy

Red

A warm, stimulating color, associated with blood, life, power, vitality, excitement, joy and love on one hand. On the other hand it is associated with lust, extreme anger and violence. It can influence us to quicken our movements and decisions and causes impulsive behavior.

Orange

Orange combines the extroverted impulsiveness of red with the intuition of yellow. As a color preference it denotes sociability, a penchant for easy, perhaps superficial, but not intimate interaction with others. It may represent energetic activity and nourishment, and many foods are this color. Excess orange may denote restless nervousness.

Yellow

Golden yellow is the color of the sun god, denoting wisdom, understanding, intuition and joy. Yellow is a central color in the spectrum and bridges the warm and cool colors. It can be acid lemon color or warm and golden. It is the color of weighing decisions and legal pad stationery. A preference for yellow

may indicate a tendency to theorize rather than to carry out plans. Yellow may also be associated with destructiveness, hate, deceit, cowardice and prejudice.

Green

Green is the color of nature and growth, permanent, dependable and straightforward. It is soothing, peaceful, static and healing. Those who prefer green may resist change or imaginative solutions. Yellow green may represent new life, vigor, growth, regeneration and joy. Some greens are associated with envy, laziness, selfishness and depression.

Blue

Blue is experienced as constantly receding into infinite distance or infinite depth. It is the heavenly color of truth, fidelity, harmony, calm and hope. It can be sedating, but in excess may be experienced as depressing the energy needed for life. Dark blue may be associated with ultimate rest, or the cold detachment of death.

Violet

Violet is the color of royalty or high spiritual position, inspiration, mystery, mysticism, and magic. It can also denote deceit, snobbery. When near black it may indicate emotional detachment from life and refuge in a fantasy world.

White

White is the perfection and harmony of all colors; it represents innocence and faith, and is the revealer of truth. Flags of surrender are white. Kandinsky describes white as a great silence, pregnant with possibilities, but causing other colors to become mute (1977, p.39).

Black

Black is the Void, the absence of light and is not a color. It may be associated with power, ultimate mystery and the primordial darkness from whence life emerges. It can also be associated with sorrow, mourning, evil, witchcraft, spiritual darkness and Hell. Kandinsky sees black as a totally dead silence with no possibilities, as motionless as a corpse (1977, p.39), but providing a background to enhance the qualities of other colors.

Brown

Brown is the color of earth and may represent growth, nurturing and the fertility of Mother Nature, the mud from which all things grow. Earth appears in children's drawings usually after age four or five, as a flat-horizontal base at the page bottom, supporting plants, people and houses. When it is missing, it may indicate lack of primary support and security. Brown is also associated with excrement and feelings of inner decay and dirtiness. It may be associated with putrefaction, foul smells, graves and death. As the color of earth, brown may indicate a solid communal approach to life rather than a search for individuality.

The Creation of Form
in Art Therapy and Sandplay

Visual Expression

Graphic messages: The mind, body and spirit of the image

Art therapy and sandplay are creative expressive therapies in which the creative dialogue between artmaker and materials bestows upon inner images a visual external form. The ensuing dialogue with the formed visual image may include providing voice and movement to the image as well. McNiff (1993, pp.3–9) suggests that images are autonomous and wish to present themselves and tell us how they feel: 'In order to practice imaginal dialogue, it is necessary to respect the image as an animated thing that is capable of offering support and guidance.' McNiff finds it helpful 'to extend the same courtesy to an image' that he would give to another person, treating him as a guest and getting to know him. McNiff proposes that it may be difficult to accept disturbing personal images as guests until we realize that these images do not intend to harm us, but rather to show us where we are already in pain.

Some images, like actors in the wings of a theater, appraise their audience and choose a timely moment for their entry, making themselves known as a created object. Other inner entities may be too pained to cope with being seen and exist as formless spirits hovering in internal time. Years may pass until some event enables them to emerge. When images are created they are not immediately identifiable as representatives of emotions or of the life events which are their source. Yet in some inner place there resides an invisible blueprint of each individual's graphic language, his choice of lines, forms, colors and placement. This blueprint could be called the 'mind' of the image. The 'body' of the image is provided by engaging in concrete expression, using materials in configurations that may come to be seen as a decipherable language. The personal visual code is often clearer when a series of works is done. The 'spirit' of the image is that which joins materials into a meaningful representation, insuring that the created image will be emotionally faithful to the blueprint, breathing life into the symbol constructed to represent it.

Looked at in another way, we could say that specific physical movements are invoked by a corresponding mental state. Concrete form is the material recording of these movements. Rhyne (1990) states that the Gestalt psychology principle of isomorphism corroborates the validity of a created image as representing an inner state. Isomorphism, she says:

> has the literal meaning 'similar or identical in form' without necessarily being similar in content or in the substance of which the form is made... Isomorphism is Gestalt psychology's answer to the mind-body problem. Form and order in experience corresponds to (is isomorphous with) form and order in the physical world, and form and order in the physiological processes. (Rhyne 1990, p.3)

A simple form of graphic expression is through line. Lines grow from a point which has begun to move into space. Basically, lines are straight or rounded. Either type of line in certain configurations can evince feelings of calm or tension in a viewer. Straight lines can combine into angular shapes that meet and form triangles, cubes, rectangles or other geometric shapes. In art therapy workshops, the author has asked participants to draw quick spontaneous symbols for specific concepts. The words 'security' and 'responsibility' are frequently recorded graphically as a blue, green or brown cube. 'Death' is drawn by some as a flat black shape. Straight lines may be experienced as serious, determined and fast moving when left open, and as stationary when a closed angled form is created. Diagonal zig-zag lines abruptly change direction and may seem to express tension or nervousness. Wavy lines seem to move more slowly, calmly and less deliberately. They may be experienced as expressing fantasy, playfulness, curiosity and airiness, although a tangled mass of interwoven wavy lines may be interpreted as expressing confusion and disorder. A round line may continue moving at a consistent angle and meet its beginning point, closing a circle.

The word 'life' is often drawn as a circle by different people, while the word 'creativity' sometimes materializes as a group of various colored wavy lines, radiating from a common lower point.

Horizontal lines parallel the flat extending earth plane upon which we walk, and create a structural division between upper and lower areas. This may sometimes be a division between sky and earth, masculine and feminine, or spiritual and body areas. In this division either area may be dominant, depending on the proportional size of each, color distribution, or intricacy of content in each area. Vertical lines seem to move between top and bottom, aspiring to connect earth and sky. They divide left and right sides. This may

be an egalitarian or a conflictual division between opposite sides. People frequently draw time on a horizontal time line as moving from left to right. Thus, the left side of a picture may contain past issues and the right side the present, and also future goals.

Diagonal lines have the potential to link opposites – upper and lower planes, and the right and left sides of an area. Within a rectangle, a diagonal enables a transaction between the two points most distant from each other and may pre-empt an option of bringing them towards the center to meet. These points will be discussed later in relation to mapping the sandtray.

Kandinsky (1977, 1979) drew parallels between form, movement, color, sound, fragrance and human emotion. His psychological reading of the elements of visual creativity produced a pure vocabulary of art, the building tools for breathing life into the blueprint of the artist's inner world. The art therapist tries to understand lines, shapes, forms, placement, size and the relationships between all these, and colors, which may augment structures with emotional definition.

Fully expressed artistic form contains a message in its configuration, while the content it portrays may have been intended to convey a different message. As an example, the circle is a form created by virtue of its having a center, from which the radius is equidistant from all points on the circumference. The radius of a circle will always be of a length that intersects the circle's circumference exactly six times. In numerology, the number six is the number of combining perfectly or completing all things. Six, when represented by two overlapping triangles, one pointing up and the other down, symbolizes the coming together of opposites (Wood 1981). The circumference separates inner and outer content. Ryce-Menuhin (1988, p.69) states: 'In the Jungian view, the circle is seen to represent a delimiting or magical area used to ward off danger from within or without.'

Children's drawings from age 18 months to 3 years old progress from unplanned scribbling to a closed circular form (mandala). This becomes a first attempt at human figure drawing when inner features and ray-like arms and legs are added. The circle is the first graphic realization of a sense of wholeness or self. Ryce-Menuhin writes: 'The self is believed to be represented by the centre, by the surrounding contents and by the circumference jointly. The mandala is thus the most powerful symbol of the self known to Jungian psychology' (1988, p.67).

The basic configuration of a circle and rays can become a human figure, a flower, a flying creature or a sun, which is usually drawn in an upper corner or

sometimes in the upper central area. The sun is a universal visual symbol drawn as a circle. Its supreme life-giving power is recognized in the art of all cultures. Children make sun-like representations when they draw a circle and extend many rays outward from the periphery. Visual variations in depictions of suns depend on how straight or wavy lines are used, along with choice of color, size and placement. The sun, as provider of warmth and light from above, may often stand as a symbol for a parental authority figure. 'Light' as a symbol is connected to enlightenment, knowledge, judgment and law. Individual suns may represent the child's experience of the parent–child relationship, as either stern, cold, remote, warm, giving, loving or engulfing.

Cooper (1978) states that in visual sun symbols light is indicated by straight rays, while wavy lines represent warmth. Thus forms, movements and colors can transpose into unconscious personal visual expression that conveys invisible experienced states, in addition to portraying obvious intended content.

Four messengers of the infinite

The sandtray is a physically finite and stationary uncovered low rectangular box of specific dimensions and clear boundaries. It consists of a supportive base and four protective horizontal sides. Accessibility comes from above, as this enclosure opens upward into undefined space. The multitude of minia-ture objects that will be used in sandplay are also physically finite with constant boundaries. Their accessibility derives from being chosen and located in the sandtray. Both sandtray and objects have stable boundaries and quantity limitations.

Sand, water, the color blue and the imagination of the sandplayer are the four limitless and boundaryless elements of sandplay. Each in its own way is a messenger of the infinite, that which has no boundaries of its own. The first three – sand, water and blue – in addition to symbolizing the concept of infiniteness, are also ancient in time and nature on Earth. Blue as part of the spectrum is as old as light itself in the world. Water is younger and sand younger still. Together, water, sand and light are among the oldest entities on our planet. Intrinsic to their nature, and in accordance with atmospheric conditions, each moves, flows or shifts and travels great distances. When we use these substances in the sandtray, we are literally touching and using primeval substances of our planet, which existed before and at the dawn of life. When we relate to sand, water and the color blue at the start of creating a

sandtray world, prior to introducing miniature objects, we are in a sense mirroring with these primeval materials the evolutionary process of the gradual creation of life and social systems on Earth.

The imagination of the sandplayer, the fourth boundaryless aspect of sandplay, is limitless, drawing on the immeasurable reservoirs of the personal and collective unconscious. Without a protective space this could be over-whelming. Within the sandtray, the unconscious can find a 'concrete representative' and lose 'its threatening aspect' (Weinrib 1983, p.47).

Form, dimension and illusion in art and sandplay

Any visual image requires a foundation material. This itself may become the form of the image. Foundation is defined as 'the basis or groundwork of anything; the natural or prepared ground or base on which some structure rests; the lowest division of a building, wall, or the like' (*New Webster's Encyclopedic Dictionary of the English Language* 1997). Sand flatly occupying the sandtray is in itself a shallow three-dimensional, given foundation of any sandworld. When untouched it remains neutral and natural, unattended and unnoticed as the earth we walk on. Untouched sand may represent the image of the archetypal good mother, who constantly supports, nurtures, and accepts unconditionally. The client's acceptance or avoidance of the sand base may indicate inability to be responsible for one's independent self, giving over the task of support to another. Untouched sand has also been linked to 'anxiety over the use of sandplay, possibly suggesting loss of boundaries and/or fear of engulfment' (Shaia 1991).

In art therapy, clients who wish to work with sandplay may relate to the base materials – sand, water and the color blue – before choosing miniatures. The entry to sandplay may be through tactile manipulation of sand and water. Any movement of the sand, small or large, distributes it unevenly within the stable container causing polarities of depth and height, or a differentiation of textures on the sand surface. The dialogue between sand and hands is sometimes a process of acquaintance, with no other intent. Getting acquainted with the sand through a range of movements actually causes the sandplayer's hands to come into contact with each individual grain. If one gave the sand a voice as an autonomous entity, it might confirm that by absorbing the movements and energies of the person who wished to dialogue with it through hand movement, textures and forms originate in an interactive dialogue. The familiar relationship between hands and sand

enables the movements already present in the mind and body to flow into form.

Form is defined as 'the outward visible shape of a body as distinguished from its substance or color; the intelligible structure of a thing which determines its substance or species, as distinguished from its matter' (*Funk and Wagnall's Standard Dictionary* 1961). This general definition could include natural or created form. Personal expressive form in art consists of the organization and relationship of basic elements through creative activity. The elements may be the words in a poem, the lines, shapes and colors in a painting or the voids and mass of a sculpture. They may produce a coherent image if a 'binding spirit' is present. If this is lacking they will remain an inexpressive group of disparate substances. The word 'dimension' is defined as 'a property of space; extension in a given direction; a measurement in length, width and thickness' (*New Webster's Encyclopedic Dictionary of the English Language* 1997). Simply put, two-dimensional markings are not independent in space. Markings on natural surfaces such as stone, sand, earth or trees must utilize a foundation but will not radically change it. Three-dimensional objects and materials stand alone in space like the human body and may be viewed from all sides.

Many methods of art-making utilize a two-dimensional base for drawing, painting or incising. A receptive surface such as paper or canvas is flat, but certain combinations of line, color, light and shadow on a flat surface can create a semblance of three-dimensionality, plasticity and depth. The discovery of perspective in the fifteenth century by Florentine architect and sculptor Fillipo Brunelleschi was based on a fixed central viewpoint. This, combined with a graded use of color from intense foreground color to faint distant color, achieved the illusion of depth in space on a painted surface. Chiaroscuro, the use of strongly contrasting light and shade, was perfected by Caravaggio and Rembrandt in the seventeenth century to achieve illusory three-dimensional form.

In the late nineteenth century Cézanne painted space in all its depth by using 'warm' or 'cool' colors. Warm colors seem to the eye to advance, while cool colors seem to recede. The school of painting known as *trompe-l'oeil* (the French term for 'deceives the eye') is based on painting so skillful that it appears to be real and not a painting. Illusory depth in Western painting was an ideal that began to change when mid-nineteenth century European artists were exposed to the flatness of Japanese woodblock prints. The flat surface of some abstract art in the early twentieth century emphasized the importance

of dimensions of emotional reality rather than visual illusory three-dimensionality (Chilvers 1996).

The word 'dimension' is used as a verbal metaphor to convey scope and importance. 'Lacking dimension' or 'flat' may be intended as a metaphor for superficiality. Today, meaningful form in art may be determined by a dimension of emotional cohesiveness of the total structure. Schaverien's 'embodied image' of art therapy (1992), infers that meaningful form is determined by an emotional transfer to the picture, irregardless of its two- or three-dimensional appearance. In the sandtray, deliberate marking or imprinting of the sand may be fully textured, expressive and meaningful, although it remains almost two-dimensional. Diagrammatic use of sand, such as drawing a boundary line between water and land, rather than constructing these differences, is two-dimensional but inexpressive. Placing figures in the sand lying down, as if standing up in a drawing, is also diagrammatic rather than embodied.

In the center of the continuum between illusory and real three-dimensionality is the relief. This art form is more than two-dimensional in itself and somewhat less independent than a three-dimensional structure, bridging painting and sculpture. It consists of a foundation or ground upon which forms project outwards in various stages of elevation, while retaining some physical connection with the ground as support. Drawing and perspective in a relief may increase the illusion of height and depth, placing the relief even more in the space between illusory and real form.

Constructing a sandworld is a creative option whose form resembles a relief or assemblage. However, the nature of sand, water and the color blue in the sandtray may often elicit basic hand movements similar to those used in beach play. Consequently, forms that emerge may resemble those done in sand at the beach. Sand is somewhat analogous to clay. As three-dimensional earth material mixed with water, its potential form is uncertain and changeable. But clay, once it finds its form, is left to solidify and dry into a stable structure. The soft texture of sand, its impermanence and the containing sandtray frame all convey a different purpose. A sandworld is an image not meant to remain in concrete permanent form. A sandworld's meaningful concrete and emotional reality is but a temporary external presence. The physical fate of a sandworld done in therapy is almost identical to that of sand structures left behind at the beach. It will be disintegrated into its flat natural form soon after it is made and its creator will not witness its destruction or 'return to nature'. In all other visual art forms, the pictorial or sculptural

image remains and can always be referred to. Although sandworlds are photographed, a photograph is a form of memory and not real. In any case photographs are not shown until the end of a process, which may take years. If the sandworld has been fashioned through spontaneous movement and unplanned choice and 'feels right', it is likely that it will take its place in the psyche after its external resolution and acknowledgment. It returns to the psyche rearranged, as a new configuration that internally consolidates after separating from the external sandworld.

In this natural medium, several grains of illusion are carried by the imagination beyond the concrete limits of the sandtray and miniatures. Worked sand as independent form or foundation for objects placed on it may take on a numinous quality. There may be a sense, or illusion, of an environment surrounding the sandtray, of greater width, height and depth than the actual structure enclosed in the tray. The sandworld frames and focuses on one area of this environment.

Some people using sandplay seem to experience their body as connecting to the lower sand area of the tray. The sense or illusion that the lower horizontal edge of the sandtray has dissolved incorporates the body into a total body–sandtray area. The merger of body and sandtray extends the total area and determines the sandworld's center as placed lower than the sandtray's center. Another illusory aspect made possible by imagination is that of immeasurable depth of sand and of blue symbolic water well below any logical limits the sandtray gives. In imagination there are many under-ground levels of earth or water. Mythological journeys into earth's underground levels connect the traveler with treasure, death, transformation and divine guidance. Miniatures also awaken illusory realms. As metaphors they may partially harmonize with the sandplayer's intentions for them. They have clear, fixed boundaries that separate them from the surrounding space. They seem manageable. Yet in amplification they will reveal unexplored strata and their juxtaposition and placement will form config-urations that point to other areas of import.

These examples of illusion differ from the deliberate illusion of form and depth created by perspective, light and shadow, or certain color combina-tions in a drawing, painting or relief. For clients who fear tactile work and penetration of three-dimensional substances such as clay and sand, the two-dimensional paper surface that will not be penetrated, but covered with illusory three-dimensional form, is a reassuring method of work.

In its search for concrete manifestation, imagination and its boundaryless partners in the sandtray – water, sand and blue – find themselves partners of illusion. Imagination is the power of the mind to form mental imagery, to conceive, and visualize without having to contend with reality. Illusion may be disappointing when one hopes that fantasies, dreams or mirages will remain in reality and they do not. But a sandworld might prove equally disappointing if it did remain in reality and were seen a week later. When distanced from the numinosity of spontaneous creativity and immediate observation, created objects often lose their magic and seem to shrink in size. This can jar the intact wholeness of the introjected image and damage its value. The therapeutic sandworld is left physically intact in the therapy room and remains intact in the psyche, although it will be shortly dismantled. Its construction has been observed, and its constellated form has been mirrored and witnessed. This closes its role and actually makes it as physically unserviceable as a mask whose power fades after its use in a tribal ceremony of rites of passage and is subsequently destroyed (Janson 1962). During their brief ceremonial life, masks are employed as protectors, filters or transit zones between inner and outer worlds. Likewise, the construction and physical presence of a sandplay allows internal, unwanted or dysfunctional states to exit from the psyche into the sand, which first absorbs everything and then loses its binding power, separating and dispersing. New forces of life enter and the sandplayer forms new configurations in a shared, special moment of time.

Space and form in the sandtray as metaphors

Sand forms are literally created from the sand/earth. They are not painted or sculpted in one material intending to portray something else. In contrast to unlimited nature, the limited quantity of sand within the sandtray frame makes its use likely to be selective and symbolic. Textured or impressed sand, or the use of the blue base as a point, line or shape surrounded by beige sand, create fairly flat forms. Notably unequal allocations of sand produce forms of height and depth, protrusions and depressions. A protrusion juts out and is noticeable.

The need to be noticed is a normal developmental trait. The growing ego of a child is strengthened and validated by being noticed, as mirrored in mother's warm glance and in her admiration. Loving approval is essential for continued positive growth. Being noticeable may be concretely translated in sand form as a protrusion, from a small mound to a large mountain. If

attention seeking is condemned as selfish, aggressive, arrogant, and immodest, it may cause shame and a need to remain unnoticed, hidden, secret, melting into the wall and not protruding 'like a sore thumb'. Non-protrusion as a psychological state may be transposed into flat sand, or the creation of small crevices and hiding places. Nevertheless the need to leave a mark of existence may manifest in very subtle textures on sand which may not be immediately discernible. A slightly textured surface may resemble 'prickly skin.' Small objects hidden in crevices may also express a need for caution and careful disclosure of surprising aspects. Sometimes the sand foundation will be hidden by an exaggerated use of objects that create a chaotic surface texture. The meaningful object is also hidden in the chaos, although it is visible.

Physical height and depth in the sandtray are achieved by gathering sand into high mounds and digging, or uncovering the blue bottom. Variations of height and depth in the sand may refer to a need for ascent to higher realms or descent and grounding. Height and depth may be translations of verbal metaphors. Achievement, social status, elation and spiritual joy are expressed in phrases of upward movement, such as 'the climb to the top', 'social climbing', 'getting high', 'flying high' and 'exaltation'. The mound or mountain may be used to dialogue with these emotional needs. From a mountaintop one views things in perspective, still standing on solid ground.

Earthly depth can be a metaphor for inner exploration and soul searching, discovering unconscious knowledge and allowing inner boundaries of understanding to expand. Depth in verbal metaphor speaks of treasure and guidance, sadness, despair and death. Some phrases using a downward motion are 'buried treasure', 'feeling low', 'stuck in a hole', 'deep down inside', 'buried feelings', 'jump off a cliff' and 'six feet under'.

The imaginary depth of water may be used in the sandtray as a symbol of access to deeper unconscious knowledge in the form of a well, pond, lake or ocean. The sandplayer may intuitively know what level of depth is meant when he/she forms water structures. Water can also express 'sinking feelings' and forms of unresolved loss. A 9-year-old girl whose father had died of a disease when she was 4 years old unconsciously expressed his disappearance in a series of sandplays depicting earthly or watery depth: a museum with ancient excavated artifacts and bones; a pharoah's tomb with a mummy and valued objects; and an underwater mermaid's abode filled with sunken treasure.

Space in the sandtray is boundaried by four corners. In verbal metaphors, corners are places of entrapment or preparation for a journey. Being 'stuck, or pushed into a corner', punished by 'standing in the corner', wanting to hide in a corner or to observe the outside world from a corner in preparation for a move towards the center are common metaphors. Corners in the sandtray may be used as solid limited space when related to these metaphors. The extending imaginary space beyond each of the sandtray's corners has meaning in accordance to its position, above or below, on the right or left side of the rectangular sandtray, from the sandplayer's viewpoint. The energies that enter and exit in each corner and use of the center are discussed next.

Maps of the sandtray

Sandplay therapists have noticed certain recurring uses of space in the sandtray. Ryce-Menuhin (1992) has compiled eight principal mappings illustrating how the 'three principal levels of the psyche (are) being projected into sandplays: the conscious level, the level of the personal unconscious, and the level of the collective (archetypal) unconscious' (p.91).

Ammann (1991, p.48) proposes a division of the sandtray into quadrants, as a way to understand the universal forces that determine placement in the sandtray. The tray is divided in theory into upper and lower areas and left and right sides. The upper level is considered as patriarchal, related to distance, air and spirit. The lower level is close to the body and is considered matriarchal, related to earth, instincts and the body. In a division between left and right sides, the left side is considered to hold unconscious attributes and represent the inner world. The right side contains conscious attributes and relates to the outer world, reality and life goals. Each corner can be an entry point for specific forces, or an exit.

Ammann describes the lower left quadrant as holding the instincts and new creative impulses arising from the 'ocean of the unconscious', which can also devour. A line or path that begins or ends in this quadrant might be in dialogue with the corner itself and whatever was imagined beyond the lower left sandtray frame. Placement of a single object facing right in the lower left corner might be experienced as a wish to progress towards a future goal, or as being alone. Ammann relates the lower right corner to the personal mother and primary others. Use of this corner might be connected to present concern with unresolved family issues, past or present, or one's place in the family.

The upper left corner may hold inner spiritual and religious aspects. Objects or paths linked to this corner may imply imaginative, magical or spiritual activity. Powerful spirits, both frightening and protective, may enter from this corner and exit there when their role is resolved. The upper right corner may pertain to relationships with the personal father, school and one's profession. A thrust towards this corner may be experienced as movement towards one's future in the world.

Ammann sees the sandtray's center as symbolizing the center of the personality or ego. The center spotlights immediate issues and is the place where all things meet. The center represents totality, wholeness, the origin of all existence, containing all possibilities. The center is the point of origin of departure and the point to which one returns (Cooper 1978, p.32). In the sandtray, the center may be specifically used by building forms or placing objects there. It may be the starting point of a spiral from center to one of the corners, or in reverse a spiral connecting a corner to the center. Diagonal lines from opposite corners cross each other in the center, marking it with an 'X'.

Bradway records the sequences of placement of objects by dividing her sandtray into seven equal measures on the length of the tray, and dividing the width into five equal spaces. This forms a grid, in which one edge may be labeled alphabetically with letters, and the other edge with numbers in sequence. This helps quickly to record while the client works. Bradway notes that 'mapping of the sandtray as an aid to understanding the meaning of objects placed in different locations in the tray' may be different for different therapists. She adds: 'If you are going to use such a system, I think it is preferable to develop your own method out of your own experience' (Bradway and McCoard 1997, p.26).

The author's experience with clients who are involved in the arts, is that they are intuitively aware of the use of space and materials in the sandtray. Other clients with no artistic background may choose art therapy in order to access their creative potential, or to contact the deep source of their limitations. These clients eventually come to rely on their senses and develop sensitivity to space, form and materials. Therefore, in the art therapy setting, it could be possible to assess potential meanings in sandworlds by observing the movement of sand, water and objects within the quadrants.

Individual and collective process and form

Self-created sand forms and choice and placement of objects are personal acts. Within variations of size, forms and complexity, sandworlds reflect not only personal aspiration, but a universal tendency of the psyche to heal itself and be whole. Sandworlds created by different people may show very similar use of space and form, and similarity of choice of objects. Similar form in the works of different people may occur at similar developmental stages of the psyche's journey. These similar forms connect the sandplayer with the deep core of existence and its reverberations, in the personal journey through processes of birth, life, fertility, consciousness, death and rebirth.

The individual sandplay process consists of a sequence of spontaneously created images. Each successive sandworld leads towards a subsequent stage in the individuation process. Kalff integrated her understanding of children's stages of development in sandplay with Jungian developmental theory, as formulated by eminent Jungian analyst Erich Neumann (1954; 1988). Kalff's insights were passed on to Jungian analysts who studied with her. Among them, Weinrib formulated a clear description of stages in the sandplay process. It is a useful reference for grasping and organizing the sequence of works in a total process (Weinrib 1983, p.98). The stages are:

1. An initial realistic scene hinting at problems and possible resolutions.

2. Descent into the personal unconscious (shadow), revealing problems and healing potentialities more clearly.

3. Partial resolution of a major complex.

4. Differentiation of the opposites, centering, constellation of the Self.

5. Emergence of the nascent ego and an ensuing struggle to differentiate masculine and feminine aspects of the personality.

6. Emergence of the anima/animus.

7. Relativization of the ego with respect to the transpersonal.

8. Emergence from the matriarchal toward the patriarchal level of consciousness.

The author has found that when an individual therapeutic process combines art therapy and sandplay, rather than verbal therapy and sandplay, the stages outlined by Weinrib are still applicable for analyzing the sandplay process.

Individual imagery and group imagery

In art therapy groups, creation of imagery is primarily an individual act. However, a singular phenomenon may be observed when the group's work is reviewed together at the close of the session. Similar form and imagery simultaneously appear in different people's work, manifested by similar choice, amount and placement of color and materials. This is often noticeable in those working in proximity to each other, although they may not be aware of other's work. One group of art therapy students in their third year of training became accustomed to the similarity of imagery during a session. Yet they were always surprised by the particular resemblance that emerged, despite lack of interaction between participants. For example, in one session based on finding an image in a personal scribble, dogs appeared in the work of six people sitting on the same side of the room. On the other side there were three or four works with birds. In a clay session, several people in a general area sculpted things with wings, while elsewhere several people used holes, and others snakelike elements. McNiff (1986, p.99) writes in an introduction to a dialogue with James Hillman:

> There is no single, correct interpretation of an artwork or dream, although there will be some that suit the image better than others. There is no single human ego responsible for the creation of the image. The images have a live force unto themselves, and do not belong to individual people.

Hillman says that images visit us because they love us. The image 'keeps visiting us, wanting to be a guest, there when we need it, entering into a conversation with us. We can lose our images by ignoring them' (McNiff 1986). The dogs and birds that appeared in one art therapy group session were visually diverse and seemed to reflect different needs. Different dogs and different birds have different meanings. But the general association with the dog species is 'fidelity; watchfulness; nobility'. Birds symbolize 'trans-cendence; the soul; a spirit; the ability to communicate with gods or to enter into a higher state of consciousness' (Cooper 1978). The multiple appear-ance of dogs may have mirrored this animal as a symbol of fidelity, in this group a collective attitude of cohesiveness and support. The birds may have been a symbol of the group task of communicating as therapists, working towards clarity of consciousness.

People work alone, unaware of structural similarities until the total group artwork is displayed. A wish to believe that one is unique may at first conflict with collective similarities. Gradually an understanding develops that within

a universal pattern of development towards individuation each person does remain an individual. Art therapy or sandplay therapy training groups are homogeneous in that participants are there to learn the process of art therapy and sandplay therapy. They become part of a group whole, a circle, a microcosmos.

Sandplay training in the art therapy setting is experiential and done in group. The presence of many sandtrays lined up around the room may somewhat simulate the atmosphere of beach play in which basic mounds, holes, paths, molded forms and drip-castles punctuate the shoreline on a sunny day. Beach building is observed and sometimes appreciated for aesthetic and structural achievement by sandplayers and passers-by, before being leveled by wind, water and people. In contrast, sandplay in the therapeutic context is witnessed by a single therapist whose presence and persistent observation may impact on the work and its deeper meaning. No one else will see the sandworld. The client also will never see or be influenced directly by another client's work.

In sandplay training groups, participants review the total group work after all have finished. As in the above-mentioned art therapy training group, the phenomenon of similar form in the spontaneous work of different people also occurs. In the author's experience, in a beginning sandplay training group, roughly half the total sandworlds may show mountains or projecting forms and the other half will show holes and work into the depth. During later sessions, there will be works with more unique sand structure that resemble each other. There may also be resemblance in choice, amount and placement of miniatures. For example, on the third day of a five-day intensive training group of special education teachers, two women in the same area of the room formed sandworlds that had flat surfaces and five deep holes that led to connecting underground passages. Their choice and placement of objects seemed similar, but their goals contrasted. One woman wanted to unify her family and the other wanted her children to feel more independent. There is usually a good deal of wonder expressed in group when these events occur. It would seem that these images and forms do not belong to anyone, but they do come to visit. As McNiff (1986) says, 'the images have a live force unto themselves, and do not belong to individual people'.

The examples given above are illustrations of phenomena that occur in experiential art therapy or sandplay therapy training groups, where similar imagery occurs simultaneously and can form subgroups. This may show that experiential creative work in group may lower individual consciousness and

enable unhampered meta-communication and strengthening of communal imagery, without detracting from personal process. Experiential art therapy training group work has proved an effective method of teaching a form of therapy that can only be learned by undergoing the process. Individual process can always be reviewed because artwork is a permanent record.

Many aspects of the group art process have been acknowledged but remain to be accurately recorded and researched. In contrast, conventional sandplay training consists of non-experiential group seminars, a personal sandplay process with an experienced sandplay therapist and supervision on work with individual sandplay clients. Experiential group sandplay training seems to be primarily in expressive-creative therapy groups. Comparing an individual's process in private therapy with that same individual's process in a sandplay group could shed light on individual and universal form and process. Meanwhile, sandplay group participants do experience an intensive personal sandplay process which is also part of the group process from which it derives part of its strength and support, and some of its final visual form.

Primary Modes of Play
with Sand and Water

Introduction

Modes of spontaneous or therapeutic play with sand and water can be arranged into three categories. In the first category the sand surface is used for creating protruding forms such as mounds, or drawing lines and making impressions. The second category comprises activities in which the sand surface is penetrated, such as digging holes and tunnels, burying and exhuming. A third category involves the inclusion of water for dripping or flooding. Sand construction may become increasingly complex according to one's developmental stage of growth, at the beach and in the sandtray. However, all the forms of sandplay may be used at any age. In therapy, the sandtray provides a theater for presentation of the inner drama of that moment. A single form, or a combination of forms, may become the final image, or an essential base upon which objects are placed.

The three modes of play with sand and water will be discussed in separate chapters. Each chapter is prefaced by a brief inquiry into the implications of the concept that characterizes it: 'surface', 'penetration' and 'fluidity'. Examples of sandworlds of children and adult clients in therapy will illustrate the particular forms and their connections to developmental stages and psychological needs. Inability to use sandplay comprises a fourth chapter, illustrated by three case examples of resistance to sandplay.

The Sand Surface

Molding, gathering, drawing, impressing

Surface

A surface is the outside face of something, a visible boundary between inner material and the outside world. Sand is geologically part of earth's surface crust. In the art therapy context, where materials represent both themselves and intangible emotional reality, sand may represent both the earth's surface and under-depth and the body's surface and interior. As an earth base, it supports objects placed on it and defines their relationship to space, environment and form. As representative of the human body's skin surface and interior, sand may awaken tactile memories of the skin as the first zone of communication between baby and mother. The tactile dialogue between mother's breast, hands and extended skin area and baby's body and mouth can be satisfying or a cause of anxiety. Anzieu (1989) states in a summary of an article by Biven (1982):

> Projection of the skin on to the object is a process commonly seen in infants. It is also found in painting, where the canvas (often thickened with paint or cross-hatched) provides a symbolic skin that functions as a barrier against depression. (Anzieu 1989, p.19)

Tactile manipulation of sand in the sandtray involves direct encounter between one's body skin and symbolic sand-skin-surface. Thus, the need to caress sand or to mark a surface, or the anxiety that may arise in intimately touching paint, clay or sand, may sometimes be a projection of the skin onto the creative material.

Anzieu (1989) states: 'Every living being, organ and cell has a skin or covering, husk, carapace, membrane, meninx, armour, pellicle, tunica, septum or pleura' (p.13). He continues: 'In its structure as well as in its functions, the skin is not a single organ, but a whole set of different organs' (p.14). The skin perceives touch, pressure, pain and temperature. It reacts to

different stimuli and cannot 'close like the eyes or the mouth, nor be stopped up like the ears and nose ... It breathes and perspires, secretes and expels, maintains the tonus, stimulates respiration, circulation, digestion, excretion, and of course, reproduction' (p.15). The skin's appearance often reveals our sickness or well-being. Anzieu sees the skin's primary function as 'the sac which contains and retains inside it the goodness and fullness accumulating there through feeding, care, the bathing in words'.

The skin's second function is as a protective boundary and barrier against harmful aggression, shielding the body, holding in the blood and body organs. Its third function is 'as a site and a primary means of communicating with others, of establishing signifying relations: it is, moreover, an 'inscribing surface' for the marks left by those others' (p.40). In daily language, a 'thick' or a 'thin' skin, metaphorically defines the shielding skin as emotionally impenetrable, or vulnerable. 'On the surface of things', or 'skin deep' is used as a metaphor for superficiality, not reaching the root or core of under-standing. To 'get under one's skin' is to penetrate the skin shield and affect one deeply. 'By the skin of one's teeth' is to just barely manage. A 'skin magazine' publishes explicit sexual photos. To be 'skinned alive' could be a metaphor for losing everything, one's protective skin shield appropriated by another.

Protruding surface form: Molds and mounds

Molding

A child's first independent play with sand at the beach often begins by taking undifferentiated sand from the surface and packing it into a mold or bucket. It is then turned upside down and the packed sand is carefully released, so it retains the mold's form and becomes a 'pie'. This process changes formless sand into an independent, identifiable object and returns it transformed to its source. The almost magical production of compact three-dimensional form from loose sand fascinates children and continual efforts may be made to perfect the technique. Rows of sandpies appear even at later ages, as part of a sand project. In the sandtray, children may fill containers with sand and leave them upright as rudimentary mounds needing a mold's external support, or overturn them to make 'pies'. The release of the molded form from the child's bucket into the world is a transition similar to a birth. The mother's body is the child's original world container before birth. 'That is why in all living creatures who come into being inside a mother, the dependency of the small

and infantile on the large containing vessel stands at the beginning of all existence' (Neumann 1988, p.17).

Gathering

Another protruding sand form is achieved by gathering sand with movements that push towards center, so that a mound accumulates. The small swelling mound resembles a breast, belly or womb, each a feminine container of warmth and nurturance, a part of the Earth Mother. A mound can also resemble a Tel, an accumulated mound of strata of ancient civilizations, a tomb, a dwelling of the dead, the entrance to the otherworld. A higher structure becomes a mountain. As symbol, it is a world center, an omphalos, reaching into the clouds and connecting earth and heaven. As the highest point of the earth it is regarded as central and represents constancy, eternity, firmness and stillness. Pilgrimages up sacred mountains symbolize renunciation of worldly desires and aspiration to attain the highest states in ascent from the limited, to the whole and unlimited (Cooper 1978, pp.109–110). As mound making becomes more accomplished, the mound's size and complexity grows and a hole, tunnel, a spiral track or sand and water drips may be incorporated as part of the main form. In the sandtray, a mound or mountain may stand attached to the surrounding sand/earth base. However, the sandtray's blue symbolic water can be exploited as a physically sturdy base on which all the sand is gathered into a central mountain, like an island rising out of the sea, as 'the conscious rises out of the unconscious' (Jung 1954, p.7). An earth-based mountain creates an axis between earth and air, body and spirit. A mountain rising from water presents earth, as the connecting axis between water and air, the body as intermediary between the collective unconscious and the refinement of ideals.

The flat marked surface: Drawing lines, leaving imprints

The sandtray's flat sand surface may serve as a base for drawing paths and lines on the sand, or incising deep lines through the sand, exposing the sandtray base as a blue line. Imprints of body parts or objects pressed into the sand also mark a surface with designs and textures.

Drawing

Lines are made by moving an object, or one's finger through the sand, creating boundaries demarcating territory, or the start of a purposeful path, an intended road, the way. Within the limited shape and size of the sandtray, straight, curved and spiral paths can be made. On a straight path, a traveler can see the place of the journey's origin behind and the direction of the intended goal beyond. A spiral path may be longer and connect one corner with the center. Its curves limit visibility and the path can only be seen directly in front or behind the traveler. On a spiral road, each segment of the unfolding path may be a destination, compared to the straighter road whose journey aims for a final destination.

Both straight and spiral paths have destinations whose meanings may be linked to the areas of the sandtray they connect. The spiral can be seen as moving from center outwards towards a corner, or from periphery towards center, on a flat or protruding surface. A spiral that ascends or descends a mountain connects earth and sky, reality and inspiration or spirituality. The spiral may symbolize the manifestation of energy in nature, the spinning and weaving of the web of life, the wanderings of the soul in manifestation and its ultimate return to the center (Cooper 1978, p.156). In beach play, a spiral path on a mound may become a runway built at a gentle angle of descent for a ball. The ball must spiral down slowly and not fly off the path before reaching ground level. In a sandplay, mountains may have a spiral path but the ball game is not frequent.

The archetype of 'the way' in visual form begins with a line that leaves one place and goes to another. A line can meander quietly or become jagged and tense. It becomes a road when a destination becomes defined. The archetype of 'the way' first appeared among prehistoric men in their ritual ascent to secret and almost inaccessible caves. These caves, containing wall paintings of the animals hunted for food and fur, had magical and sacral significance, 'but it is also evident that the 'hard and dangerous way' by which alone these caves could be reached formed a part of the ritual reality of (these) mountain temples' (Neumann 1983, p.8). Bolen (1989) says of the God Hermes, guardian of roads, trickster and father of alchemy: 'We invite Hermes to be with us whenever we are willing to venture into new territory with an attitude of exploration and openness' (p.171). Drawing a line in the sandtray may initiate the sandplay journey and begin communication between areas that have become separated.

Impressing

Imprints are unintentionally made at first by feet walking on a flat sand surface. The idea of impressing clear shapes of hands and feet or objects may later become a deliberate method of decoration of sand forms, or play with imprinting as a concrete sign of one's presence. Imprints are reverse molds of some concrete form. The air our bodies move through is not solid and we can leave no visible imprint on it, although we take up space. Sand for a moment can be imagined as concrete air, corroborating our form and existence. At the beach, a reverse mold or imprint of some or all of the body is made by covering it with sand and then exiting, leaving the negative form, like an empty womb in the sand. Hands smeared with paint and imprinted on paper, as early as age two, leave a handprint consciously signifying 'me, I am, I exist'. In the sandtray, various textures are imprinted on the sand by finger movements or with repetitive use of an object, such as the prongs of a rake or a comb. A textured surface may be loosely rough, or it may be done with clear patterns and direction. Straight horizontal or vertical lines created by the small impressions of a rake may resemble a plowed field.

In therapeutic sandplay with adults, the handprint may become a central theme in a sandworld done in an early stage of the individuation process. One or both hands may be imprinted. Handprints are sometimes spontaneously ornamented with marbles, semi-precious stones and quartzes, or with sky-power objects such as a sun, stars and a rainbow. A handprint embellished with these translucent, shiny celestial objects makes the work resemble a Hamsa, a common Middle Eastern talisman in the shape of a stylized hand, believed to ward off the 'evil eye'. The hand as symbol may represent divine power, protection and justice (Cooper 1978). Commercial Hamsas often contain additional good luck or fertility symbols such as an eye, fish or a written blessing. The author has noticed that a sand handprint embellished with marbles and shiny objects creating a Hamsa was present in an early sandworld of each of three women in art therapy who found themselves to be infertile, and in the course of therapy did become pregnant. It has also appeared in the work of other sandplayers in connection with the theme of validation of one's existence. It may then become a wish for magically powerful protection to alleviate the sense of helplessness, confusion and disturbing emotions which bring a client to therapy.

Illustrative case examples of molds and mounds

Maya: First mound and a sand-filled container

Maya, aged 3 years 8 months, was thrilled that she was tall enough to use the sandtray. She gathered all the sand into a mountain, patting it down, layer on layer, like a Tel. She laughed enthusiastically at the mound's large size and began to insert small colorful plastic pegs all over the top. She carefully replaced sand on any blue area, connecting the mound to an earth base, and then positioned objects all over the sand surface until the density of objects almost visually obscured the mountain. Maya had re-experienced the topography she constructed by placing numerous objects, which confirm the mound's form and existence (Figure 13.1).

In her second sandplay Maya filled and refilled a transparent plastic container with dry sand. She leveled the sand each time it became a pointy mound. The sand became important just because she could use it to fill forms. She tried to lift the filled container and expressed amazement at its heavy weight. This portable plastic-supported mound is like the beginning of the building of the world, with some external support still needed (Neumann 1988, p.10).

Subsequently Maya filled a small basket with tiny babies, milk bottles and a blanket and then placed this upon the filled container. She put tables holding food, small objects and furniture near the container and then added many small fish on the sand below. Aware that the blue sandtray bottom could represent water, she cleared a small space for a large dolphin in the left bottom quadrant (Figure 13.2). Two months later Maya used sand to bury objects that frightened her, such as dogs and snakes. After her fourth birthday she began to use fences and enclosures to contain but visibly separate animals, objects, or people.

Maya used sand at first as an earth base and a gathered mound. She then filled a mold creating a primary mountain, and imagined sand as water by placing fish on it. Finally sand was moved aside to reveal the blue symbolic water. In contrast to an almost arbitrary use of objects in her first sandplay the objects in the second sandplay have been consciously chosen and located.

Bowyer (1970) found that 2- to 4-year-old children using sandplay consistently poured and pushed sand or used it for burying, and that 'topics related to eating were common before 5 years of age' (Mitchell and Friedman 1994, p.67). Bowyer (1970) states: 'No control was shown by the 1–3-year-olds, i.e., their worlds were chaotic... From 3–4 years, however, little islands of coherent detail increased' (pp.26–27). Maya has

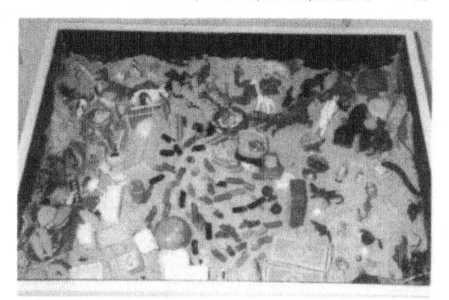

Figure 13.1 Maya: First mound

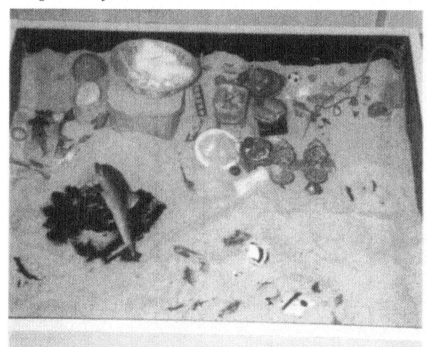

Figure 13.2 Maya: A sand-filled container

accomplished these developmental norms in her sandplays. She has also polarized the world in sequential stages: objects are buried or revealed; earth and water, upper and lower areas, high and low strata are clearly depicted; fences are used to delineate boundaries between inner and outer worlds (Stewart 1990).

Aya: Seven mounds

Aya was born in Europe at the end of World War II and had spent the first year and a half of her life on moving trains, as a refugee. She was now 50 years old and in her fourth year of art therapy, after having spent many years in Jungian analysis. She usually preferred to draw or paint, but did use sandplay several times a year. In one session she spontaneously formed seven mounds in the sandtray, and then imprinted each with a crude face (Figure 13.3). The mounds were arranged in three horizontal rows, with three low mounds on the lower and central levels and one solitary mound at top center. She covered with sand any blue showing through and scattered stones in the lower spaces between mounds. She inserted a single pine tree into one facial

Figure 13.3 Aya: Seven mounds

feature of each mound, except for the central mound that alone held three trees. The feeling was ghostly and powerful, as the trees seemed to grow out of an eye, nose, mouth or forehead. She felt the mounds to have an oracular quality, but considered oracles frightening because the answer given might be hard to bear. Still, it was important to her to know who she was and what she came from. She then saw the trees as something hopeful, like an answer of new life growing on the mounds of the Holocaust dead, a tragic tomb becoming a womb.

Illustrative case examples of drawing lines and impressing

Renata: The double spiral road

Renata's father was killed when she was eight years old. His shadow seemed always near, but intangible. As the 42-year-old mother of three children, her use of art and sandplay had helped her work through the shock of his disappearance. Her sandplays began to show a gradual resolve of her mourning. In the sandplay shown in Plate 1 a deeply incised double spiral touches the sandtray's bottom and creates a wide blue-boundaried road that circles a central area. The blue lines seem to emphasize the road and the separate center, rather than representing water. The circular uterine center contains and protects the objects in it. Bounding the center, the spiral road leads to encounters with three dark objects located on the upper level of the sand tray. A black grandfather's clock right of center, a chest of drawers in the upper left corner in the outer sand band and a black piano will be passed on the way to the upper right corner, the area of the personal father and social and professional relationships.

In the upper center, four red dwarfs guard a beckoning witch closed in by two pyramids behind her, and three glass lenses in front of her. She is distanced from a lone, empty red chair in the lower center, guarded on either side by two more dwarfs. Dwarfs, in myths, often work in forests or in underground mines and may symbolize unconscious natural forces working to excavate treasure into consciousness. The dwarfs chosen here are clothed in red, like Santa Claus's helpers. They and the elegant red chair form a group of positive red central forces that may balance the internal witch and help cope with the external black objects to be passed on the road to the upper right corner. The majority of objects in the center, or ego, of this spiral and the three dark external objects are all located in the upper level of the

sandworld, emphasizing the psyche's activity in the upper, spirit level (Ammann 1991).

Ray: Four roads, heart Hamsa

Ray's family immigrated to Israel when she was five years old. A year later she was given to a relative in a distant settlement, who had no children. For two years she felt abandoned and tortured, and nearly died. After she was returned to her family she feared nightly that God would take her for her 'sins', not knowing if she would wake up alive the next morning. When Ray began therapy she was a 45-year-old mother of three. In her second sandplay (Figure 3.4) she placed a small ochre pyramid in the upper left area on barely leveled sand. She created a semicircle of objects (small metal masks interspersed with semiprecious stones, trees and two mushrooms) from the upper left area to lower right. With her fingers she impressed tracks in the sand from the pyramid to each of the four corners, placing a black witch in the upper right corner. The small pyramid was now a point of departure for travel to all the corners of this world. This roadmap has just been conceived, the witch is distant and other destinations are undefined.

Ray's fourth sandplay was done six weeks later (Figure 13.5). She pressed both her hands strongly on the upper area of the sandtray, saying she wanted to transfer energy and burdens from herself into the earth. She then embellished each palm and fingerprint with a quartz or colored stone, placed like a ring. She drew a heart around these hands and placed opaque light blue and dark blue marbles in the heart line, adding one red and white striped marble at the bottom tip of the heart. She outlined the palm prints deeply, with a metal spoon handle.

The heart is the center of physical and spiritual being and represents the wisdom of feeling (Cooper 1978). The heart and the sand Hamsa combined are two powerful symbols of protection and guidance. They appear together early in therapy, as Ray begins to examine her fearful hallucinations and traumatic childhood.

In both Renata's and Ray's sandplays of roads, there appear small pyramids and witches. Pyramids, like mountains, are world centers and may represent the desire to ascend to spiritual consciousness. A pyramid may also symbolize fire and solar masculine force, which are elements in a process of transformation (Cooper 1978). Renata's sandworld was done after a time in therapy. Both witch and pyramids are contained within the center and the next stage seems to be the path back into the world.

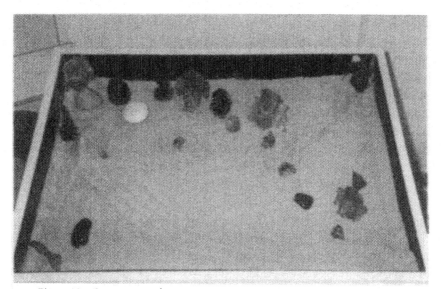

Figure 13.4 Ray: Four roads

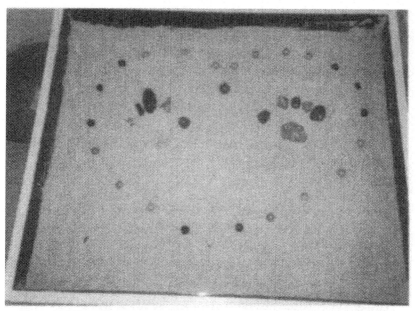

Figure 13.5 Ray: Heart Hamsa

Ray's sandplay was done at the start of her therapeutic process. She chose the pyramid as the source of all the paths to be traveled, with the witch still an external destination. In her second year of therapy she constructed four sandworlds featuring a central circular form, showing the blue base, representing water and the willingness to descend into the unconscious. Three subsequent sandplays showed the theme of birth, watched over by gods and goddesses. After two and a half years in therapy she spontaneously constructed her own mountain in the center of a sandworld. The following session Ray again chose the pyramid and this time placed it in the center of a

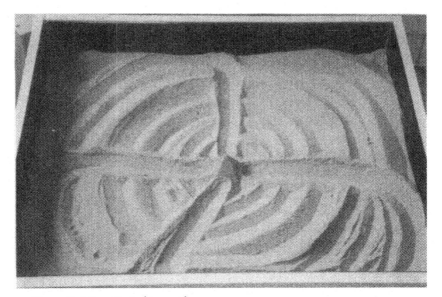

Figure 13.6 Ray: Central pyramid

series of concentric circles and four directional paths drawn in sand. The pyramid is now the source and destination of the four paths meeting at the center (Figure 13.6).

This sandplay is structured as a quaternity, and mandala, centered by a triangular pyramid. Edinger (1972) states:

> One of Jung's major discoveries is the psychological significance of the number four as it relates to the symbolism of psychic wholeness and the

four functions. The significance of the quaternity is basic to his whole theory of the psyche, both as regards its structure and its developmental goal, the individuation process. (Edinger 1972, p.179)

He continues:

> The archetype of the trinity or threefoldness and the archetype of quaternity or fourfoldness would refer to two different aspects of the psyche, each valid, appropriate and complete in its own realm. The quaternity image expresses the totality of the psyche in its structural, static or eternal sense, whereas the trinity image expresses the totality of psychological experience in its dynamic, developmental, temporal aspect … Quaternity, mandala images emerge in times of psychic turmoil and convey a sense of stability and rest. The image of the fourfold nature of the psyche provides stabilizing orientation. It gives one a glimpse of static eternity. (Edinger 1972, p.182)

In Ray's last pyramid sandworld she has arrived at her sense of stability, power and growth.

Gali: Hamsa and divine protection

Gali, aged 28, entered art therapy when her lack of self-confidence threatened her employment as a teacher. The eldest of three daughters, her fear of open conflict with her invasive mother had caused her anger to break out in the form of exema on her hands. After several months of being in therapy, the exema on her hands subsided. She had been married for several years and had no children. In her fifth sandplay she imprinted both hands together five times in dry sand and filled in three of the ten handprints with marbles. In her next session, she again imprinted both her hands five times in the moist sandtray. She now ornamented all ten imprints with a small smooth stone in the palm, and stones and glass in the fingertips of a few. Her hand imprints cover all available space as if to state her sovereignty over the territory and obstruct encroachment (Figure 13.7).

During the next three years, Gali used sandplay and art to resolve her repugnance of her mother's personality and body and her fear that she might resemble her. She now wanted a child, but had suffered miscarriages at early stages of pregnancy. Fertility treatments did not succeed. A year before she became pregnant naturally, she did an earth-based sandplay of her inner organs and inserted two tiny babies and a turquoise fertility goddess in the apertures (see Plate 2).

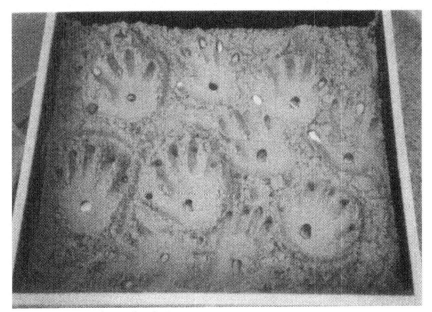

Figure 13.7 Gali: Ten handprints

Discussion

Sandplays that work the sand surface in flat or protruding form, with little or no indication of watery blue depth, are concerned with the Earth element, the Mother, nurturing and fertile, supportive and continually creative, and also absorbing in death. The earth is the concrete, tangible body that human beings live on, centered between two intangible entities, the heavens and the underworld (Neumann 1983). In the sandtray, the sand base is symbolic of earth as our environment, our grounding, and thus may be used to explore issues of security or anxiety in relation to movement, environment and space. The sand base is also symbolic of the body, its external skin, and the unseen inner content, both physical and psychological. Issues having to do with maternal support, security, growth, or health may be expressed by primarily using the sand surface, with little exploration of the depths of water or earth, or the height above us.

Penetrating the Sand Surface
Holes, Tunnels, Burying, Unburying

Penetration

Penetration is the act of piercing or passing beneath the exterior of something, entering its under-substance or interior. Penetration of the human body occurs in natural orifices designed to accommodate entry from outer to inner. Orifices biologically designated for physical penetration are the mouth, in its breathing and feeding functions, or the vagina into which a penis enters. Air and smell, light and visual phenomena and sound penetrate the nose, eyes and ears and are processed in the brain.

The experience of being penetrated by physical or sensory means may be pleasurable and positive, or unwanted and experienced as intrusive. Violent penetration, piercing, jabbing, or rupturing, may perforate a surface not meant to be entered by force, causing wounding, as if the skin could not shield its inner content. Natural receptive orifices located in the head are the ears, eyes, nostrils and mouth. These orifices evacuate or discharge matter when something is wrong: the ears may discharge pus, the nose mucus, in case of infection. The eyes shed tears when irritated or when one is overcome with emotion. The mouth can spit and vomit when disease is present. Excluding exhalation, discharge from upper orifices indicates stress. In the lower body, only the female vagina is biologically receptive. The normal function of the anus and urinary tract is to evacuate waste. Thus the protective skin shield is designed with a system of functional apertures that enable transition between outer and inner for biologically favorable reasons.

The secure skin boundary is formed when a baby gets to know his own skin boundaries, through warm and caressing body contact with mother, a communication through the skin that all will go well. The body boundary will not develop securely if touch is lacking, or if touch is invasive or aggressive (Anzieu 1989). Early physical and sexual abuse may cause

dissociation of the individual from his body, experienced as an unclean or unpleasant place to live in. In discussing abused eating disordered patients' sense of living in their bodies and in the world, Rogers (1995) states:

> There is growing evidence that the most serious long-term effects result from highly intrusive sexual abuse, such as oral, anal or vaginal penetration, abuse that is violent or sadistic in nature, continued over many years – and intrafamilial abuse, particularly when the perpetrator is a parent, step-parent or parent figure. (Rogers 1995, pp.265–266)

The betrayal of the body boundaries by unwanted penetration may be devastating to self-image and the ability to trust.

Penetration of the surface of the sandtray

The body's skin surface, the earth's surface and the surface of sand in the sandtray are all external coverings whose inner or under-substance is sensed to be present. A penetration of the sand surface may represent entry into the protective membrane of the earth or the human body. Some very artistically talented people who have fear of physical and psychological penetration will engage in art therapy, usually through painting and drawing. They will refuse to sculpt or use sandplay due to a sense of the skin as permeable and thin, or deteriorated, activating awareness of the body as vulnerable and defenseless. Three-dimensional work in clay or sand awakens the sense of threat to the defenseless inner body and self. Painting and drawing leaves the paper surface intact and supports illusional three-dimensionality, which for this client may be preferable.

Penetration of the sand surface can begin by jabbing with a tool into the sand, or by digging a hole with the hands or a tool. Consistent digging and displacement of the sand to another area produces orifices by penetration of the sand surface. Displaced sand is still part of the sandtray's total sand matter/energy, which may represent the self or psyche. Subsequent reintegration of displaced sand into the sandworld may be understood as a redistribution of energy for another use. There are four types of hollows created by digging or penetration of the sand: holes, tunnels, purposeful burying places and entry for the purpose of exhuming what is already hidden under the sand. These will be discussed and illustrated with examples of clients' sandworlds.

Holes

A hole is formed by digging with the hand or a tool into the sand's depth and removing the inner sand to some other area. At the beach, sand is boundless and holes can acquire depth and width large enough to sit in or bury parts of the body. When holes reach the level of water, it seeps in and slowly dissolves the sand structure at the point of contact. In the sandtray, the blue bottom used as water is technically protective and the sand structure will not collapse unless real water is added. The shallow sandtray and its small amount of sand quickly restricts the depth of a hole. Dug downwards, a hole soon reaches the sandtray's bottom and takes the form of a well, pond, pool or lake. Water may symbolize the deep unconscious. Within the rounded water forms, both frightening monsters and valuable insights may be present. A hole may also be a toilet or symbolic orifice, for draining something away into the symbolic underground blue water or sewer. A hole may extend in one direction until it becomes a stream. This resembles Kandinsky's point, that begins to move and turns into a line. The intent may be to use the blue bottom as water in its flowing state, moving on until it reaches its goal.

When sand is concentrated, digging in the sandtray on a horizontal plane will produce a cave. The cave may represent a warmly protective womb, a place of rebirth or a place of burial, a tomb. It is that which is hidden, a holy place where humans meet the divine or where oracles reside. The cave is the internal sheltering feminine principle, the womb of Mother Earth, as the mountain may be the external ascending masculine principle (Cooper 1978).

In the shallow sandtray, very few children or adults seem to dig out caves. A ready-made sculpted cave is available as an object. It may be placed simply sitting on the sand. Sometimes a surrounding sand mound is added to integrate it organically into the sandworld and gain a tactile sense of its meaning.

In reviewing photographs of sandplays done by children in art therapy with the author in the last 12 years, just one sandworld by an 8-year-old girl was found using a ready-made cave. No self-made caves were made by girls. A ready-made cave was used by five boys, aged 5 to 8, once or twice. Two of these boys each dug caves twice, as well. Four adult women used a ready-made cave and two of these also gathered sand so they could dig one themselves. The low incidence of self-made caves, compared to frequent hole digging at the beach, might be due to the shallow sandtray and limited sand which restrict concrete depth. Since a ready-made cave is not widely used

either in the sandtray, its use in therapy may be a significant event focusing on one of the highly specific meanings of this form.

In a high mound, a hole may be dug down vertically from the peak. It becomes a central deep shaft connecting the surface to the earth's hot depths, a conduit for a volcano's lava and fire. This hole can become a vent for explosive inner matter, or a channel through which inner emotions may be outwardly released. One 11-year-old girl dug a deep shaft as part of a volcano, described later in Chapter 15.

Tunnels

A tunnel is an underground passage connecting an external place of entry and an external place of exit. As a means of transition between two locations separated by space, it provides a similar function to a bridge above ground. Both symbolize communication, connecting and a process of crossing from one state to another. Tunnels begin and end in the light, but their passage is in the under-darkness of the earth, or under water. At the beach, or in the sandtray, sand tunnels are usually small and narrow because of the technical problems of collapse when working with sand and water. The danger of collapse comes from within the tunnel, because of the sand's heavy weight above, or because water seeps in and dissolves the base. At the beach, tunnels become a joint enterprise as diggers come from opposite directions towards a central point. Their hands meet under the sand when the last sand barrier between them is penetrated. In therapy, a client builds a tunnel alone. This requires the cooperation of both hands to strengthen the tunnel walls, support the upper structure and meet in the center coming separately from either side. The tunnel usually allows concrete passage for various objects from one end to the opposite exit. Passage through the wet dark tunnel/ canal of the sandtray may symbolize every human being's first rite of passage, through the birth canal. Passage may be experienced as a birth, or an emotional transition.

Descent from surface level into the sand

Descent into the sandtray's sand manifests concretely and in imagination which is endlessly deep. The sandplayer's hands penetrate the sand's depth to bury, conceal, save, protect or entomb, or to search for something which is already underground. The imaginative journey into earth's underground levels universally appears in myth. Examples are the Greek myths of Orpheus

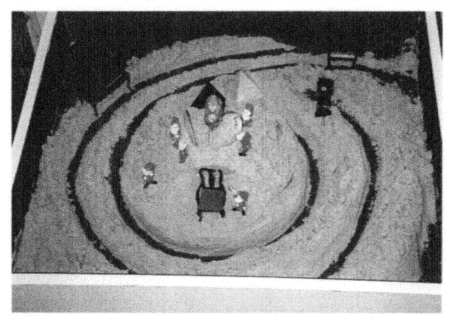

Plate 1 Renata: Double spiral road

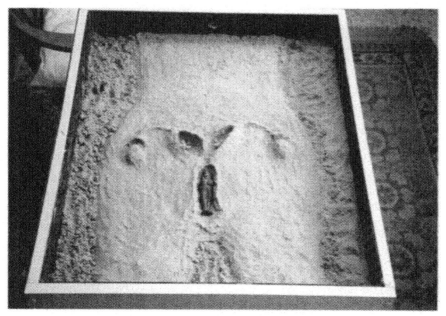

Plate 2 Gali: Sandwoman and goddess

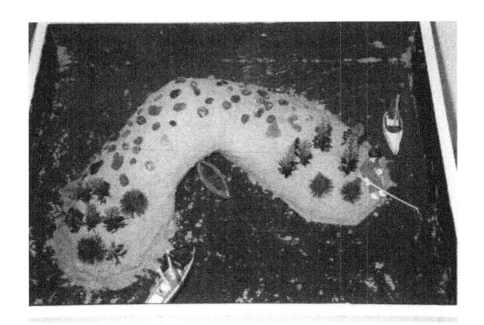

Plate 3 Nina: Tunnel

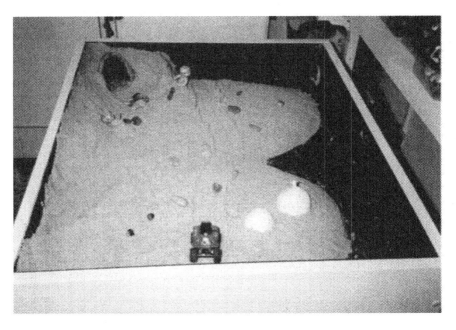

Plate 4 A1: Children collecting seashells near a cave

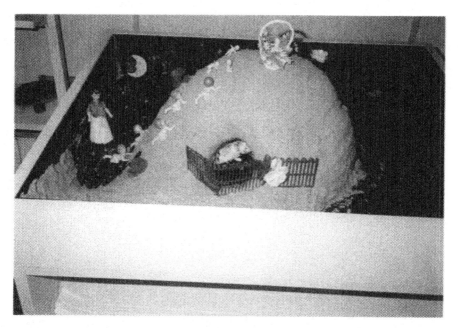

Plate 5 A3: Central mound and cave

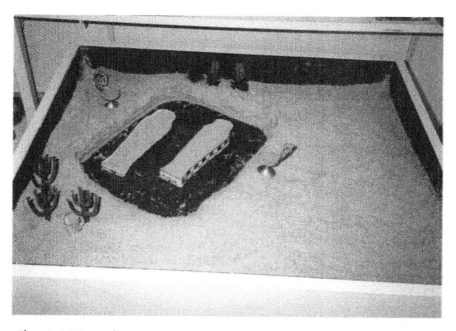

Plate 6 A4: Sarcophagus, Gingi

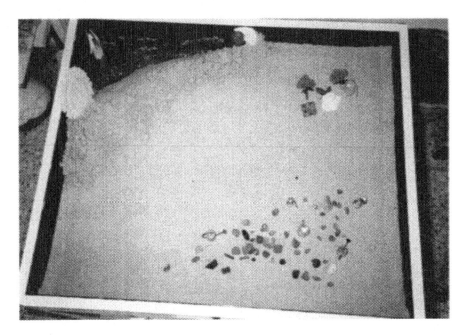

Plate 7 A12: Desert garden grave

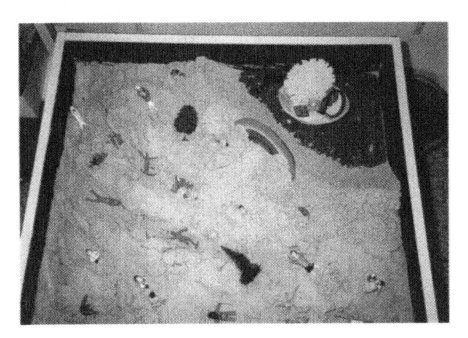

Plate 8 A24: Kibbutz walls, rainbow wall

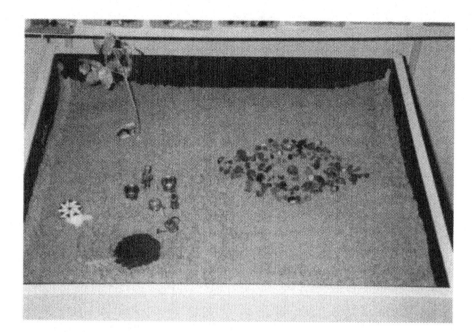

Plate 9 B5: Water returns to the desert

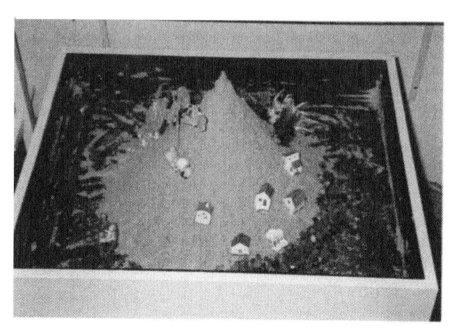

Plate 10 B7: sheep hill in a blue sea

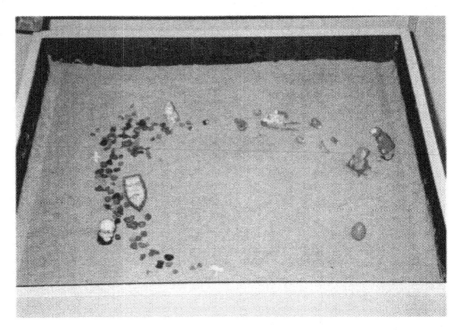

Plate 11 B11: Rounded path and blue egg

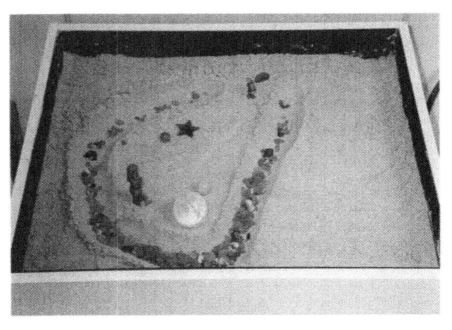

Plate 12 B13: God and goddess in womb

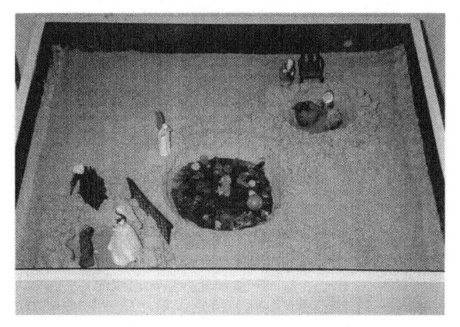

Plate 13 B16: Three pools – from cold to heat

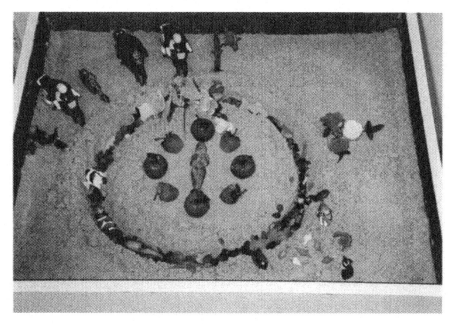

Plate 14 B20: Red pre-birth ceremony

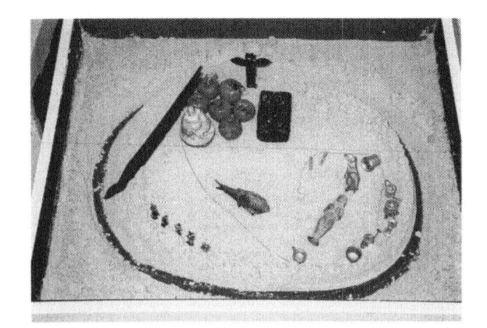

Plate 15 B21: Six weeks before second birth

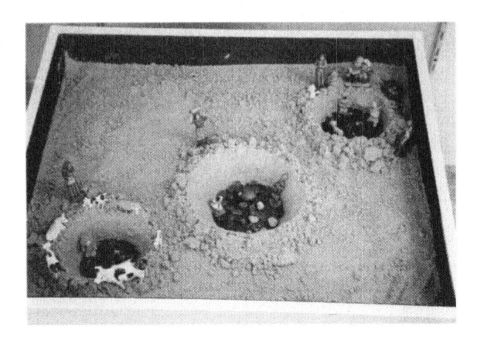

Plate 16 B26: Three phases

and Eurydice, Persephone and Hades (Bulfinch 1981), or the fairytale 'The Dancing Shoes' (Grimm and Grimm 1981). The downward path leads to caves, graves and hiding places, to crystal treasures of deeper levels and to the animal spirit guides we may seek in underground worlds according to shamanic tradition (Harner 1980, pp.25–39).

Entombment reflects the capacity of the earth to swallow and absorb back in death what it has given. Frightening or repulsive associations with rot, decay and timelessness may be felt. Sand as a tomb can cause feelings of being imprisoned, choked, dead and buried, but there may also be a sense of restfulness and eternal peace at the end of struggle. Conversely, sand protects, holds warmth, is intimate and restful, a womb for new life. Concealing unwanted embarrassing qualities by burying them is another reason sym-bolically to hide something under the sand. Secrets of value can also be concealed, protected and saved until one returns to claim them.

Ascent from within the sand to surface level

Burying and exhuming objects or the body is a final use of the sand's actual depth. From the underground, something ascends to surface level and becomes visible. Uncovering may expose something unpleasant that was purposely obscured and needs to be coped with and understood. Uncovering may reveal treasure, or something meaningful and ripe after a sojourn of underground growth, bringing new insight to light in a pleasurable way. We may remember what was forgotten, or release something from the darkness born anew. In nature, bears emerge after their winter hibernation, snakes warm to the spring sun and flowers thrust upwards from a bulb, after a long underground process of preparation in the dark.

Children in therapy often enjoy burying a small object in the sandtray. The child may try to find it, or ask the therapist to do this. The underground search in the uncharted sand depth may express for the child a belief that something valuable in his dark inner world can be unearthed in therapy with the therapist's help. Or it may be that things which have been left in the dark can now be revealed and accepted in the light without fear or revulsion. It may also symbolize the child's search for a lost valuable, such as parental love or self-love, and its retrieval. The sand may in some way be experienced as the mother's body and the object placed within it as being in the womb. Some children want to leave something buried in the sand until the next session, or for someone else to find. Whatever the reason, this becomes a mysterious

communication with unseen others who also visit the therapy room, and perhaps shows a hint of curiosity about what others do there.

Illustrative case examples of holes, tunnels, burial and ascent

Wanda: The cave in the mound

Wanda was 30 years old, married and in mourning for a recently deceased sibling. Her first sandplay featured a ready-made cave reinforced by sand behind it, in the lower left corner. She felt the cave as protective for the nearby children in the scene gathering shells, so they would not be too exposed. The moon in the upper left corner creates a nocturnal, introspective atmosphere, perhaps in expectation of the quiet intimacy of therapy, with a maternal cave for protection. The sand is divided symmetrically in the upper area into two breast shapes. A red vehicle has cut across the sand from left to right leaving a track that divides the upper from lower half. Sand and objects tell a story on the surface of this work, but the cave is the entrance to the underground, and here at the very start of therapy its depth and content is unknown. The cave, as a symbol for the therapeutic temenos, did prove to be protective. As a symbol of the womb that gives forth new life, this cave became a place of struggle for fertility and motherhood. Wanda's sandplay process is presented in Part 6 (see Figure 17.1).

Nina: A blue line and a tunnel

Nina, aged 46, an intelligent mother of three, had been in art therapy for ten months. Her parents' families had perished during the Holocaust or from fatal illnesses. She was often torn between her mother's manipulative demands and her guilt that she was not a caring daughter. In her eighth sandplay (Figure 14.1) her hands penetrated through the sand to create a serpentine blue line that undulates through the sand, dividing the territory fairly equally in a yin-yang relationship. The blue line enters and exits this sandworld through the upper right and lower right corners, swinging over into the left side and then returning strongly to the right, in whichever direction is chosen. This snakelike journey seems to emanate from depths beneath the surface in an awakening of flowing movement. Jung (1956) wrote:

> The snake symbolizes the numen of the transformative act as well as the transformative substance itself, as is particularly clear in alchemy. As the chthonic dweller in the cave she lives in the womb of mother earth like

the Kundalini serpent who lies coiled in the abdominal cavity at the base of the spine. (Jung 1956, p.436)

This dormant serpent may be awakened through concentrated inner focusing, which causes it to 'ascend through the chakras, bringing increasing powers into play, until it reaches the highest point in total awareness and realization' (Cooper 1978, p.92).

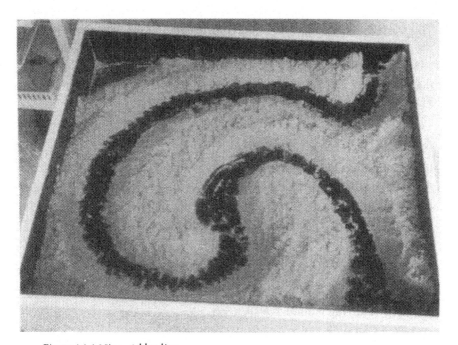

Figure 14.1 Nina: A blue line

Edinger (1972) wrote of the snake in connection with the expulsion of Adam and Eve from the Garden of Eden: 'Psychologically the serpent is the principle of gnosis, knowledge or emerging consciousness. The serpent's temptation represents the urge to self-realization in man and symbolizes the principle of individuation' (p.18).

The boundary line between the sand walls and Nina's blue serpent is uneven, not smooth or sharp, interlocking sand and blue on a surface level, while from below the psyche seems to call for an awakening of the personality, a call for transformation in an endless round of perpetual movement.

Two years later, while driving on the freeway to our session, Nina noticed a new tunnel beneath her. She wondered what supported the road she was on and why it did not collapse into the tunnel below. In the sandtray she built her image as a mound of all the sand in the tray, leaving a large clean blue surrounding area. She dug a low cavern through the mound's center, which became a tunnel supported by embankments. It was not high enough for a small canoe to pass through. Both her hands met under the tunnel, to pack the sand, reinforce the inner structure and simultaneously enlarge the tunnel. The mound did not fall as she had anticipated and the canoe was moved through the tunnel. She felt exaltation, an experience of giving birth. She added trees, stones, boats and a single fisherman, which numinously added to the emotional experience of the basic theme of birth and transformation (see Plate 3).

Burial and return to life

In the sandtray, sand lends itself naturally to depiction of death and burial. Although frightening, one can mourn a deceased loved one by constructing a grave and a personally choreographed funeral. Funeral services in society may abide by standard religious procedure and do not always allow for a personal mourning rite. Some resolution of the death of a close but conflictual person may also be achieved by dramatic enactment in the sandtray. One can even imagine and build one's own funeral or the funeral of someone living whom 'you wished were dead' and begin to understand emotions centering around a death wish.

Ella, a charming and vivacious woman aged 45, wanted to work in the field of therapy but was never able to finish any focused academic program. She spent much of her time involved in the problems of members of her immediate and extended family, but felt unappreciated and useless. She said she wanted to die because she couldn't pull herself out of the hole she was in. In the sandtray she dug a hole and placed a white angel, representing herself, in it. On the right side of the 'grave' she placed figures representing her mother, siblings and their spouses. On the left side were figures and objects representing her children, grandchildren and husband. She covered the angel with sand a few times, alternately pouring water on it. She added trees, flower wreaths and a white 'Magen David', until she was satisfied that this really looked like a grave.

Now that everyone was positioned for the funeral, she said with surprise: 'How few people there are, and those who came are not really suffering. My

children are angry, and my mother will get lots of support now that her daughter is dead. Only my younger brother cries. My husband, after a month, will continue with his life. I won, but what did I win?'

In the next session she dug another grave in the center of the sandtray and placed the white angel in it surrounded by a circle of trees. 'I feel like Snow White after she threw up the apple,' she said. Near a well on the left outside of the circle, the well symbolizing access to the depths of the unconscious, she placed a white figure of Kwan Yin, Chinese goddess of compassion. She said that Kwan Yin would give the angel water, as no prince could help heal her. Ella then said she felt stronger and could heal herself. Slowly, she rearranged the scene, removing the angel from the grave and placing her with Kwan Yin. She put a house, furniture and a table with bountiful food in the lower left area of the sandtray and moved the trees from the grave to the house area. She closed the grave and created a flat porch area, adding a baby crib and bench. She said: 'I thought of Snow White, who was for so long in the forest. She died. I'll save my life and enjoy what I have, a home, children and grandchildren, a place for all the family. I am like her – Kwan Yin – strong as marble, but not an angel, that's not realistic. That grave will always be waiting, but not now; until it comes, there is a lot to do.'

Discussion

At the beach, penetration of the sand surface by digging is a common activity. In the shallow sandtray, digging vertically or horizontally into the sand to produce a hole depends on the concentration of sand in the area that is penetrated. Holes that quickly reach the sandtray's blue-bottomed symbolic water become pools. These are often dug out by children and adults, but caves, tunnels and shafts are relatively rare. An alternate sandtray with a depth of 17 to 20 cm would hold more sand and perhaps enable an experience of depth and penetration of the sand body. Digging holes, caves and tunnels, or reaching the inner darkness of the sand itself, might be more frequently seen as a means of self-expression. It is true that in a deeper sandtray parts of the sandworld may be obscured from immediate view and will be difficult or impossible to photograph. In the conventional shallow sandtray, almost everything is visually accessible and will also be seen in a photograph. The lack of physical depth leads the sandplayer into imaginary sand, which is as deep as that which seeks our attention. It would seem that the factors involved in choosing a deep or shallow sandtray are tied to the

client's immediate need for a more concrete experience or a less concrete, larger imaginative experience in the therapy room, in the therapist's presence.

The art therapy experience offers two-dimensional work in painting, drawing and collage, or three-dimensional tactile work in clay, plasticine or assemblage. The client is presented with a choice of working on a paper's flat, unruptured surface, that may be used to create illusional three-dimensionality, or using a concretely three-dimensional penetrable material. Current sandplay equipment does not give a choice of concrete depth and perhaps this is unnecessary in sandplay frameworks connected to conventional therapy. However, the art therapy environment presents a range of materials to be chosen for constructing representations of inner states. It might be consistent in this environment to have an option of depth in the sandtray. The cycle of entering the sand underground and emerging reflects a cycle between the psyche's polarities: darkness and light, invisible and visible, hidden and found, protected or exposed, trapped or free, death and rebirth.

The Use of Water

Dripping and Flooding

Fluidity, flow and movement

A 'fluid' is defined as 'a substance, a liquid or gas, that is capable of flowing and that changes its shape at a steady rate when acted on by a force' (*New Webster's Encyclopedic Dictionary of the English Language* 1997). Fluidity then, is a flowing state of some substance, whose shape can easily change and is not stable or rigid. Flow denotes a continuous unbroken process of forward movement, that proceeds continuously and easily. Examples are a flow of air, of water in a stream, of dry sand through the hands, or a flowing movement of the body. An example of fundamental flow is given by physicist Fritjof Capra (1979): 'Physicists and mystics alike have come to understand reality in terms of flow and movement, change and transformation. They have come to see that the universe is engaged in endless motion and activity; in a continual cosmic dance of energy.' He continues:

> All the material objects in our environment are made of atoms which link up with each other in various ways to form an enormous variety of molecular structures, and these structures are not rigid and motionless, but vibrate according to their temperature and in harmony with the thermal vibrations of their environment... According to quantum theory, nature is never in a static equilibrium but always in a state of dynamic balance. (Capra 1979, pp.61–62)

Body movement is an integral part of human development, an evolving, intricate adaptation to one's age, status and cultural role. The making of art requires a certain amount of body movement, in dialogue with materials such as clay or paint. In some schools of art, action and movement become the subject of the final image. Action painting, a term coined by art critic Harold Rosenberg, defines the canvas as an event and the act of painting as more significant than the finished picture (Chilvers 1996). A picture is an immobile object whose creation proceeds through a series of movements

made by the artmaker, that are graphically recorded by means of lines, shapes and colors. The drip paintings of Jackson Pollock done between 1947 and 1951 exemplify close communication between artist and picture. Sometimes the movement involved in painting a picture does not overtly show, but its forms and colors seem to flow with movement. Henri Matisse's paintings of women and dancers often have this quality (Chilvers 1996).

The profession of dance and movement therapy is founded on the premise that body movement can be a cathartic and therapeutic tool. 'Body movement reflects inner emotional states and…changes in movement behavior can lead to changes in the psyche, thus promoting health and growth' (Levy 1988, p.1). According to Laban and Lamb's system of movement analysis known as effort/shape, human movement may be analyzed in terms of effort and the shape of the body adaptation in space. The four motion factors of effort in movement dynamics are space, weight, time and flow. One can use space directly or indirectly; use weight strongly or lightly; use time quickly or slowly; and use flow in a restrained fashion, or freely (Levy 1988, p.134). A body in movement, from the graphic point of view, is a body drawing its movement on air. In comparison, art-making may utilize a compact version of external body movement, using space, weight, time and flow to register inner emotional movement by sketching a visual image in a medium other than the body.

Art therapy provides conditions for the process of concretely recording whatever internal imagery and body movement needs to be expressed in an external graphic image. Small controlled movements come from the wrist. Movement coming from the shoulder or from the standing body may be larger, freer and comprise many directions of movement. Wherever they emanate from, body movements can be short or long, rigid or fluid. Fluid flowing movement requires an intuitive confidence that an internal state of dynamic balance is not a loss of control but a rearrangement of energies. Essentially, flowing body movement is possible when inner movement and outer movement coincide. Symmetry, or a static equilibrium, is the moment when movement and flow freeze. Whitehouse, a Jungian movement therapist, stated:

> The core of the movement experience is the sensation of moving and being moved…it is a moment of total awareness, the coming together of what I am doing and what is happening to me. It cannot be anticipated, explained, specifically worked for, nor repeated exactly. (Whitehouse quoted in Levy 1988, p.67)

In art, hands and the markmaking tools they hold are the parts that move and are moved by an inner state of need. Capra (1979) places subatomic movement and flow, change and transformation at the heart of the universe. Part of the dance of a structure may be at that inner atomic level, although the external appearance of the structure shows slow or limited movement. Taken as an analogy to outer and inner human movement, there may be a difference between one's sometimes static outer appearance and the multitude of inner emotional movements simultaneously present. When the body does not move, the visual image may show the actual inner state of movement.

The forms of water

In the Tao, water is seen as the 'fluidity of life, as opposed to the rigidity of death' (Cooper 1978). Flowing movement is an essential quality of water in addition to depth, flooding, supporting, reflection or cleansing. In the concentrated art therapy-sandplay session, the presence of water in paints and in the moist sandtray may access the notion of everything linked to it, including the outward flow of body fluids such as tears, urine, saliva, sweat and blood, to express emotion. The blue shape portraying water in the sandtray may express the aspect of water one needs to be in touch with. A round pool may communicate the depth of water, a meandering stream may signify emotional flow, one's flow in the stream of life, or a place of crossing. The waters that come from above as rain may express divine blessing, fecundity and 'penetration, both as fertility and spiritual revelation... The sky gods fertilize the earth by rain'. The lower waters, the deep mineral-rich salt ocean, represent the feminine principle, the source of all life, a formless, chaotic endlessly moving sea of potential (Cooper 1978). In the sandtray, an ocean can be formed by moving all the sand to one side, left, right, upper or lower, and leaving an uncovered blue area as if extending out and beyond the sandtray's boundaries. Water as ocean appears in many sandplay processes of children and adults.

Dripping and flooding

In sandplay at the beach or in the therapy room, the use of real water as a material is concrete. The sandtray's small size allows limited actual use of water, with a symbolic aspect, which in nature could take place on a grander scale. In beach play, water poured into a hole softens the sand so the digging can deepen. Water's role then expands for controlled dripping, for streaming water through channels, or for flooding. The controlled use of water and

sand, at the beach or in the sandtray, is employed to construct sandcastles by releasing watery drops of sand from above to form delicate lacy drips. They fall one on top of the other in delicate balance. The challenge is to form as high a structure as possible without collapse. The dripped sandcastle requires patience and delicacy, careful intent and a steady hand. Often drips are used after a sturdy mound has been constructed, the lacy fantasy spire reaching towards heavenly ideals at the summit.

In the sandtray, addition of real water must be measured. A need may arise to see a real body of water not absorbed by the sand. Symbolic water and the limited presence of real water in the moist sandtray do not always satisfy this need. A small transparent container filled with real water and placed in the sandtray may prevent damage and sometimes suffice. Adults in individual therapy or in training groups may devise contraptions of clear plastic sheets and other waterproof containers to hold the water in the special shapes they give it. At times, uncontainable destructiveness is activated by the sight of real rather than symbolic water, and manifests in flooding. In the beach environment this does no harm and needs no caution. In the sandtray, flooding is the uncontrolled use of real water beyond the quantity that sand and the container can absorb. Flooding disintegrates form and boundaries, destroying differentiated structures, leaving a chaotic fluid environment. The story of Noah's ark is about flooding as the end of a cycle and the beginning of a new era, causing death but hopefully leading to regeneration (Cooper 1978, p.70).

The flow of sand and water

Sand in its dry form flows in response to wind, water or human action. Thus, the notion of flow is present in the sandtray as a natural aspect of both sand and water. Paradoxically, sand and water cannot really flow in the confines of the sandtray. Dry sand flows through the fingers but no flowing water is present. The flowing potential of sand or water is eliminated when they are combined, as their mixture forms a sturdy building material.

Therefore, the flow of one's emotions, the feeling of life flowing in the body, may be expressed somewhat by the movement of dry sand and much more so by seeing or feeling the movement of water. The two possibilities available in the sandtray are controlled dripping of sand from above, using water for its penetrating and fertilizing qualities, or channeling larger amounts of water into the sandtray, to the point that the sandtray and sand are able to contain.

Illustrative case examples of the use of water

Shira: Mountain, hole and sand-water drips

Shira had begun art therapy at age eight and a half, four years after her father's death. Her therapy had lasted two years and we now had ten more sessions until termination. During the course of therapy she found it hard to speak of her father, yet had used sandplay to express her sorrow in an unconscious mourning process. Her social abilities greatly improved and she was academically and creatively at the top of her class. Shira was silent with emotion, unable to verbalize her feelings about termination. She threw a box of marbles into the sand and then sifted the marbles out and replaced them in the box. She then gathered all the sand into a central heap, cutting a deep hole down into the center. She poured most of the marbles into this volcano-like aperture and inlaid five paths of marbles down the mountain-sides, placing on top a black hourglass. On top of the hourglass she dripped sand-drips, patiently taking time to form a small peak, perhaps a culmination point of our journey together. 'I have too many thoughts, each marble is a thought. It all went by so fast. It is sad leaving here,' she said (Figure 5.1).

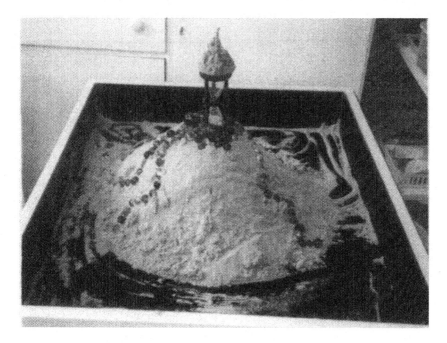

Figure 5.1 Shira: Mountain, hole and sand-water drips

During the session before final closure, she reviewed her sandplay works and paintings and chose three photographs to take home: a sandplay done one year previously of an erupting volcano, the sandplay mountain of her thoughts spilling out, and a photo of a large painting of a mandala containing an eye, surrounded by handprints (perhaps a Hamsa). 'Thoughts are more dangerous than lava,' she said. 'You can flee from lava, but not from your thoughts.' I suggested that her thoughts could now spill out in some order, rather than bursting out as a destructive volcano. The black hourglass, perhaps symbolizing real time, and the lacy crown of delicate victory balanced so carefully on the mountaintop, would have been instantly destroyed if she were still like an explosive volcano. The mountain is an independent structure supporting its own contents, surrounded on all sides by blue 'water', an island of consciousness rising from the sea of the unconscious. Therapy had helped her gather strength to live the healthy parts of her life. Ending therapy enabled work on the pain of our separation, and correspondingly the pain of the unresolved separation from father at so young an age.

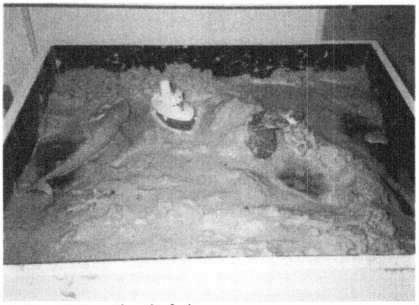

Figure 15.2 Barry: The need to flood

Barry: The need to flood

Barry was 6 years old, hyperactive, taking Ritalin. His first sandplay (Figure 15.2) shows a flooded environment, not completely submerged as the therapist had limited the amount of water he could pour into the sandtray. When he left the session he opened the water hose outside and flooded the garden. His need to flood was as strong as his need to burn things, which he tried to do in later sessions. After four watery sandplays he arrived at drier, more controlled imagery of death, using plastic and real bones and skeletons in the drier sandtray. His need to flood may have been the need to view the unorganized chaos he often felt. It may have been an unconscious attempt to return to the primordial ocean, destroying all form and boundaries of his present state of life, and then begin again.

Discussion

The need for seeing and feeling real water in the sandtray may be connected to water's qualities of depth, cleansing, reflection and flow. Flowing emotion and flowing body movement is a state of release. It may also be a state of integration of inner emotional movement and perceptible outer movement. Of all materials, water represents flow very well. With control it drips together with sand from above. When emotional flooding is present, a stronger use of water may be sought after, possibly endangering the sandtray's boundaries. Dripping sand and water is frequent in beach play but not in individual sandplay therapy. It does seem to occur more often in adult sandplay training groups. Flooding as part of beach activity cannot actually be an isolated act, as flooding is an inevitable attribute of ocean tide movement and breaking waves. Excess use of water or cleaning rituals using large amounts of water in the sandtray may be needed by children.

In the author's experience, some use of real water occurs in a majority of sandplay processes. A sandplay therapist might consider a waterproof sandtray in the therapy room that can hold water without danger. One could use a smaller tray that might be flooded, within a larger tray which contained the flooding with no danger to the therapy environment. This would serve as a metaphor for the therapist being able to contain the client's overflowing emotion.

Tactile Communication
and Untouched Sand

Adequate tactile communication through the skin, between mother and child, provides warmth, organic stimulation and a diffuse sense of well-being. 'An inadequate response from the immediate environment leads to disturbances in the differentiation of the Me and the not-Me; an excessive response lays the ground for a defensive hyperdevelopment of the intellectual and imaginative capacities' (Anzieu 1989, p.26). Touch precedes other forms of interpersonal communication, such as scent, sound, vision and language. Ongoing interaction with the environment through touch is influenced by early experience and remains throughout life a sensitive area of physical and emotional communication. The sand surface could stand for body skin or function as a representation of earth, environment and space. One's early experience of tactile communication and the right to territory might be projected in some way on one's current approach to sand.

Sandplay and the use of sand may be reparative to a damaged sense of tactile communication or to the right to space of one's own, but that opportunity is not always taken. Sand may be equated to unpredictable, destructive nature, on the environmental or personal level, and will be resisted. The confining walls of the sandtray are for some more secure than the sand surface. The sand might remain untouched, with objects placed near the walls, as if imminent danger were present in the sand, or in its control by unknown forces. Working the sand is an encounter between the skin of the hands and the sand itself. For some, retreat or brief hesitant touch is overcome by using tools for surface marking, which may be more comfortable than direct hand contact. The marked surface may seem more submissive, perhaps like a ploughed field, the subordination of chaotic nature to culture. Markmaking with tools, and perhaps with hands later on, may be a

way of giving form to the unorganized chaos of nature, a claim of ownership of a piece of earth. The sand/earth is infinite but the road is one's own.

Styles of direct hand communication with sand encompass a range of movements. Some take possession of the sand by smoothing, texturing, aerating, perforating, packing down and pounding, or slashing and throwing. Packed down sand forms an 'impenetrable' surface, defending some inner content. Receptive aerated sand might invite touch and penetration. Three-dimensional, free-standing sand form may imply a secure sense of the body skin as protective, the right to own space and territory, or a secure relationship with the therapist. Simple and spontaneous as these styles of touching sand may seem, the very thought of touching and moving sand may invoke deep resistance which must be respected, and may not be overcome or understood during the therapeutic process.

Illustrative case examples of untouched sand

The refusal to touch sand is presented through three examples illustrating issues of identity and tactility, communication and territory and fear of penetration.

Kidnapped sand

Eddy entered the studio for his art therapy session and sat on the sofa. He observed the sandtray and said, 'That sand is a fake, a worthless imitation, not the real thing.' The white, fine sea sand in my sandtrays had come directly from a nearby Mediterranean beach. Eddy strongly continued to insist that it was false, an imitation. He called me a 'sand-napper' and insisted that I had kidnapped the sand from its true home, the sand beach, and detached it without permission from its Mother, the Sea. It could *never* be real, as it had lost contact with the rhythm of the waves and the winds and the foam of the sea. The only way to make the sand real again would be to return it to its origin, that seashore from whence it had been stolen.

Eddy was a charming, very intelligent 15-year-old, adopted as a baby from a South American country. His parents had placed him in art therapy to help improve his poor self-image and low academic motivation. He enjoyed the sea and lying on the sand at the beach. He did not enjoy his only sandplay attempt during the sixth session when he built a divided, confused world. Six weeks later, accusing me of sand-napping, he was able to verbalize symbolically his unconscious suspicion that his adoptive parents had perhaps

absconded with him as a baby. He lived in a warm and protective home, symbolized by the sand deposited in the protected sandtray. Yet he felt unreal, an imitation, while his heart called him to a reality he could only dream of, to the distant rhythm, sound and waves of the South American seacoast of his biological mother.

An untouched base

A 58-year-old woman agreed to enter art therapy after five years of mourning for a son killed in a terrorist attack. Since his death she wore only black and vowed to keep his memory alive by declining to leave her home, refusing to attend family weddings, bar-mitzvahs or funerals. As the unquestioned matriarch of a large family, her other grown children and their families visited weekly to consult her on all major decisions, but could not draw her out of mourning. The trust gained by the author's work with her orphaned grandchild convinced her to undergo art therapy herself with an emphasis on sandplay. During 18 months she completed 26 sandplays, but never touched the sand. Her approach was consistent. She selected miniatures of people or mythical characters from the same area of the shelf and arranged them in a semi-circle along the sides and upper perimeter of the sandtray. She closed a full circle of miniatures in her ninth sandplay using Indians and thereafter retained the full circle format.

Although her first two sandworlds showed some furniture and a house, people were what she focused on. The unclosed lower area of her first eight semi-circular sandplays could have reflected an enmeshed sense of self and body with her sandworld, as it was with her family. Her large strong body had birthed many children and she maintained a close caretaking relationship with them all. She may have left the circle of objects unclosed as she felt that the 'bottom had fallen out of her life' with one son's death. Once the full circle of objects was attained, she made gradual changes in her choices. In her eleventh sandplay, she placed a squaw inside a tent in the center of a circle of Indians, touching center for the first time. Her thirteenth sandplay featured a circle of doctors and six items of hospital furniture, perhaps an unconscious acknowledgment that healing was an option, although her son had not been saved by doctors.

Her fourteenth sandplay was radically different showing fifteen horses in three vertical rows of five horses each, facing left. Suddenly she moved the uppermost horse in the third and last row on the right, forward and above, out of line. She never spoke while she worked and said nothing this time. The

out-of-context horse might have represented her fallen son. Three successive sandplays showed lively clusters of colorful people in a looser circle and introduction of trees and vehicles. One of these she called 'New Life'. She had begun taking driving lessons.

In her eighteenth sandplay the center was used for the second time, for a single peasant woman surrounded by a loose circle of six superheroes on the right, five grandparent figures on the lower edge, five amusing characters on the left, and two musicians on the left upper edge. Her last eight sandworlds were circular, with more varied choice and placement of objects. The twenty-fifth sandworld used animals again. The quiet animal farm she now portrayed contrasted with the tense past sandplay of fifteen horses. She passed her driving test, cautiously left her home at measured intervals and visited her children and their families. Her final sandworld depicted a circle of Indians, with an empty tent in the top center of the circle.

This entire process was based on a repetitive circular format, using different kinds of people for all but two sandworlds. Objects were usually placed close to the sandtray walls and the sand was never touched. The sandplay of fifteen horses in three straight rows was the one time that the circular pattern vanished. An avoidance of sand, combined with a usually empty center and figures hugging the sandtray walls, may have reflected this woman's loss, not only of her son, but of her power and pride. A deep vulnerability which was not evident in her dominant family role may have been depicted by the circle format, herself as part of a tribe, rarely stepping into the differentiated position of center. Fear of the dangerous space in the world outside her own home, which rendered her anonymous, may have been another reason for a circle format. Thus, figures hugged the sandtray walls. They circulated freely in the sandtray only towards her transition into activity in the world. The sand may also have been for her a place of burial of her son, which she could not disturb.

Virginity

A 32-year-old exotically pretty young woman entered art therapy because of extreme shyness and inability to form relationships. She had sought therapy and enjoyed art, yet she was wary and silent and worked only when a framework was suggested. Her slow, indistinct verbal responses affected the therapist's intuition, as if the woman had no wish to be understood, experiencing empathy as an intrusion. After 18 months in therapy, her art grew more powerful and she became more desperate for a relationship. She

blurted out that she was a virgin and felt like a freak and that she would be mortified if anyone found out. The therapist suggested working with three-dimensional material such as sandplay or clay as appropriate for working on tactility and her fear of penetration. She reluctantly made one attempt in clay, and sculpted a cave. In her one sandplay, she placed the cave on dry sand, putting a stone in it and some pebbles in a distant corner. She never overcame her aversion to these media and could never explain her profound terror of touch. Fortunately her paintings grew bolder and larger, her colors thickly laid on, as if she was struggling for three-dimensionality. She registered for organized group trips and met a man her own age who fell in love with her and she with him. She decided to conceal her virginity by arranging an operation to remove the hymen. But they had intercourse before the operation date. They decided to marry and have children, which they did. Despite this woman's resistance to work with tactile materials, she was able to communicate for the first time with a live body, instead of a transitional object.

Discussion

Three examples of inability to touch sand have been presented. These people could not overcome at this point in their lives unyielding resistance to a more flowing approach to life. Therapy proceeded in alternate ways for them, as it can for others who refuse clay or sandplay. A verbal approach to therapy, use of objects as symbols and a sensual painting process were alternative solutions for these three people.

Conclusion to Part 5

All forms that are created in the sandtray with sand and water originate in similar activities in beach play. Sand and water by their nature invite certain hand movements in the dialogue between themselves and a sandplayer. However, in the protective therapeutic sandtray the dialogue may be between a client's outer movement and the inner movement of one's emotional world. A hole scooped out is no longer just a hole. It could become a cave, a womb, the mouth of a volcano, a path of descent to the lower world, a tomb or the entrance to the collective unconscious, its demons and treasures.

A mound or mountain becomes more than a playful gathering of sand. It is part of the body of the Earth Mother, a breast, belly or womb, a container of warmth and nurturance. It is an axis connecting earth and heaven. Drawing lines in the sand in a sandplay may be pure movement, demarcation of territory, or a 'way', a sign that one is ready to venture outwards, embark on a new road. A line in the sand becomes a life path, the center becomes the place where all things meet.

A common goal of therapy is to be able to leave familiar but unproductive behaviors behind and cross over to a more authentic and self-fulfilling approach to life. Passage from one place to another may be indicated by a tunnel or a bridge, visually symbolizing the potential of communication between where one is and the desired destination. A passage downward from the surface into the depths, to hide, bury or preserve something, may be symbolized by burying an object in the sandtray. When an object is raised up from the depths to the surface it might symbolize being exposed, or being released or reborn. When the journey to the depths and to the heights has been undergone, the time comes to cross over from the therapy room into the world.

Back at the beach, the sand and water welcome us equally. The blue distancing sky disperses the sun's light to all, promising itself for another day to come. The promise of a time of building is a promise of eternal forms, of brief life. Then, the sun, the wind, the water and the sand will reclaim their gifts to give another time equally to all who come.

A Presentation
of a Sandplay Process

Wanda: A Young Woman's
Journey Through Mourning, Death
and Loss to Fertility and Birth

Part 6 presents a series of sandplay images done over three years by a young woman in a process of recovery from complex mourning. In art therapy she found a medium for non-verbal visual expression which could bypass her rational and critical thought patterns. She chose sandplay more often than art because she enjoyed contacting the sand and was always surprised by the spontaneous and meaningful images that emerged. She allowed her hands to begin a sensuous dialogue with the moist sand until a form, texture, surface or blue exposed area satisfied her intuitively, and then added objects. In 50 out of 55 sandworlds, the sand was kept fairly level while different areas were individualized by subtle variations in height and texture which a quick glance would not divulge. Slowly, differences in height and depth became clearer and the objects chosen increased in size. Hand imprints and meaningful imprinting with an object were used several times. The first sandworld in this process, and others done later on seem intuitively organized into quadrants, and some contain polarities in diagonal relationships, with a cautious use of the center, or ego, the center of the personality (Ammann 1991, p.48). Observing her use of color in sandplay, form and texture, object placement, quadrants and the use of center in her work enhance understanding of her visual and psychic process.

Wanda

Overthrowing the collective

Wanda

Wanda, aged 29 and recently married, began art therapy two years after her brother's death in an army helicopter accident. In the framework of her studies, Wanda had begun writing her thesis on the mourning process of others like herself, whose siblings had been killed during their army service. Unable to focus on theoretical material or organize interviews with others, she began art therapy with an emphasis on sandplay. Within four months she had accomplished her first clear therapeutic objective, the creation of an individual rite of mourning for her brother and separation from him, using sandplay and active imagination.

She then became pregnant and finished her thesis in her sixth month of pregnancy. But her sandplays had unearthed anxiety about her own potential motherhood and the influence of her upbringing in a kibbutz. She remained in therapy until just before the anticipated birth, using art therapy rather than sandplay. Tragically, her first son was strangled by the umbilical cord just before the delivery, leaving her full of guilt and confused anger. Six months after the stillbirth she returned to therapy focusing on sandplay for another year and a half. The pain of a second loss and new mourning was intensified due to infertility, which medical treatment did not help. Recovery, achievement of natural fertility and the successful birth of a second son are presented upon the background of communal education in the Israeli kibbutz, a unique social structure that formed this woman's identity.

Wanda, her family and the kibbutz

The kibbutz founders' ideals of equality, togetherness and communality were manifested in their creation – Collective Education. Every child, from the day of his or her birth, grew up in a children's house in same age groups of

five children. They were cared for by a succession of nurses responsible for all aspects of the children's lives such as sleeping, eating, hygiene, learning and playing. New mothers nursed their babies in groups only at specified feeding times. No adult attended at night and a sick child would have to cope alone.

Wanda's parents were both raised in a kibbutz. Neither parent had received natural mothering within an intact family structure. Their children were born and grew up in this system as well. Wanda and her younger brothers lived in separate units in the children's house, each with their kibbutz 'brothers and sisters', cared for by women who were not their mother. Parents were visited once a day from four o'clock to seven in the afternoon and then the children returned to sleep with their group in their communal room.

Thus, family and personal boundaries in this closed self-contained society dissolved and lost clarity from the start of life. Individuality was discouraged in favor of the communal good. Each child had multiple surrogate parents and siblings who were not blood relatives, while real parents and siblings were separated. All were 'at home' in the kibbutz container. The house one lived in was called the 'room' and all property merged into the collective.

Wanda left kibbutz at age 21 after her army service. Her parents had divorced but continued to live in the kibbutz. Their children had had no example of autonomous family life and no example of separation between the divorced parents. Wanda described her mother as externally submissive and indirect and her father as warm, weak, mothering and childish. She was closest to Nir, the brother who had died, and less so to a younger brother.

Mourning ceremonies

Several times a year, Israel officially commemorates her dead. Holocaust Day honors the memory of holocaust victims. On Memorial Day the nation mourns Israeli soldiers who have died during their army service. On Yom Kippur, the Day of Atonement, candles are lit in memory of deceased family members. The army dead are mourned in additional community and military ceremonies. Thus bereaved families mourn their sons as sons of the nation, the community and the army unit, in addition to mourning on the day of the son's birth, the day of his death and the many visits to the grave.

Wanda's parents attended communal memorial ceremonies for their son. Wanda attended twice and then abstained from attending, perhaps in an unconscious attempt to separate her personal pain from the collective pain.

Yet she had no framework for private mourning. She researched mourning rites in ethnic cultures for her thesis and intuited that resolving her bereavement could only be in the imagination, where the dead live on. Primitive societies assist their dead to depart in rites of passage, as the deceased may not want to leave and survivors may not want to let them go, she thought. Writing the thesis, a rational method of coping with grief, had expanded into a therapeutic context where mourning rites and separation from the dead could be dealt with emotionally and psychologically. Writing the thesis would not suffice to work through her wounds and heal herself. Yet writing and coping with her brother's death in sandplay was the door through which she entered a deep therapeutic process.

Therapy

Wanda's therapeutic process spanned three years with a six-month interval after the stillbirth. Twenty-nine sandplays were done in the first eleven months of therapy. In this phase, she mourned her brother and separated from him, became pregnant and finished her thesis. The goal that brought her to therapy seemed resolved, but her sandplays also expressed anger at the collective's power to divide families and hinted at other unresolved issues. Wanda compared herself to her 'group' long after she left kibbutz. She claimed to be the last to get her period, to get married and to get pregnant – all feminine issues. Her ambivalence and desire to have a child became an issue of femininity when her mother joked that Wanda was too thin to have a child and that she, the mother, was still young enough to be her surrogate mother. Her mother designated to herself the feminine role and essentially denied Wanda permission to be a woman rather than a maiden.

Male identities were interchangeable in her sandplays, either father, brother, husband or son. Nir's death had left incomplete the process of normal masculine individuation that he would have undergone had he lived. During Wanda's first pregnancy, several anxious fantasies formed in her intrapsychic world. Was she pregnant with her brother? Could the collective confiscate her child? Would her child have to bear Nir's name and replace him in the collective? Her individual rights to her own mourning, child, home, husband and profession did not seem to be naturally hers.

Wanda returned to a second phase of therapy six months after the stillbirth, bitter and fearful. In the next one and a half years she mourned her first son, suffered unsuccessful fertility treatments and finally became pregnant again naturally. Balanced inner male and female forces of life eventually

manifested in archetypal imagery and a healthy boy was born. Wanda completed 23 sandplays until just before the second birth and three follow-up sandplays four months later, making a total of 55 sandplays. Twenty-seven sandplays presenting key themes of the process will be discussed. Because of the length and complexity of this sandplay process and the limited space of this text, it may be helpful to provide here a brief outline of essential ongoing themes.

Key themes

Mourning

Wanda's initial mourning of her brother expanded to include mourning the loss of an intact family, a mother–child unity, trust and the individual creative child-self to the collective. After the stillbirth, she mourned her own child and her unsuccessful womb in a period of infertility.

Masculine/Feminine

Preparation for 'differentiation of the opposites, centering, constellation of the Self' (Weinrib 1983) appeared throughout the first phase of therapy. Wanda's sandworlds disclosed interchangeable male identities and an unindividuated feminine, in which beneficent and monstrous feminine aspects flipped back and forth. The struggle for a fertile womb and carrying a pregnancy to term began with awareness of Wanda's own lack of mothering and the need for secrecy concerning individual creative endeavor in the collective.

The sternly regulated collective placed high value on leveling everyone within it to equal status. Overly visible behavior could be interpreted as not adapting to the collective. Matriarchal nurturance and patriarchal edicts of work, law and order became within the collective framework a shame-inducing critical form of control. The womb could become protective and containing only after a clear differentiation of masculine and feminine, and their positive and negative aspects. This work continued well into the second pregnancy with development of a series of trusting male–female relationships. Masculine and feminine archetypal images came alive in sandplay and helped to preserve Wanda's growing healthy ego, resist the 'evil eye' and negative aspects of the collective, resulting in the birth of a baby.

The environment, trust, mistrust and individuation

A major issue throughout therapy was the struggle for individuation on the background of the inner voices of a collective upbringing. These voices continued to censor individuality and the right to personal ownership. Even after leaving the kibbutz, Wanda related to the environment with a mistrust forged by collective life. She expected condemning criticism in work and social situations although her performance was usually exemplary. Isolation and loneliness often seemed safer than belonging to any group. Her overly critical nature and defensive rationality both carried her wounds and hid them. The medium of sandplay bypassed her need for control and freed her deeply sensual, body-intuitive, creative self. Eventually, her strengthened ego found a balance between independence and fear of autonomy.

The interwoven sequence of themes

The above themes interlock throughout Wanda's sandplay process, their development and resolution interconnected. The struggle for individuation challenged Wanda with a succession of goals that she had not foreseen. Her immediate goal of individually mourning her brother appeared at the onset of therapy and resolved in sandworld A12 as a first milestone in therapy. Several other sandplays in the first phase are the groundwork for exploration of the relationship between individual and collective power, and individuation and mourning in the collective.

Other themes in the first phase are an early differentiation of the feminine, the idea of having a child, and disdain and sorrow at the offensive division of people in the collective, like animals in pens, as a norm in kibbutz life. Wanda symbolically overthrows the kibbutz in sandplay A24, but in her early pregnancy her sandworlds lose vitality and convey a sense of loneliness. Wanda's consistent use of the blue base as integral form in the first 21 sandworlds stopped during this time of revolt and early pregnancy and 5 sandplays show a dry flat sand base.

During the second phase of therapy Wanda was determined to become pregnant again, but could not. Themes of mourning for her first son alternate with a struggle to breathe life into her womb. A cautious differentiation of masculine and feminine, good and evil forces and human and archetypal help lead to new beginnings, and the return of blue and water to the center. Preparation for fertilization is conducted through the appearance of archetypal imagery. With the protective imagery of the Good Great Mother and unification of opposites, Wanda does become pregnant. A final series of

sandworlds show strong and bursting expansion of life forces and figures representing divine protection. The analysis of the chosen sand pictures is based on a Jungian approach and includes an art therapy awareness of meanings attached to use of sand and form, color, placement, materials and objects.

The sandplays: Phase A

Sandworld A1: Children collecting seashells near a cave

Wanda's first sandplay (see Plate 4) presents a beach scene. She and her younger brother had gone to the beach that week at noon on a rainy day and a rainbow had appeared. She said that this was the stimulus for the sandplay, the moon rather than a sun symbolizing the diffuse gray light of that afternoon. In the lower left corner, a boy and girl are poised on either side of a cave, he with three brown stone pebbles and the girl with two pieces of sea glass near her. The children's legs are buried in the sand, as if immobilized.

The healing journey cannot begin with these young feminine and masculine aspects of Wanda yet. A small pile of pebbles and sea glass at the cave's entrance may represent their joint work in Wanda's psyche. Stone pebbles are traditionally left on a grave by Jewish mourners and here may link to Wanda's unresolved mourning for her brother. The sea-glass pebbles are small pieces of turquoise glass, perhaps two thousand years old, found on the Israeli Mediterranean shore at the site of an ancient Roman glass factory. The translucent glass has a radiantly numinous quality absorbed from its long sojourn in the sea. It may represent water, the eternal womb of creation, due to its color and history. It may link to the symbol of the sea as the unconscious, the emergence of the sea glass representing something revealed from the unconscious. It has a celestial magical quality, perhaps implying that at this time only an imaginary mobility was possible through spirituality or fantasy.

The scene seems divided into four quadrants: a tractor's path divides upper and lower areas and two semicircular symmetrical sand masses protrude into the upper blue area like flat breasts or rainbows, dividing the scene into left and right sides. On the left side, the waxing moon above and the protective womb-cave below point to potential feminine development. The moon may signify an accessible feminine spiritual essence. The cave may signify feminine depth into and beyond the womb into the collective unconscious and the protective temenos of therapy. There are two brown

pebbles and two turquoise sea-glass pebbles in the upper left quadrant, balancing four brown pebbles on a diagonal path in the lower right quadrant. The colors of the left side of the sandtray are browns, beige and blues, subdued unemotional colors that often accompany a depressive state.

The red and black tractor has incised its central path and stopped under two white eggshell hills in the upper right quadrant. Red, black and white are the most basic color combination in human symbolism – darkness (black), light (white) and the blood of life (red). The tractor represents energy for a journey on the life path, but it halts. Its path divides upper and lower worlds rather than connecting conscious and unconscious life.

A tiny white baby sits on the upper eggshell hill. Wanda describes the baby's identity as 'half angel, half baby, or perhaps my husband waiting' and the white eggshell hills as stepping stones to the sea beyond. She did not postulate a connection between the white baby's ghostliness and her dead brother, nor the 'dead white' empty eggshells, all the life sucked out of them, to gravestones. If it is her husband waiting, then prognostically life waits. If it is her deceased brother, then death waits.

In the center of the sandtray, a small apple, banana and steak lie scattered behind the tractor. This warmly colored food is minimal and unnoticed, but central. The banana in exact center links the quadrants, while its shape mirrors the half-moon. This unobtrusive food may show that Wanda finds nourishment in sandplay therapy, that she needs nourishment, that she is finding nourishment within herself while doing a sandplay, or that she is putting forth the fruit seeds of her future life, but so cautiously that these good aspects of herself would not be seen or commented upon. Reflecting her tendency to hide important things from others, these small fruits may contain great meaning.

As diagonal counterparts, the lower left quadrant contains a path through the cave into the womb or unconscious, and live children potentially able to extricate themselves from immobility into life. The upper right quadrant contains a path of potential movement into fantasy and possible death. The lower right quadrant and upper left quadrant are all sand, with four pebbles placed on each. Thus this diagonal connects sparsely touched areas where no movement occurs.

Wanda commented: 'The children unhurriedly collect things together disconnected from the world while someone waits for them. The girl needs to collect, while observing herself and wondering what she is doing. The boy looks to the distance. Good that the cave is there to protect them'.

Sandworld A2: Bridges, central pool, frightening mask

Framed in a central blue pond is a dramatic but unseen relationship between two opposites, a frightening mask and a lustrous white marble concealed beneath it (Figure 17.1). The mask's placement in a round blue pond could be Wanda's image of pregnancy, herself as a container, sharing her inner space with a frightening child. The feeling that her body could create monsters or that she was a monster was a recurrent theme in later sandplays. The mask could also represent the protective persona necessary in the collective, concealing a pure, beautiful 'true self', the marble. The pond of water implies willingness for deeper entry into the unconscious.

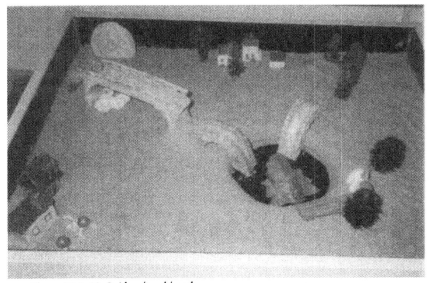

Figure 17.1 A2: Bridges/pool/mask

A bridge leads into the pond from a group of three houses in the upper center. From the upper left corner two bridges create a road to the pond. In this corner there is a sleeping angel under the bridge, an unused yellow wheelbarrow behind the bridge, an alarm clock on the bridge, and a gray disc in the corner, where the moon was in sandworld A1 (Plate 4). Another angel sleeps on the opposite side of the pool, near a bench.

Two houses and two unsupervised babies in the lower left corner face the scary mask, perhaps reflecting the lack of protective mothering in Wanda's early life. The bridge-roads are unused and all seems motionless. The alarm clock may indicate the need to wake something up. The bridges may imply a pull towards communication between difficult and conflicting polarities in Wanda's psyche. Wanda experienced this sandworld as the kibbutz, where she didn't want to live, and the mask as a monstrous scary demon. She wanted a baby, but felt that something inside her was undecided. A stage is set for energies not yet in motion.

Sandworld A3: Central mound and cave

Most of the sand is gathered into a rounded hill surrounded by a blue base, except for a sandy area of attachment to the lower left corner (see Plate 5). On the left blue base, a motherly woman watches eight pink babies crawling up the left side of the hill. Wanda saw the woman as good, giving freedom to the babies, perhaps a memory of a good caretaker, or an image of her present expectations from the therapist. The babies crawl towards a white basket at the summit, containing white flowers and two tiny white babies. Also on the right side is a barely seen blue helicopter on the blue base, the cause of her brother's death. The helicopter, wreaths, white babies, and white roses below, link the right side to Wanda's brother's death. With death as the focus, the mound and a watery based cave below containing a little girl function as a tomb. The girl lies closed off by a green fence with two white roses on it to the right.

Wanda identified with her, noting the contrast between the outer lively movement of the children and the immobile girl inside. Wanda wondered if a baby fell into the cave, would the girl be happy or send him back? But the mound also resembles a whale whose tail touches the lower left corner, a child swallowed into its belly.

Campbell speaks about the image of the whale's belly as a mythological womb, a place of transit into which the hero is swallowed, awaiting rebirth (1973, p.90). Perhaps the wish to be reborn and grow healthily is expressed by the cave's location on the mound's left side, nearer to motion, new life and growth. Then the blue-bottomed cave and mound would become a womb. The waxing moon again in the upper left corner could indicate Wanda's readiness to rely more on her feminine intuition as a way back to life. The baby who hypothetically falls into the cave might represent the task of

connecting inner and outer worlds through children's natural growth potential and the protection found in therapy.

Sandworld A4: Sarcophagus and the appearance of Gingi

A small red-haired doll, Gingi, appears here for the first time (see Plate 6). She hides as an active observer behind three cacti in the lower left quadrant, her red hair a bright fiery spot of color in this motionless landscape. The red hair might imply her character, impulsive, emotional, or something activated in Wanda's psyche. She observes a large blue square placed diagonally on the left side of the sandtray. Within it are two parallel open halves of an Egyptian sarcophagus filled with sand. Two empty metal chairs observe the sarcophagi from the left and right banks of the blue square. The right side of the sandtray is empty. Three trees stand above the square. The blue square and sarcophagi seem to focus on death, but not burial. There is no earth base for the sarcophagi, just as there was no earth base in the cave in sandworld A3. The sarcophagi are undifferentiated, as are the empty chairs that face each other. This may refer to her parents' indistinct masculine or feminine roles, their divorce and separate mourning for their son, unclear family structure in the kibbutz, or Wanda's unclear perception of her own masculine and feminine traits. The number two implies a state of differentiation of opposites, the yin and yang, male and female, which here have their positions but are identically empty.

The number three – the trees and cacti – is the number of children born to Wanda's family. But the number three as a trinity is discussed by Edinger who cites Jung: 'trinitarian symbols...imply growth, development and movement in time. They surround themselves with dynamic rather than static associations' (1972, p.182). The spiky cacti which Gingi hides behind scare her, scare others off and protect her as well. Wanda's psyche is being activated perhaps in preparation for differentiation of the opposites.

Sandworld A5: Island, mainland and Gingi opposite a wall

Gingi has begun to move, from the lower right corner which has been empty for five sandplays towards an obstruction in the lower left corner containing an angel. This corner was used for a cave, houses and babies, a whale's tail, Gingi and three cacti. The enclosed angel is neither male nor female and indifferent to Gingi, just as Wanda experienced her parents in childhood. Beyond, the road continues upwards to the upper left corner, where a bench, tree and waxing moon seem to convey a sense of sadness and waiting. Gingi

has mapped out a road towards individual mourning, but she has not separated out her parents, and subsequently her own feminine and masculine aspects. This must occur before the journey continues. The little isolated island in the blue sea seems again an image of pregnancy, womb or tomb (Figure 17.1).

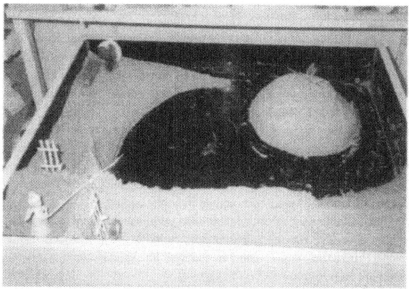

Figure 17.2 A5: Island, mainland, Gingi

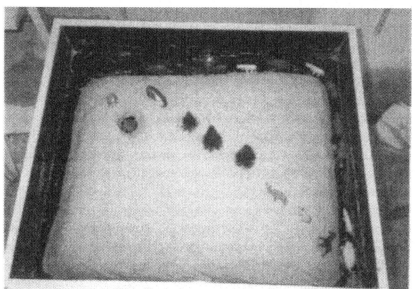

Figure 17.3 A8: March of the animals, uroborus

Sandworld A8: March of the animals; the uroboros appears

Red-haired Gingi sits in the top left area of a square flat sand shape, isolated by wide blue margins all around (Figure 17.3). She looks downward at a new companion, a small uroboric snake in a blue-bottomed hole in front of her. Wanda saw that the snake was eating its tail and thought this would mean that she would not have to fight with him. She said, 'The snake has a problem, he can't get out, he is childish, immature. Something in-between. He doesn't belong to the males or the females, something from both.'

There are 16 natural animals in this sandworld and a uroboric snake. They emanate from the lower right corner in two processions. An armadillo in this corner is the starting point. Its shape is containing and feminine. Its armor may imply Wanda's shielding herself as a child, without shielding from a mother–child unity. Twelve large animals whom Wanda considers masculine – elephants, rhinoceri and hippopotami – march upwards along the right and upper blue margins to top center. A shorter group of three animals whom Wanda considers feminine – a giraffe, kangaroo and camel – begins a diagonal axis on the sand, followed by three trees and the moon near Gingi. This first meeting with a positive feminine in instinctual animal form, occurs within an isolated square, and excludes the male animals hidden by the moon. The square shape seems to establish the serious intent of placing feminine identification first on the agenda.

Sandworld A10: Rabbit/womb

A blue shape like a rabbit's head, or an image of ovaries, womb and a birth canal, is placed centrally on a diagonal from lower right to upper left (Figure 17.4). A round sand island becomes the rabbit's face, with two glass candy eyes, a dark smooth stone for a nose and a crescent moon for a smiling mouth. Gingi and her snake sit in the upper left ear, or ovary, of the rabbit/womb. Three transpersonal powers observe from the upper left corner, a black witch, a black totem and a blue fairy. Wanda sees the angel or blue fairy as relating most to Gingi, who sits with her back to the powers, unaware. The archetypal feminine is specifically differentiated into good fairy and black witch. The male totem, being horse and eagle, seems to her more frightening than the witch, although both could catch and strangle a child, she said. She saw the powers as quarrelsome, the witch restraining the totem from doing harm. The moon has moved out of its corner and become the rabbit's 'mouth', or part of the island fetus in the womb.

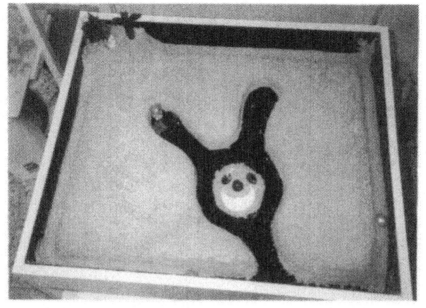

Figure 17.4 A10: Rabbit/womb

Wanda thought the rabbit looked stupid, defensively disguising serious intent to become pregnant, distancing acceptance of feminine fertility as hers. The edges of the sand are impressed creating a square frame. A gold ball, perhaps representing masculine forces, has rolled along the top right edge and downwards, stopping on the right lower margin. A silver ball, perhaps representing feminine forces, has rolled down from the upper left to the lower center margin. They do not meet yet.

Sandworld A11: God throne

A blue path or river, commencing in the lower right area and ascending diagonally to the center, feeds into a blue pond where Gingi, her snake and a tiny pink baby sit (Figure 17.5). They sat in the same blue shape and spot in sandworld A10 (Figure 17.4). To Wanda, Gingi seems regressed, stuck again in a hole. On the flat sand, the blue path seems like a flower stem leaning leftwards. It is separated by a sand bridge from another group of three objects and two symmetrical hand prints, which form a flower shape above. A beige angel lies between the handprints. Above them stands the blue fairy. Behind her a red plush wooden chair touches the sandtray's upper left edge. The composition and objects make this a sky area.

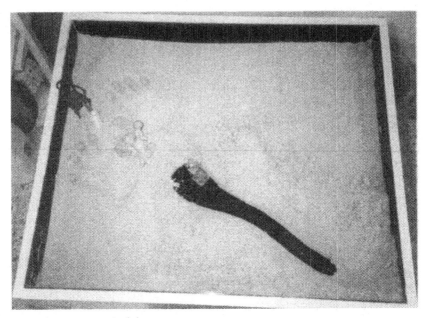

Figure 17.5 A11: God throne

In sandworld A10 (Figure 17.4) the blue fairy doubled as angel. These roles are now differentiated. Wanda sees the chair as God's throne, and says that those above have work to do. She thought that the division between upper and lower could be a division she must make between her husband and her brother, between her old family and her new one.

Active imagination as forerunner to sandplay, 19 April

The month of April remained a powerful intersection of births and deaths in Wanda's life. She had been born in April. Her brother died in April. Holocaust Day and Army Memorial Day are in April. Passover, the family holiday, is in April. April was a time when something bad could happen, when collective mourning rites drew attention and private pain remained unresolved. The end of April brought relief that it was over and a time of emptiness. Yet April brings the spring, a season of birth and renewal. In Wanda the need for life also awoke in thoughts of having a child. As her process unfolded the month of April seemed inherent in her destiny, always bearing both tragedy and triumph. In Wanda's inner world, this fusion of

forces of life and death might reflect lack of differentiation of the archetypal Great Mother, representing Life and Death in Nature.

On Memorial Day, Wanda secretly placed a red rose on the headstone of Nir's grave while others laid bouquets at the foot of the grave. She felt that something inside her could not come to light, as if she had something to throw up first. In our session we discussed an imaginary pregnancy, of being pregnant with Nir, or the tears and sorrow left of him in physical form. She felt ready to create her own mourning rite for Nir in active imagination. Her eyes closed and she cried gently as she spoke:

> I carry him in my arms to an isolated place in a desert with sweet water, and an ocean with salty water and dunes, a place filled with sand, music and flowers. His hair grows longer as it was when he was a teenager. I wash him, cover him with sand, touch him, decorate him with flowers, refresh him. It would take a lot of time and patience. Together we would read his poetry. I would accompany him part way as he took leave from what was important to him. We would visit each of our parents separately and discuss his current life, and how it would be now for him and for them. Together we go to the girls he loved, imagine how they would grow. Nir would ask my husband to take good care of me, the way he would have. Together we take our younger brother with us. All three of us play, run wild, fly, laugh…then we separate from him and continue. It would take a whole day, from sunrise to sunset. Together we would fly, float as birds and butterflies. Accompanying him didn't make our parting easier. My turn had come and it was getting harder, for consciously, willingly, I would never choose to separate at all. I am going up with him. We laugh, hug and cry, and then I wake up alone in the desert.

> I'm like a small child, perhaps the little girl, with a long way to grow until I reach my 30-year-old body. My soul is very young, a part of me went with him. I'm here alone and alive, he cannot return to his body, but I can. I'm small and alone in the desert but not frightened. It feels natural. I open my eyes and beside me is a little snake. I know he left it for me. The dunes begin to scatter away with the flowers and the wind, till a desert remains that could be anybody's. It becomes an eternal desert when she is not there. But when she is present there is a grave, and flowers blossom. Whenever she is in need she has a place to go back to.

Sandworld A21: Desert garden grave

Wanda described herself as feeling weak and weightless. She spontaneously created the desert garden grave sandplay a week after her active imagination and three days before her thirtieth birthday (see Plate 7).

This sandworld embodies in physical form the ceremony created in active imagination. It is a personal major event, witnessed and formed in a manner sensitive to her needs and to her deceased brother's needs. It may be Wanda's first individuated statement. Nir, dead son of the nation and kibbutz, is claimed as *her* brother. In death he becomes individuated from the collective through their joint rite.

In this and other sandworlds, much space is unused and uninhabited. The surface is worked but kept level. Leveling may reflect the kibbutz policy of keeping people equalized, rather than individualized. It may reflect depression and loss, an unlived in, uncultured landscape. But water does come to the desert. Around a blue triangle in the upper left corner the sand is heightened and textured. The triangle is bounded by a waxing moon at top center and by a sun on the left edge, delineating its limits and framing the blue fairy exiting in the upper left corner, her role as distant mediator over.

In the lower right the sand supports an eye-shaped scattering of sea glass and eight brass pots and objects. The idea of sweet water in the pots and salt water in the upper left corner provides a coalition of masculine nourishment from above and feminine ocean water. The potentially dangerous ocean of the initial sandworld seems now to represent a positive aspect of the Great Mother and the collective unconscious. Metal may be the transformation of the brown pebbles of the initial sandworld. Rather than glass and stone, glass and metal are paired. Both substances can be transformed by fire. They form a vague eye shape, perhaps connected to the divine, or to Wanda's transformed vision after her ceremony. Both glass and metal here relate to water: the glass comes from the sea, the pots hold water. Purification and nourishment seem to be taking hold.

In the upper right, two red roses and one white rose are bounded by the uroboric snake on the left and Gingi on the right. The uroboros represents the undifferentiated union of opposites, the original state when all is yet one (Neumann 1973, p.46). For Wanda the snake is associated with her deceased brother. She senses that the snake will soon end its role as Gingi's companion. This, and the recognition and tolerance of the opposites, might imply that she will continue her process of individuation. Gingi, apparently representing Wanda's young creative and innocent self, initiates the journey.

This sandworld divides horizontally because of the color, materials and location of objects. The central moon, half dark and half light, subtly makes another division into left and right halves. A moon provided diffuse light in the initial sandworld and occupied the upper left corner for nine sessions. Here a sun joins the moon, adding rational, direct, clear sunlight to the inner intuitive moonlight. The sun and moon appear together again in the fourteenth and twenty-fourth sandplays.

Bradway notes that women used sun and moon together more often than men: 'Sometimes they were in close proximity to each other, perhaps representing the union of the opposites of conscious/unconscious, male/female, light/dark, day/night, hot/cold' (Bradway and McCoard 1997, p.99).

In the upper half are eight objects, their number mirrored by eight metal objects interspersed with sea glass in the lower half. The number eight, coming after seven, represents 'Paradise regained; regeneration, resurrection; felicity; perfect rhythm.' It also 'represents the pairs of opposites' and, as octagon, 'the beginning of the transformation of the square into the circle, and vice versa' (Cooper 1978). Thus eight objects above and eight below may show new beginnings. Wanda commented:

> I used sea glass in my first sandplay near the cave. Here I wanted to create something beautiful, like bells. The brass objects can make sounds like musical instruments. I couldn't leave it as a desert. I needed the sea. It's like the place of my fantasy last week. There is a moon and a sun, not completely realistic. It's morning and also evening, or even a full 24-hour day. The fairy was protective, now she can go. I don't know when the music began, if the girl played alone or if there were people. She remains alone with the flowers. This is a farewell from Nir, but also from mother and father. The people here were friends of mine and Nir, not like all the people you don't know in Memorial Day ceremonies. A beautiful place. I imagine it scattering and disappearing. The instruments sink, the stones disperse to the sides, the sun and the moon become distant, the angel disappears over the horizon. The sea may remain, but waves will slowly leave.

> The girl goes with her snake, the flowers accompany them part of the way, and the petals begin to scatter. And what is left, the stems, fly away. They accompany her in a dance with the wind, and slowly they scatter. I must bid farewell sometime to the snake too. Maybe she [Gingi] is separated from him when she leaves the desert. She can't keep going

around with a snake. He is part of the magic, from the imaginary, and he can't be with her in the everyday. It's hard to leave this desert garden. Maybe when it begins to disappear, she will have to bid farewell.

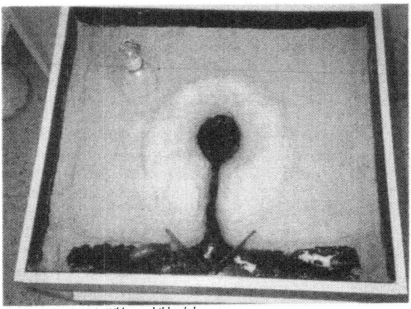

Figure 17.6 A16: Kibbutz, children's house

Sandworld A16: Children's house

Gingi sits on a metal chair elevated by a breast-shaped mound in the upper left quadrant (Figure 17.6). This chair was once an empty observer of two sarcophagi in sandworld A4 (Plate 6), when Gingi first appeared. She now sits on the 'high chair'. Her elevation gives her an uninvolved perspective on the kibbutz below, a move towards patriarchal consciousness. She sees a central round raised toilet-seat shape with a blue-bottomed hollow center leading downwards in a long blue channel to a narrow horizontal blue rectangle at the base. This striking shape resembles a man's head, neck and shoulders. At center bottom, a V-shaped gate separates left and right blue areas. Wanda saw the two brown horses in the left pen as male. They are separated from two black and white female cows in the right pen. In the center pen is one calf. Wanda says that both want the calf:

In this war the gates never open together, just one at a time. Some power organizes it all, like in kibbutz. This is my family, the cows are I and my mother. The horses are Nir and my father. My younger brother is the calf. The water in the center is the children's house in kibbutz. Someone else cleans the babies and diapers them. At first I saw the water as a pregnancy.

The elevated observation brought up feelings as a small child of not understanding adult activities. Themes of longing for the mother–child unity and sadness for her parents' helplessness in forming a loving family unit contrast with the high kibbutz powers dissecting families into separate caged units. These she had introjected as a divided world.

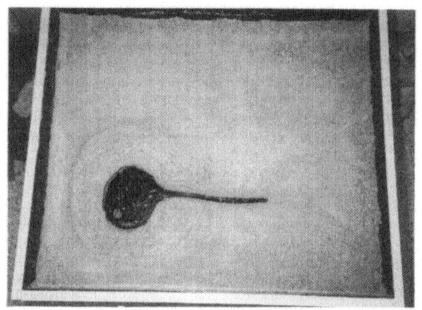

Figure 17.7 A21: Womb and channel facing right

Sandworld A21: Womb and channel facing right

In a stark barren landscape, a toilet-seat shaped, textured round sandbank surrounds a blue circle tapering into a thin blue channel which extends to the right onto the sand (Figure 17.7). It forms a shape very similar to that of the kibbutz children's house of sandworld A16 (Figure 17.6), a person's head and neck, but lying down on its side. Within the blue area, almost hidden on

the lower left end is a small red snail shell. Wanda's comments express her struggle: 'I must protect what is here. If they see it they will take it. The opening is not big. The red snail is protected but should not stand too close to the opening, better to hide.' The conflict between wanting to be oneself and the need to remain hidden continues. The small snail remains fearful and stuck, unborn.

Sandworld A24: Observing the kibbutz walls being destroyed from behind the rainbow wall

Wanda is seven weeks pregnant. In previous sandplays she continued to focus on understanding her place in the kibbutz. Here a rainbow is used as a wall in the upper right quadrant, separating a triangular blue sea in the corner from an overturned kibbutz below (see Plate 8). Wanda likes and identifies with the sea. A rainbow may reflect hope, a bridge to happiness and finding a 'pot of gold'. Wanda's initial sandworld was stimulated actually viewing a rainbow. The eggshell hills of that sandworld were stepping stones to the water. They have been replaced here by the rainbow, whose curve recalls the two sand breast shapes in that first sandworld. This rainbow is three-dimensional and fully colored, strong enough to separate an area of revolt against the old collective consciousness, from an area of new personal consciousness – the triangular blue sea.

Seven-eighths of the sandtray contains a scene of the overthrown kibbutz. Twenty-four overturned objects – kibbutz workers, wheelbarrows and trees – lie in diagonal rounded low walls from upper left to lower right corners. Wanda spoke with scorn of the kibbutz's masculine wall-building rulers and stupid, harsh feminine caretakers who maintained the isolating walls and controlled and socialized children by brutal rules. She recalled how the caretakers put children to sleep by shouting, 'Face to the wall.' Thus the symbol of 'wall' was maintained even as something one relates to in sleep. Yet Wanda also builds defensive walls in her current world. This large shadow area dominated her inner world and only now has been overthrown. She still fears the kibbutz taking her child and doubts her capacity to be a mother.

The people she chose are workers, except for one small elegant woman in a ballgown placed near center. She may represent the dresses Wanda brought back from a trip to the USA when she was 11, but could not wear as they were seen as decadent and corrupting for other kibbutz children. The woman could also represent her secret true inner life, through a small seemingly

insignificant object. Thus important things become visible without attracting attention.

The little blue sea, about one-eighth of the sandtray, supports a round basket with five objects – a sun, moon, Gingi, the snake and a violin. Perhaps this is the 'pot of gold' found over the rainbow. Gingi and her snake are the young feminine–masculine duo that initiated the journey. The basket liberates Wanda's psyche from a collective existence, recalling the liberation of Moses from slavery in a round basket. The basket contains three round objects: the sun, moon and snake. This roundness is echoed by the coastline, the diagonal rounded sand walls and the semicircular rainbow. Roundness is feminine, cyclical, representing intuition and natural feeling. The sun and moon may represent Wanda's newly paired intellect and intuition. This is the last time that sun and moon appear together. The moon never returns. The sun, 'the source of all life' (Bradway and McCoard 1997, p.100), appears in the second phase of Wanda's process, two months before her second pregnancy.

Music is now represented by a violin. Violins are used for playing 'swan songs', the demise of a powerful person or environment. Perhaps this signals the 'swan song' for Wanda's inner walls and the kibbutz wall builders in her psyche. There are 24 objects in front of the rainbow. In sandworld A12 (Plate 7), Wanda parted from Nir in a complete 24-hour cycle of day and night. Each 24 hours a cycle closes and a new one begins. These 24 overturned objects may indicate that this cycle is closing.

Wanda commented that she first built an island for Gingi, giving her what was important for herself. Only then could she get angry and bury the kibbutz, as if in an earthquake:

> First I destroyed the men who rule the kibbutz. But the women are the caretakers. The only good thing I have from kibbutz is Nature. What a waste of time to demolish the walls they built, a waste of time to build them, a waste of childhood. I wanted the rainbow to be a wall. Gingi sees them through the hole in the rainbow, but they don't see her.

Sandworld A26: Gingi on a grate over a womb/tomb/toilet

In the center Wanda formed a central blue hole made deeper by a round sand bank enclosing it (Figure 17.8). This reminded her of the pool in sandworld A2 (Figure 17.1) with the monster inside. 'If this is my pregnancy then it is as if it is a monster, or what it does to me. Takes over my body. That I am a monster, frightening, even today. It looks like a toilet. It needs a cover.'

Wanda then placed blue grates on the opening and Gingi on this. In structure this 'toilet seat' resembles sandworld A16 (Figure 17.6), the 'children's house', and sandworld A21 (Figure 17.7), an uncovered blue hole with a thin channel hiding a red shell. The grates which separated families now cover the hole so Gingi can't fall in. The form is round and feminine but associated with refuse. In a collective childhood, a child who was bothersome might feel monstrous, filthy, to be flushed down the toilet and buried in a place for hiding monstrous things.

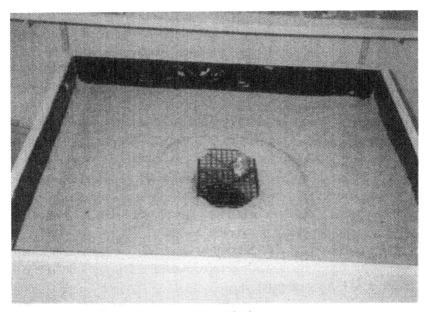

Figure 17.8 A26: Gingi over a womb / tomb / toilet

Sandworld A27: Ominous birthing

Wanda is three months pregnant and due to give birth in April. Her pregnancy is small and hidden. She is full of wonder, and yet disturbing thoughts intrude of pregnancy as a monster taking over her body, or she as the monster.

In this sandworld (Figure 17.9) a lone woman gives birth on a bed facing a wall in the lower left near a black piano in the corner. The wall recalls Wanda's loneliness in the children's house at night, being told to sleep 'face to the wall'. The piano is dark but has white keys and may represent a

yin–yang balance in its sound potential. Yet it is mysteriously placed, blocking the lower left corner, the door to the collective unconscious.

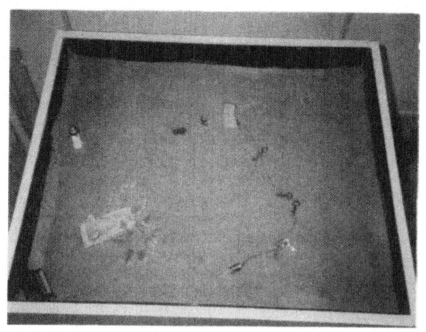

Figure 17.9 A27: Ominous birthing

The bed is bounded above on either side by two wreaths of pale green and white flowers linked to Nir's death in sandworld A2 (Figure 17.1), the only close presence. A phallic lighthouse stands two-thirds up the left edge, remote and cold, its living house buried in sand. The sand is mostly empty and untextured, on top, on the right side and lower area. A half-buried wooden cube, a tiny metal bird and a small jewel box connect to a fragile chain and frame a lonely empty center. The chain begins with two tiny metal hearts, then five keys are interspersed on its length, ending in a cola can. The five keys may represent Wanda's original family of five, the two hearts her and her brother. Among the meanings of the number five is the pentagon as human microcosm, the arms, legs and head forming five points. In Buddhism, the heart or center has four directions, making five, representing universality (Cooper 1978).

Keys symbolize 'the power of opening and closing, dissolution and coagulation... The key also denotes liberation; knowledge; the mysteries;

initiation' (Cooper 1978). The chain ambivalently canopies the woman from a distance, as if the use of its keys and hearts is not immediate. These are the boundaries and background for the birth of a child.

The overturned kibbutz in sandworld A24 (Plate 8) eliminated support from the collective. Wanda's family as a united source of support has been fragmented by kibbutz 'wall building' and she still lacks an inner ego strength to replace the overthrown area. The chain's distance from the woman may reflect an ambivalent wish for support for her pregnancy and child conjoint with an inner belief in the danger of accepting support. Wanda's autonomy has been forged through mistrust. Her child could be kidnapped by the kibbutz, her parents or husband. Loneliness and alienation assure that the child is hers. There is fearsome premonition in the birthing woman's loneliness and acceptance of it.

Wanda commented:

> How will April be this year? The center may be a desert connected to Nir, part Nir and part baby. I thought the bed would be for a baby, not for the woman. I can't imagine this, she is alone. The lighthouse protects her from a distance. Wondrous. Unclear if my husband will be at the birth. How will he go through this, and how will I? He wants to. Maybe I have to suffer alone.

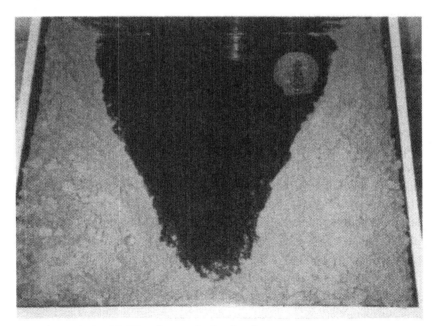

Figure 17.10 A29: Water between banks of garbage

Sandworld A29: Water between banks of garbage

This is Wanda's last sandplay before giving birth (Figure 17.10). She is four months pregnant. A large triangular blue shape pointing downwards is created by two sandbanks sloping inward from the upper corners, meeting in lower center. Wanda describes these mounds as garbage built by the cleansing of the psyche – pushing the unwanted refuse of the psyche to the sides. She knew that cleansing out the garbage must take place. But with her pregnancy visible now, the garbage mountains on the sides could hide her. She questioned the fate of all the garbage. 'Would children play with it?' she asked. She does not imagine transformation of the garbage into earth, for new growth.

A pink glass seashell containing a violin and a brass male African god float in the upper right corner where Gingi once sailed in a basket with a sun, moon, snake and violin. The African god is primitive, strong and protective and carries a stick like a policeman. Wanda thinks he represents something she should have learned as a child in an aggressive, exposed world. Less than halfway through her pregnancy, she is tired, without an earth base, and presented with a goal of becoming acquainted with her animus, becoming discerning, aggressive, a heroine. Wanda finished her thesis and then did no more sandplays in this phase.

Wanda

Bringing Water to the Center

Phrase B

Wanda resumed sandplay and art therapy six months after her first son was stillborn, determined to become pregnant again. Each time she got her period she cried and her entire body hurt. She and her husband visited a certain rabbi's grave to ask for fertility, although neither was religious or superstitious. Medical fertility treatments did not help, causing more guilt and pain. Ten months after resuming therapy and after completing sixteen sandplays she stopped the treatments and became pregnant naturally.

The last few sandworlds done in the first phase before the stillbirth show an alienated and lonely environment, a lack of feminine eros-relatedness and no warm human interaction, protection or containment. Wanda's battle to overthrow the collective was a first step. In her psyche there may not have developed maternal awareness and her body had not yet become a safe container for her fetus. There would have to be a shift in belief, away from the terrible devouring aspect of the feminine, towards accepting a beneficial dominance of the matriarchal power of nature as a first stage. This could occur within the therapeutic relationship, allowing herself to be supported by the therapist and her own sandplay work.

Twelve sandworlds out of twenty-three done in the second phase will be discussed in Chapter 18 and Chapter 19. The seven sandworlds presented in Chapter 18 depict recovery from mourning her son and achievement of new fertility despite loneliness and insecurity. Later sandworlds presented in Chapter 19 acknowledge masculine and feminine protective archetypal forces. Sandplay B23 (Figure 19.2), done just before birth, and B26 (Plate 16), done four months after the birth, conclude the series.

Sandworld B5: Water returns to the desert

The general atmosphere of this flat sandworld is muted but pure (see Plate 9). Three clear groupings are formed through Wanda's use of metal, water, glass and two symbols of wind and spirit – a silver-penny branch and a windmill. In this sandworld, materials and elements convey meaning in themselves.

The first group centers around a small blue pond in the lower left quadrant, with a ladder leading into it from the left. To its left is a windmill turned on its side. Above the pond are five metal pots and a small metal African god.

Water signifies the womb, the unconscious, the emotions and the flow of life. The ladder enables passage into the lower abundance and return with this water for use in this world. The pond is becoming a source of nourishment, rather than the domain of monsters, as in some earlier sandworlds.

The five brass containers form an independent metallic group above the pond, amplifying the idea of fertility, waiting for water. They may be a transformation of the five unused keys in sandworld A27 (Figure 17.9). They are attended by the small brass African male god holding a stick. He appeared first in sandworld A29 (Figure 17.10) as a passive but clearly masculine adult protective presence. Here he brings nourishing resources from the desert well into the psyche, the feminine containers. This begins an adult male–female cooperation supporting Wanda's goal of fertilization and introducing a male figure as nourisher, implying a shift towards acceptance of mature patriarchality. Metals are symbolically considered embryos of the earth's womb. Brass, the metal of which the containers and god are made, is associated with Venus, goddess of love, beauty, creativity and procreativity.

Wind, the breath of the universe, is the power that sustains life and holds it together (Cooper 1978). The windmill on its side must pull this complex group together and encourage movement and life, helping the god become an agent of change. Despite the loss and tragedy Wanda has endured, the water below is accessible, supporting the goal of fertilization and new life. The movement of wind and the nourishing aspect of water are redeeming qualities in a time of mourning.

The second group, in the upper left quadrant, holds a starkly simple memorial of double mourning for brother and son. An impure sea-glass stone integrates the sea glass and small brown pebbles that represented Wanda and Nir in the initial sandplay. Above it, a silver-penny branch as spirit portrays

the intangible, transient and elusive qualities of wind (Cooper 1978), linking with Wanda's mourning for her son.

The third group is formed by a large central eye shape on the right side, made of sea-glass pebbles. Its pupil is a small red snail shell. This red shell symbolized the need to hide in sandworld A21 (Figure 17.7). Here its redness adds warmth to this otherwise cool sandworld. The translucent sea glass allows light to pass through it, the eye is clearly seen and seeing. An eye is used as a protective symbol on amulets for keeping evil away. This eye may be felt as a great godly presence protecting the little god and his work. It may be a beneficial manifestation of a transpersonal power, or imply a new viewpoint evolved from the unconscious, or sea, the source of this glass. This power brings the wind, the wind moves the little god, who brings water to the receptive pots.

This sandworld echoes sandworld A12, 'Desert Garden Grave', done one year and seven months previously (Plate 7). Both have three groups of action. In both a sea-glass eye is found on the right. Both are organized into two halves. The earlier sandworld divides top from bottom. This type of division may imply a split between daily life activity and an unintegrated upper world of spirit and fantasy. This sandworld divides into left and right sides, a more egalitarian concept of organization and differentiation between the strengths, cooperation or competition between sides.

Wanda saw this sandplay as presenting three interconnected centers. She said: 'The eye looks at the well. The containers are to bring the water. The ladder makes clear that it is possible to get out. The silver pennies are sad and connect to the wind, the windmill.'

In summary, the memorial for double mourning in the upper left links wind as spirit to the wind below, activating preparations for new life. Wind and glass are two masculine symbols. Glass allies with crystal, representing purity, spiritual perfection and knowledge. They are balanced by two feminine symbols, water and brass. The balanced inclusion of primal feminine and masculine imagery may show cautiously positive, life-desiring presence and activity.

Sandworld B7: Steep hill in a blue sea

Wanda was taking fertility hormones which caused extreme moods. Her work with adolescents caused her to reflect with concern on her own capacity to be a parent, given her kibbutz upbringing with no real idea of family. In this sandworld (see Plate 10), all the sand is thrown into a high

sharply pointed mountain, piercing three-dimensional space. The blue surrounding water seems unquiet with sandy finger marks, as if there were movement below. Jung describes the origins of the ego: 'the conscious rises out of the unconscious like an island newly risen from the sea' (Jung 1954, p.7). This polarity of depth and height establishes the relationship between consciousness and its source below. This mountain is unusual for Wanda, who usually keeps things level. Elevation or height, can be a metaphor for joy or exaltation. Perhaps Wanda is elated and frightened at her growing autonomy. She says: 'There are many dangers here. Everything here is suspect, bad or good, separate and alone. The mountain is threatening, attractive and dangerous. The top is unreachable, everything seems to end in the middle.' Wanda's imagery carries her basic mistrust of seemingly supportive situations.

The mountain's slopes contain four distinct areas of action, like four three-dimensional quadrants. In the two rear quadrants the shadow of danger and threat hover at the water's edge. In the left rear a cow-headed woman whom Wanda does not like tends a group of seven tiny pink or white babies. The eighth has been kidnapped by the African god to his boat on the lower left front. The cow-woman's role is to be a cow, to feed and represent a nourishing maternal aspect. She does not do this well and provides impersonal nourishment to a collective group of babies. Wanda contemptuously relates this to the stupidity of kibbutz caretakers. In sandworld A16 (Figure 17.6) cows and horses in separate pens expressed the break-up of human family units in kibbutz, leaving them disunited and powerless. Wanda's goal is to be a mother, but her internal feminine role models are contemptible examples.

In the right rear quadrant a threatening spiky conch shell is hidden by a thick growth of trees behind the hill near the water. This may mirror Wanda's feeling that something poisonous hides in her, the destructive potential in her body resulting in a stillbirth.

The two frontal quadrants contain helpful, hopeful, sad and endangered elements. On the lower right front six red and white small ceramic houses clutch an empty hillside. The shore below them is bolstered against inundation from the turbulent sea with about two cups of sea glass, which may also prevent landslide. The sea glass has become a protective barrier rather than a godly abstract eye.

On the left front slope above the halfway point a grandparent couple stand with the silver-penny tree behind them. They view a small rowboat on

the water's edge below in which the African male god has kidnapped one tiny pink baby from the collective. Wanda saw the grandparents as passive and uninvolved in life, not caring if they die. But they are wise and could give support. Wanda's inability to be central and active in her own life could have been construed as tiredness or lack of interest, a defense stemming from her past kibbutz life. The grandparents are clearly human, male and female, and old beyond the conflicts of youth. They could extend the cooperative male–female unity begun by Gingi and the snake. The grandparent dyad could refer to the author as therapist-observer and facilitator of an intuitive feminine sandplay process, and as rational masculine interpreter at times. Wanda knew the therapist was a grandmother.

After building this sandworld, Wanda suddenly moved the metal god in his rowboat upwards to the children's group. There he kidnapped one little baby into the boat. Then Wanda distanced them to the lower left shore. This movement caused an active response in the grandparents as Wanda moved their gaze downwards to watch this event, like an awakening and revival of interest in life. The salvation of the kidnapped baby which Wanda, through the male god, evacuates from the lonely collective, is the first significant differentiation of an individual from the collective. This seems to be a first symbolic representation of Wanda's ego.

In this sandworld, people are concentrated on the left, an area which may sometimes be construed as representing the past. The people seem to display shadow areas of Wanda's psyche – stupid authority, naive compliance and support made powerless. But the god's action causes a differentiation of consciousness. The right side, sometimes seen as representing the present or future, contains houses and trees. The houses resemble a new building site in an undeveloped area and seem endangered by the loose sand and the stormy sea. The struggle to build a house/home of one's own is still unresolved. Nearby trees could protectively hold down earth and shade houses, but instead they hide a spiky shell. Joy as an elevated mood seems as unreachable as the bare mountaintop. Yet the summit is visible. Although nothing lives above and so much sorrow is still below, joy and exaltation may be conceivable. The silver-penny tree and grandparents are above the halfway point.

Sandworld B11: Rounded path and a blue egg

Wanda had visited the kibbutz and felt criticized by her mother's seeming lack of acceptance of the loss of Wanda's child and her infertility. Wanda

criticized kibbutz parents leaving their young children alone, but regimenting everything. She had gotten her period despite hormonal treatments.

In this sandworld (see Plate 11), untouched sand supports a semi-circular path divided into left and right sides by a specific choice of objects and colors placed on either side. The entire path forms a canopy for a solitary blue egg in the lower right area. Beginning on the right facing counter-clockwise, red-haired Gingi in a wheelbarrow is joined by an orange-haired clown. The clown may represent the active male energy she needs to push her wheel-barrow. The clown, like Wanda's father, uses the strength of humor in coping with sorrow. Wanda saw the clown as smiling and crying, like her own mood transitions each month. Gingi and her father/clown walk together towards a place of loss. He has lost mother, father, wife and son. She has lost son and brother. Wanda said: 'If the clown is my father, this is his story. Then mother is the egg. Then children are born to him. And he lost her a long time ago. Then he lost his mother, and Nir, and his father. This is my story too. Like my parents, I am a child and an adult, a clown and Gingi.'

The clown as a trickster deflates others' ego by tripping them, indirectly expressing aggression. The trickster as saviour punctures existing reality and opens up new possibilities. Wanda may now draw nourishment and energy from the clown, to feed her creative potential and push herself forward to salvation.

Three pink babies in a second wheelbarrow, six red, yellow and green vegetables and two steaks form the path in front of Gingi and the clown, completing this warmly colored segment. A wagon-full of babies pushed by a caretaker is a traditional kibbutz sight. It may represent Wanda's image of childhood as a collective event diminishing her personal identity. Yet the cart and food are available when needed.

A stream of blue sea glass continues the path on the left, intersected on either side by five objects: two grandparents, two white babies and the small blue and red rowboat. The grandmother, a great mother figure, guards the blue path's entrance above like the gatekeeper of the 'Land of the Dead'. The grandfather, a great father figure, standing at left center below, may be he who permits exit from the Land of the Dead, perhaps to a white baby closing the path at bottom. Another baby and the rowboat stand on either side of the path's center. In some myths and legends, boats are vehicles of transport over water, connecting the banks of the land of the living to the land of the dead. The boat here was used in sandworld B7 (Plate 10) as a vehicle for the metal

god to rescue a pink baby from the land of the dead/kibbutz to a land of life still undefined. Here it may transport spirits to rest.

The road's two segments create an integrated path of new colorful life and mourning. Gingi must cross onto the left side of this road, where warm colors become blue and mute in death, where familiar configurations disperse and lose their power. The path must be journeyed before the beginning of recovery into life can be realized, symbolized by a blue egg.

A solitary blue egg waits patiently in the lower right corner, an area sometimes representing the relationship to the personal mother and family (Ammann 1991). In two previous sandworlds the egg had no clear role. Now it focuses on new life waiting – a baby – and Wanda's changing attitude towards herself as a fertile healthy woman. The egg's rich turquoise color mirrors the blue sea glass and contrasts with the empty, ghostly white eggshells of the initial sandworld. The sea glass has become a road between death and life. The scattering of the grandparents, boat and white babies on alternate sides of the sea-glass path recalls the dispersing of objects in sandworld A12 (Plate 7) that signified the ending of the rite of separation from Nir. There is no feeling of fear, or confrontation. In Wanda's ego consciousness, male and female forces walk together on a road through death into life. Although the clown is a diminished form of masculine strength and Gingi is still a small child, this sandworld may announce a change towards involvement and commitment to the slow process of individuation.

Sandworld B13: God and goddess in womb

Wanda said that people with no fertility problems thought those who did have them should seek emotional help rather than medical treatment. She herself thought it important to see doctors and continue fertility treatments.

The idea of containment is being established by a protective pear-womb shape in the left area of the sandtray (see Plate 12), its well guarded narrow entrance opening upwards. This womblike enclosure was made by moving a large round white-clear crystal ball through the sand, leaving an imprint at an enduring depth below the surface like a moat. Incising this meaningful deep path may indicate a bodily forming of a more receptive womb. It is filled in with sea glass, abundant at the bottom and sparse at the top. Inside at bottom are three objects. A turquoise-colored metal fertility goddess appears for the first time, facing upwards, as if the blue egg of sandworld B11 (Plate 11) has transposed into her, the feminine guardian of the eggs. She represents the

fertile benign Great Mother and on a personal level Wanda's growing trust in natural processes, her own intuition and outside help.

On her right are the crystal ball that made the track and a smaller silver ball, which leaves a straight inner track in its descent from the top. In the upper left part of the enclosure are a red marble and a red star. The small African god guards the upper entrance facing outwards. Before him is a red tear-shaped jewel. Wanda said that this sandworld resembled a womb, the woman inside, and the male guarding the entrance selecting what comes in, good, not good. She related red colors to the man, blue to the woman. She saw them both as protectively aggressive, standing with their hands ready.

A semi-circular enclosure above an object appeared in sandworlds A27 (Figure 17.9), where a chain of small objects distantly frames a lone birthing woman, and in B11 (Plate 11), where a path made of small objects leads to and protects an egg. This secure womb encloses numinous events. The path made by moving an object through the sand recalls the tractor's track in the initial sand scene. Two white round objects are used to form paths, the large forming the periphery, the smaller an inner path. In previous sandworlds, roundness appeared as a small pond. Here roundness is three-dimensional, the round objects taking space inside a protected enclosure.

A masculine–feminine relationship in Wanda's work became clear with the grandparents of sandworld B7 (Plate 10). They are cutely positive but almost cartoon characters. In sandworld B11 (Plate 11) they end their joint function on the mourning path, while a second duo, Gingi and the clown, enter the life path together facing the same direction. Although more lively, the clown and Gingi embody a diminished non-threatening form of male–female relationship. The god and goddess of sandworld B13 have forceful differentiated roles. They stand apart but share a common direction and goal. The goddess seems to possess massive womanly power, while the small god discriminates between the good or not good that wishes to enter the womb. He infers an ability to guard, be on guard and be guarded. Wanda has begun to differentiate with less generalization between trustworthy people and others, accepting help from supportive sources. The ability to discriminate is a masculine logical function that now aids her in maneuvering her life and body.

Red and white as colors are transformed from their initial links to tragedy and death. Red first appeared as tractor, a tiny apple and steak. It then colored the red roses for mourning Nir and the red-roofed houses clutching the bare slope of a pointy mountain. Red here is more like rich menstrual blood

signifying healthy eggs and the blood of potential life. White was a rose of mourning for a brother, eggshells, a dead baby and a silver-penny tree. Here the whitish crystal and the translucent white glass ball are positive and hopeful. Red and white are in the presence of a fertility goddess and god as new life waits to be conceived. Wanda will become pregnant naturally in three months' time.

The color scheme of this scene, red, white and blue, is a frequently used tricolor scheme of the flags of about twenty-one countries around the world. These colors may symbolize qualities necessary for independent states, such as hope, revolution towards a new order, brotherhood, equality and freedom. The little African god brings the gold color that could symbolize wisdom and knowledge, adding this to the symbolism of red, white and blue.

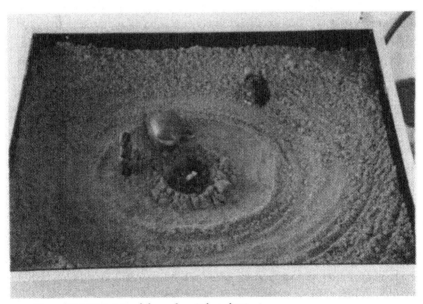

Figure 18.1 B15: Mandala, gods, witch and Gingi

Sandworld B15: Mandala, gods, witch and Gingi

Wanda decided to end fertility treatments, and went to a reflexologist and a healer. She looked good, with more light and energy in her face and body.

After 44 sandworlds, Wanda has decisively taken hold of the center (Figure 18.1). In the sand she created a series of concentric circles framing a

deep central pond-mandala where three forms of water are present. Jung considers the mandala or magic circle to be the path to the center and the center itself, the psychological expression of the totality of the self (Jung 1933/1950, CW9.1, par.542). The central opening reveals the blue symbolic water base of the sandtray. Poured to the brim inside is sea glass, another form of symbolic water. The sea glass and blue symbolic water did not suffice. Wanda filled a small Greek amphora, an earth-colored feminine vessel, with real water, placing it to the left above center as if pouring into the center. Some water dripped onto the glass, causing it to sparkle in a ray of light. The flow of water from above to below is an event preceding the beginning of life. Underground water became accessible as a pool in sandworld B5 (Plate 9). Now water has returned to the upper source and is poured into the well-pond. In seven previous sand scenes a blue depth occupied the center, and of these five inferred a monstrous or poisonous presence. This sandworld with its positive and fecund center clearly represents a meaningful change in the balance of the psyche.

Subtle distinctions in width, height or flatness of the sand define three territories. The first is the central pool slightly protected by a low ridge of sand. Outside this, a round larger flat plain of sand encompassed by a very low ridge becomes a second territory. Beyond this, lightly drawn circles in the textured sand create an outer territory.

In each of the three territories one significant act joining pairs of opposites takes place. In the center water descends from above to below, joining the upper waters and the lower. Jung writes: 'In nature the resolution of opposites is always an energic process: she acts *symbolically* in the truest sense of the word, doing something that expresses both sides, just as the waterfall visibly mediates between above and below. The waterfall itself is then the incommensurable third' (Jung 1955, CW 14, par.705). Here the manmade feminine container pours water into a natural well.

On the left center of the middle territory the turquoise goddess stands with the small god close in front of her, both facing the central rite in the glass pool. She is large, he small. She seems to preside while he guards. She is fully feminine, he masculine, a pair of opposites working in unity.

In the upper right of the outer circle Gingi and the black witch observe the central rite standing comfortably close. This unifies feminine opposites, the innocent little girl and the demonic witch. The witch appeared ambiguously in sandworld A10 (Figure 17.4). Here she is supportively close and Gingi is not frightened. Their colors, warm red-orange and black, may

represent fire, the agent of transformation. In kibbutz life, communal living may cause disowning of the shadow. Wanda was trained to be critical of others' imperfections and to hide anything not communally acceptable in herself. But hidden things fester and can become infected. The tragic loss of her first son, strangled before birth by the umbilical cord, happened within Wanda's body. Her body was responsible for her child's death. The witch's presence here together with Gingi may represent a coming to terms of the innocent kibbutznik with a monstrous shadow. The body can be freed from its shadow destiny and procreate healthily.

Wanda continues to differentiate between helpful or uncaring people around her. She is more central in her own life and in the outside world. Again there is no struggle in this scene, no victim and no saviour. Consciously Wanda is willing to trust natural processes and has stopped fertility treatments. This may mirror an inner liberation from the terrible feminine. The witch and goddess, two archetypal feminine representations whose powers can be used benignly, imply a stronger differentiated feminine ego.

Jung in his 'Commentary on the Secret of the Golden Flower' says:

> The beginning, where everything is still one...lies at the bottom of the sea, in the darkness of the unconscious... I know a series of European mandala drawings in which something like a plant seed surrounded by membranes is shown floating in the water. Then, from the depths below, fire penetrates the seed and makes it grow, causing a great golden flower to unfold from the germinal vesicle. (Jung 1929, CW 13, p.34)

The spark of fire may be a ray of sunlight, or the witch, Gingi, red and black. Water *is* the center.

Sandworld B16: Three pools – from cold to heat

Wanda spoke about hot and cold things together, her father as heat, her mother as cold, water on stones in sandplay, going to a ritual purification bath, going to the sea. She felt that water would push her to move and make a transition. In kibbutz she always felt that she went against the flow.

The base of this sandworld (see Plate 13) is a diagonal axis formed by three round pools of different color moods, placed in the lower left, center and upper right. Beneath the surface subterranean passages made by a small stick join the pools, allowing a flow of pure underground water or eros as connecting relating energy. Each pool has an observer outside and above it to the left. The three observers – a black witch, a blue fairy and a red-haired

clown – may infer an expanded ability to mediate different events in various ways.

The enlarged central pool reveals the blue sandtray bottom covered with scattered turquoise sea glass. This pool rests on the tension between the contrasting cold blue or hot red pools below and above. Gingi sits in its center. In previous scenes she represented Wanda as the young initiating creative child from whom she separated historically at a young age. Here, she may represent a living child with character, and she is watched over by a Great Mother representation, the blue fairy. She is also surrounded by protective sea glass, and the luminous white marble to her left, a life-giving seed. Gingi has the colors of the father/clown. Her blue fairy has the pale blue and white colors of the rejected negative mother, but in a favorable feminine role.

A blue fence separates Gingi from an intense confrontation in the lower left pale blue pool, between a white bride with a glass crystal at her feet and green Statue of Liberty, all observed by the black witch. Wanda identifies the bride with her unaccepting argumentative mother, hard, distant and cold. She chose the bride for the white of her dress. In the past, white was linked to death, as white eggshells, white rose, white baby. The white bride could represent the family's decision to live in the deathly collective. Wanda's goal is to build an autonomous family, and not allow this dangerous white color to freeze the central life-giving white seed. The witch, as shadow, could once have threatened Wanda and caused inertia. But witches can persistently instigate a move towards development in others. The bride, or that part of Wanda, must liberate herself as a woman from the collective, use freedom, the Statue of Liberty, to transform the feminine into a more mature, liberated and individualized Wanda.

The upper right red-based pool contains a large red apple, fire and a red-capped dwarf, childish and a bit immature. The red-haired clown, identified with Wanda's father, observes from above near an empty red chair. Wanda thought this was 'a very nice place, like an amusement park, a place to stay small, play at life and not really live'. Amplified by three red objects, the clown and dwarf may represent earthy masculine powers, indicating more involvement on the instinctual emotional level. This red circle is opposite in color, temperature, placement, sex and emotional activity to the pale blue, cold feminine pool below. The clown stands near a chair which was 'God's chair' in sandworld A11 (Figure 17.5). The God chair may represent an ultimate life-giving power. Once the kibbutz could confer life roles. Wanda

has differentiated between her father's humor and nurturing qualities and his kibbutz life role. The warmth of this circle is accessible to Gingi in the center, with no barrier between them.

Wanda sees Gingi like an 'angel', different from the father-clown and mother-witch, who are opposites. Above surface both father and mother are considered less than positive. She accepts her childish father more than her argumentative mother, and through him accepts more her own warm, childish and naive animus. Wanda became pregnant just after creating this sandworld.

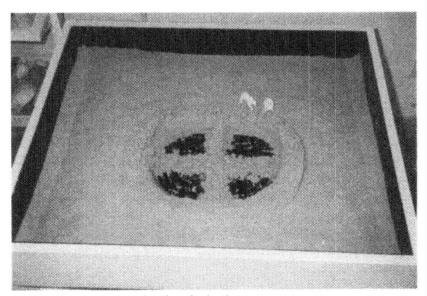

Figure 18.2 B17: Squared circle with white bears

Sandworld B17: Squared circle with white bears

Six weeks after sandworld B16 (Plate 13) Wanda returned from a trip to Paris, six weeks pregnant. She feared showing her happiness because of her past bad experience. Wanda thought that perhaps she had taken her first pregnancy too easily, working as usual. She said: 'But in therapy all my fears of kidnapped babies came out. I was surprised when I saw my baby, so big. How could there be such a large place inside my body? Now there will be a place, but I fantasize that I'll have twins, to spare another birth.' The second

birth would be in April. She imagined bringing the baby to Nir's memorial ceremony. Yet she could not be pleased with herself and criticized and devalued her work.

Wanda created a central pool reinforced by a small ridge (Figure 18.2). She filled in the shape of a cross inside it and smoothed all the outer sand. She thought the cross strange, perhaps 'connected to churches in Paris, or a heart with four ventricles, or a pulse, or the ultrasound tomorrow. Or just something organized'. She talked of her fears based on past experience. At the end of the session she placed two white bears above the center to the right as protective powers.

This squared mandala with its protective ridge represents the totality of the self – a circle and being at home in the world – the square or cross. The ridge is no longer a toilet seat. Bears represent powerful maternal instinct and fierce protection of their cubs (Bolen 1984). Their resurrection, awakening from winter's hibernation with new young, is a 'profound metaphor for our lives, for return and increase coming from something that seemed deadened' (Estes 1992, p.357). Bears are playful and may symbolize the compensatory function of play in the psyche in the face of Wanda's anxiety. The bears are white, a color that represented death in many of Wanda's sandworlds and has begun to change into the translucent seeds of life. The bears occupy the area of the white eggshell graves in the initial sandworld and may be the transformation of the two dead spirits – brother and son. They look towards the circle and are perhaps entering it. This sandworld reflects the psyche's efforts to stabilize, find reassurance and divine protection.

Wanda

Abundance and Divine Protection

Introduction

In her sixth month of pregnancy Wanda began to feel better and a positive change manifested in her sandworlds. She and her husband had gotten a dog whose instinctual nature she enjoyed and learned from. She was pleased with her work with adolescents and felt that mourning her brother and her baby was knowledge she could use to help others. Yet, she would feel more certain after the birth.

In her seventh and eight months of pregnancy, Wanda did a series of three sandplays at two or three week intervals which seemed to acknowledge archetypal forces protecting and preparing her for the new birth. Their common form, color and choice of objects are the background for an inner psychic movement accompanying her growing pregnancy. A central mandala grows in size in each sandworld, just as her pregnancy grows visibly. The turquoise goddess is central in each and the use of male and female metal objects increases until the third sandworld (Plate 15). Enormous red strawberries and apples, like the blood-fruits of life, move from the peripheries to the center. They burst forth in great contrast to the minute fruits of earlier sandplays, just as Wanda is bursting forth as a woman. Many masculine forces are present. The African god, a row of five metal soldiers, a group of six motorcyclists, a fisherman and a buddha alternate throughout the three sandworlds in roles that are protective or require patience. The three sandworlds, B19 (Figure 19.1), B20 (Plate 14) and B21 (Plate 15), will be discussed as a group, after a description of each and Wanda's comments. Sandworlds B23 (Figure 19.2) and B26 (Plate 16) close the process.

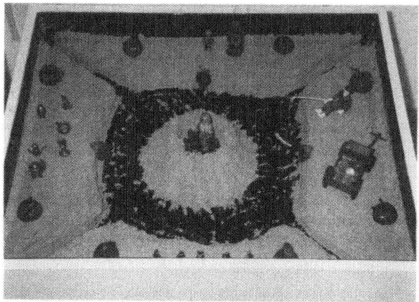

Figure 19.1 B19: Fertility, goddess, squared circle

Sandworld B19: Fertility, goddess, squared circle

The fertility goddess emerges from a central sea-glass filled crater in a round island emerging from a blue square (Figure 19.1). Four blue diagonals connect the island to the corners, creating four continents. On each are two red apples and a strawberry. Three continents – top, left and bottom – support metal objects. At top center the metal male god stands near a red metal kerosene lamp. On the left are six small metal pots. At bottom is a row of five metal soldiers.

The fourth area to the right presents ordinary everyday life. A red-clothed fisherman on the bank hooks a fish. Nearby is a wagon containing abundant food and fruit.

Wanda commented on this sandplay:

The center could be a tomb. This and the metal pots reminded me of my farewell from Nir. The woman in the center is blue. I needed red all around except for her. There are many men, the god above, soldiers below, and food to the right and left. I needed the fisherman, his red color. To sit and fish and wait suits me. But his face is stupid, a kibbutznik. The sea glass and the pots – I won't be able to separate

between my farewell from Nir and from the last baby's birth, really, until this time passes over in peace.

Sandworld B20: Red pre-birth ceremony

The large central mandala – like a uterus – is ringed by blue water abundantly filled with fish and sea glass, separating inside from outside (see Plate 14). The turquoise goddess lies in the mandala's center surrounded by eight large red fruits – four apples and four strawberries. To the left of her head is the silver-penny tree and to the right one white rose.

Outside the circle are three groups. In the upper left a row of seven powerful male motorcyclists protect the mandala from intrusion and do not invade themselves. On the right, the little brass god sits quietly between two red roses and one white rose behind him. In the lower right a few fish, a dolphin and penguin and some plastic seashells playfully spill out of the water onto land forming a loose triangle shape pointing towards the lower right. Wanda commented on this sandplay:

> I thought about a special ceremony, the woman in the middle giving birth. There is blood, sexuality, femininity, but not alone. This is the way to give birth. The white is something like a wedding ceremony. And also death, the last birth. On the right is the corner of the African god. In the upper left are many motorcyclists, aggressive but they know the rules. They will not enter, they have come to protect. The fish are movement, and protection. The lower right corner is like a children's room, I have to prepare toys for the children's room this time in the sand. After the death of the first child I can't prepare them in reality. The motorcycles remind me of something funny. My husband had a motorcycle accident and stayed at home six months. This contributed to the decision to get married. The silver-penny tree represents a separation, and also protects the woman. It is a sad tree, somehow connected to the white flowers. There are eight red fruits in the center, like my eight months of pregnancy. The white flower is the ninth month, frightening.

Sandworld B21: Six weeks before the second birth

A large central blue-ringed mandala covers almost all the sandtray (see Plate 15). All objects are concentrated within it in three areas. The sand outside is empty. At top center left inside the mandala cluster six large red apples and a gold Buddha surrounded by three black objects: a sheela-na-gig (an Irish

fertility and birthing goddess), a totem and a long wooden African bird diagonally guarding the upper left.

A second cluster consists of a fine metal chain encircling seven metal pots, two metal rods and two metal goddesses. The row of pots guards the lower right periphery within which the turquoise goddess lies as if giving birth. Above her head stands a woman holding a jug on her head. Another chain connects the Buddha to the metal pot at the goddess's feet.

Another less obvious group lies to the bottom left. Above the chain in center a large metal fish points downward, its body parallel to a row of five soldiers below the chain. Wanda commented on this sandplay:

> In sand I make a transition from words and rationality. I feel that giving birth is an upheaval for the body although the last time it was alright, but the birth of the dead baby spoiled *this* delivery for me. This time I want to be 'me' there, want a natural birth, no epidural. I can stand the pain. We won't prepare anything for the baby, because of last time. Not even a name. But it's not so hard *not* to prepare things. I can do it in the sand, even prepare a Brit Mila (circumcision). The women are on the right, the men on the left. The fish connects something. Not clear if he brings something to the woman, or if he will take the baby. He is waiting. He has something good, and something frightening. The soldiers protect, above are primitive forces. On the right are feminine forces.

Analysis of sandworlds B19, B20 and B21 as a group

Wanda's psyche is now constellated, and working towards retaining faith by building and playing. There are moments of threat when belief and doubt flip back and forth. In sandworld B19 (Figure 19.1) the center could be a tomb, although the fertility goddess is rising there. The sea glass and metal pots recall the parting ceremonies from Wanda's brother and baby (sandworlds A12, Plate 7; B5, Plate 9) even though they have been imbued with new power and nurturing water. The patient fisherman suits her but she devalues him with his 'stupid face, a kibbutznik'. In sandworld B20 (Plate 14) she creates a vibrant, throbbing birth ceremony, strengthened by acceptance of the sad silver-penny tree. Yet the triumph of eight life-affirming months of pregnancy, symbolized by the red fruits, is endangered by the frightening white flower – the ninth month of pregnancy, the finish line between joy and loss. In sandworld B21 (Plate 15) she has never been so clear, strong and differentiated. Yet the large metal fish in the center activates

her ambivalent trust/mistrust. Does he bring gifts, or swallow/kidnap babies?

The central mandala expands until it is a world containing all objects within it. Considering Wanda's frugal use of objects it is significant that new objects are introduced each session, most for just one sandplay. This richer range of expression and appetite to try new things might reflect a new-found legitimacy to enjoy rather than criticize herself.

Of the new objects, the large red apples appear in all three sandworlds. Other new objects from the first two sandplays do not return in the third (red lantern, red fisherman, food cart, four red strawberries, seven motorcyclists, and assorted sea creatures). The third sandplay contains five completely new objects (black bird, black sheela-na-gig, golden Buddha, metal fish and standing goddess with water jug), joining the apples and soldiers introduced in sandworld B19 (Figure 19.1) and the familiar fertility goddess, metal pots, totem and chains.

Seven familiar objects (African god, silver-penny tree, red and white roses, fertility goddess, chains, pots, totem) link this series to key moments in the entire process. Three of them, the god, silver-penny tree and roses, end their mourning role in sandworld B20 (Plate 14).

Four other familiar objects crystallize their roles in sandworld B21 (Plate 15), the last of the series. The fertility goddess appeared in sandworld B13 (Plate 12) within a womblike enclosure and maintained her essential central role throughout. The chains ambivalently boundaried a lonely birthing woman in sandworld A27 (Figure 17.9). Here they clearly connect and contain. The metal pots were empty sound-making objects in sandworld A12 (Plate 7), and in sandworld B5 (Plate 9) became containers of nurturing water. Here they are containing and protective. The black totem played unclear games with the black witch and blue fairy in sandworld A10 (Figure 17.4). The witch and fairy later helped prepare for pregnancy and now the totem joins the protectors.

Sandworld B21 (Plate 15) crystallizes the essential masculine and feminine powers and transforms mourning into new life force. The simple blue circle suffices to protect and separate inner from outer. Three protective aspects are defined. The borders must be secured, the divine protection of spirit powers is needed and preparation as protection for the coming birth is a priority. Male and female forces participate in these three goals. The upper right is the only open undefended area. Perhaps it is open towards the future.

The color black took form in Wanda's work three times as a witch and once as a totem. Suddenly, black bursts forth in a protective role with seven black motorcyclists in sandworld B20 (Plate 14) and three archetypal forces made of black wood in sandworld B21 (Plate 15). The long black bird, a masculine spirit, protects the upper left with its body. The black totem links to ancestral nature power. Sheela-na-gig will insure a successful birth. Significantly, three white objects of sandworld B20 (Plate 14) – the silver-penny tree and two white roses, which integrate mourning with new fertility, disappear in sandworld B21 (Plate 15). The three black objects may replace the three white ones. The spontaneous constellation of great male and female forces predicts that the bodywork of birthing will go well.

In B21 (Plate 15) the mandala's inner territory is divided into objects made of wood or plant growth above, and those made of metal below. No ordinary natural life is visible, no real people, animals, fish or flowers, and nothing made of plastic. Metals as the embryos of earth symbolize the birth that will take place. The upper powers exist in infinity and can be of grown wood.

In sandworld B21 (Plate 15) the central large metal fish seems serious, its metal weight linking it to birth from the earth. Such a large fish might be mythical, a whale creature whose belly is a place of death and rebirth. It could represent the danger Wanda fears, swallowing a baby as the whale swallowed Jonah. But after a period of initiation in darkness one emerges into life, resurrected and reborn (Campbell 1973). Fish may symbolize the phallic, fecundity, procreation, life renewed and sustained. They swim and move freely through the waters of life. This fish faces downwards. 'Fish swimming downward portray the movement of involution of spirit in matter, and swimming upward, the evolution of spirit matter returning to the first principle' (Cooper 1978). The fish may be pointing towards material realization of the birth. Yet Wanda must be modest. The ambivalent role of the large fish can level inflation and keep her sensibly cautious.

Two tiny fish, one yellow, one green, and a tiny shark first appeared in the center of sandworld A5 (Figure 17.2). This can now be understood as the creative and dangerous potentials of the unconscious. The fisherman in sandworld B19 (Figure 19.1) catches the yellow fish. Yellow is the color of rational thinking. Catching fish symbolizes the ability to enter the sea of the unconscious and bring its fruits up into consciousness. In an overflow of 'consciousness', fish and sea creatures in sandworld B20 (Plate 14) burst out

of the blue circle into the lower right area of home and family, playfully populating it.

In keeping with the general increase in these sandplays, masculine and feminine roles have expanded and diversified. Three male roles in sandworld B19 (Figure 19.1) are represented by the god, a fisherman and soldiers. The god stands alone, distanced from the goddess with whom he presided in fertility rites before the pregnancy. He complements the lone fisherman whose fish is the reward of patient slow work done in the waters of the unconscious. Five metal soldiers stand ready to provide physical safety. In sandworld B20 (Plate 14) two male roles are depicted. The god sits in the fisherman's place between the red and white roses of mourning in their final appearance. Defense is provided by seven motorcyclists on the upper left. The soldiers return in sandworld B21 (Plate 15) to share the internal protection of the left side of the circle with a black bird. The god who supported Wanda's mourning process and aided in her fertilization is gone. His solemnity is not appropriate for learning to enjoy life and so a wise and joyous golden Buddha replaces him. The Buddha is surrounded by red and black objects which may replace the red and white roses of mourning. The bird and totem amplify male spirit power.

The feminine is consistently represented by the fertility goddess and the brass pots. The goddess has moved within the circle to lying position on the lower right in sandworld B21 (Plate 15). She is joined by sheela-na-gig and a woman carrying a water jug, augmenting the feminine force in addition to the metal protective feminine vessels nearby.

The large fruits are consistently present in all three sandworlds, decreasing in number from twelve to eight to six. The four strawberries in the first two sandplays disappear in the third, when a group of six apples supplies the redness within. The fruit of the process of therapy and the womb, a baby, is soon to be born into the real world. The tiny apple of the initial sandplay has proudly transformed into a vibrant sixfold presence of apples. Number six represents a perfect male–female balance, illustrated by two triangles, the male pointing towards heaven, the female towards earth. The rich nourishing food in the containing cart of sandworld B19 (Figure 19.1) contrasts with the scattered sparse food of the initial sandworld, and the juicier food of sandworld B11 (Plate 11) forming a path.

Sandworlds B19 (Figure 19.1) and B20 (Plate 14) are fairly symmetrical. Sandworld B21 (Plate 15) is dynamically formed in the shape of a vague triangle within a mandala. Symmetry is abandoned in favor of a creative

balance of equal male and female objects. The triangle's apex is shaped by positioning three black powers around six red apples and a golden Buddha. Red, black and gold transform the red, black and white of trauma and mourning in the initial sandworld into deep life force. The left base consists of the soldiers and the right base the feminine group. The large fish almost marks center. A triangle pointing upward symbolizes fire. Although not a clearly defined triangle, the idea of fire at the apex, the red, black and gold, is perhaps appropriate. The fish swimming downwards and involuting spirit into matter may bear the fire of transformation pointing towards the birthing goddess. At the same time the blue of the goddess and the yellow metals transform the depressive beige, yellow and blue colors of the left side of sandworld A1 (Plate 4) and the blue and yellow upper left colors of sandworld A12 (Plate 7) – the exit of the blue fairy.

In sandworld B21 (Plate 15) water is innate, in the simple blue circle, in the pots and the woman's jug, and through the large fish. No sea glass is used.

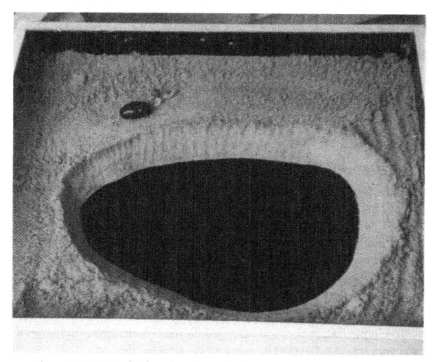

Figure 19.2 B23: Individuated mother and baby

Sandworld B23: Individuated mother, individuated baby

Two weeks before the birth, Wanda is slow, heavy, round and fat. She smiles easily and often. Her last sandworld before giving birth features a large egg-shaped clean blue lake of still deep water, whose patted down slopes descend slowly towards the center (Figure 19.2). The lake is Wanda's largest contained water area yet, shaped like the turquoise blue egg of sandworld B11 (Plate 11). The egg's color is transformed into a mature dark blue, an adult 'egg'. The surface is clean, as if calmly waiting the delivery of something precious from its depth, into the world.

The surrounding sand is flat but has been worked into various textures, differentiated tactile expressions of body/earth. This ground substance is energized like a body with new life. Every grain of sand has been touched. Above to the left, a baby crawls towards a dark blue stone, shaped and colored like the lake in miniature. The baby and egg are clear objects, new forms of life entering the world. Their sharp focus and the differentiated sand textures are mutually enhancing. Wanda said that the blue stone 'egg' could be a rock for the child to play with, 'a rock on a hill with wild cyclamen'. She saw the pool more as a womb, something she would have to go through. 'I can't see inside it, if it is the pregnancy. There are things that I can't see yet,' she said. Meanwhile she and her husband had thrown out a lot of junk, making an empty space. Garbage as a protective enclosure, as in sandworld A29 (Figure 17.10), is obsolete. She came once more in early April and we just talked, a few days before she gave birth as she wanted to.

Summing up

Wanda came for three follow-up sessions. Her baby son was four months old and growing well and Wanda looked wonderful. Her mother regularly helped care for the baby, but Wanda reported that she overstayed and gave the baby to Wanda at 'feeding times'. This awakened issues of resentment and rivalry. She felt her mother did not give her warmth and confidence. She thought that her natural devotion to her baby might have been learned from caring for the dog she got when she was six months pregnant! She wasn't afraid of making mistakes with the dog and she could love and give warmth. She became assertive and less afraid that her baby would accept her mother as his mother. Her mother was quite jealous that Wanda cared for her own baby and would call herself Mommy while holding him.

Sandworld B26: Three phases

The structure of this sandworld (see Plate 16) repeats the diagonal thrust of three pools from lower left to upper right in sandworld B16 (Plate 13) preceding Wanda's pregnancy, a similarity she noticed. She felt that she was summing up her process. Of the three pools here, the sandbank of each is precisely rounded towards the blue depth and each slope is specifically textured. The slopes of the low left pool are packed down hard and steep. The central pool has wider softer slopes and the slopes of the upper pool are loosely textured. Objects are placed within each pool and on its rim. The hot and cold surface polarities of B16 were clearly differentiated while an unconscious underground flow communicated from polarities to center. Here the upper pool seems to represent a young developing state, a polarity to the lower pool representing a past state. In the central pool are both old and new objects.

The lower left pool confirms through its objects that it represents an earlier developmental state, or an older psychological state. Wanda had often worked in sand on something that was in the past but influenced the present. All the objects linked to this pool were used in past sandplays except for the old woman carrying wood. She stands where the black witch stood in sandworld B16 (Plate 13). This old, worn woman can look back on childhood and other events long past. Wood infers the warmth of a lit and contained hearth fire, the ability to be at home within oneself, like Hestia, goddess of the hearth and keeper of the fire. An old woman with wood may also link to the ancient wisdom of the three black wooden powers of sandworld B21 (Plate 15). The crone is now in touch with her inherent positive aspect.

The cows that were penned in cages wander freely. Once a symbol of feminine stupidity, the cow now seems closer to contentment and nourishment. Six cows walk clockwise and one little cow goes against the flow. The quality of not fitting in is how Wanda regarded her kibbutz role. But now this childhood role aids in Wanda's process of individuation and a healthier relationship to her own inner instinctual nature.

Gingi was the protagonist of much of Wanda's process. She bid farewell to a dead brother and to the kibbutz and was present during the first early pregnancy. She returned in sandworld B11 (Plate 11) to pair with the clown and complete a mourning process. She paired with the black witch in sandworld B15 (Figure 18.1), observing water poured into the center. In B16 (Plate 13) she was central in Wanda's process of becoming pregnant a second

time. She made one last appearance, still uncertain and lonely and needing reassurance. Gingi is alone in the lower pool, observed by cows and the crone. Wanda's child identity as Gingi seems old and worn as the crone and kibbutz issues.

The central pool retains the sea-glass base of the center pool in sandworld B16 (Plate 13), perhaps a tribute to its role, and includes a green blowfish and little god who both were in sandworld B20 (Plate 14). The two new figures are a young Indian girl inside and a young peasant woman holding bread on the left rim. The Indian maiden kneels, her pale blue color like the fairy watching over the central pool in sandworld B16. She may represent a transition of instinctual protection to within. She is a maiden, not yet a mother. Perhaps she kneels to the little god opposite in a gesture of religious feeling and gratitude. The god was a prime power in Wanda's mourning and in becoming pregnant the second time, mediating between grief and joy. The Indian maiden and the god have completed their roles and may soon return to the unconscious. The young peasant woman above brings nourishing bread, perhaps indicating a healthier nourishing ego. The central pool is a balanced and integrated ego state holding the tension of opposites, child ego below and nurturing mother ego above.

Wanda identifies the upper right pool with her present coping abilities and how much she has to learn, and indeed there are nine new figures. Within, a yellow Indian mother with papoose recalls the yellow fish hooked by the fisherman in sandworld B19 (Figure 19.1). Yellow is the color of intuitive thought and weighing decisions. Two playful pale green animals, a bunny and lamb placed one on either side of the mother, may be the toys that Wanda could not prepare before the birth. Green is the color of concrete reality. Light green may mean a fresh new reality.

The upper rim is encircled by six figures. A cute couple in an embrace sitting on a bench are in the center of the group. They observe like the grandparent couple of the past, but unlike the grandparents they seem lovingly interested in life.

To the left of the couple are a cute alert baby and a young peasant woman with a water jug. To the right is a large green ceramic turtle and another young peasant woman. The two peasant women face each other, increase the feminine presence and perhaps guard the entry to this pool. In sandworld B21 (Plate 15) a metal goddess bearing a water jug helped prepare for the second birth. This earthy woman brings water into real life. The tiny cute baby and the green ceramic turtle may both symbolize new beginnings.

Bradway and McCoard (1997) note that the appearance of a turtle in a final sandplay is fairly frequent. The mother/therapist 'abandons' a client just as turtles are abandoned by their mother after eggs are laid. The turtle faces the ocean alone and navigates through life using inborn instincts that bring the turtle home again to lay its own eggs as a mother. Wanda's instinctual growth enables navigation in the world outside the kibbutz.

The center pool contains two new and two used objects, a balance. The total number of objects linked to the lower pool is nine and each one has been used previously. There are nine objects as well connected to the upper pool, but they are all new, perhaps replacing the nine worn out objects representing past aspects below. In many cultures the number nine is auspicious, closing the circumference of a circle (4 × 90 degrees) and referring to eight directions and center. As a triple triad, it is created by 3 × 3. It signifies 'completion; fulfillment; attainment; beginning and end; the whole; the Earthly Paradise' (Cooper 1978).

The dominant feminine presence in this sandplay is defined by eight women figures used – four peasant women and two Indian women as related to earth and nurture, Gingi as the young intuitive child and the woman as part of a loving couple on a bench as Eros. The cows and turtle augment the motherly aspect. Within the pools an inner feminine line of growth progresses from Gingi the child growing into an Indian maiden and then a mother. The outer aspect or reality is mirrored on the rims above by the tired crone of the past, the woman with bread, the woman with water and the woman on the bench – potential fire, bread, water and love. The man on the bench transforms the god's masculine solemnity and the playfulness of the clown–father of sandworld B11 (Plate 11) into love. In Wanda's psyche there has been a joining. The empty chair in the upper right in sandworld B16 (Plate 13) is now a fully occupied bench with a loving male–female couple.

Conclusion

A major issue for Wanda during therapy was the struggle for individuation on the background of the inner voices of her collective upbringing, censoring individuality and rights to personal ownership. She prepared for criticism in work and social situations although on the surface her performance was usually exemplary. In her inner world, childhood helplessness and shame caused others' opinions to be experienced like the negative intrusions of the collective. Her marriage, mourning, fertility and child seemed in danger of being claimed by the collective. The lack of value placed on personal

relationships or self-expression caused Wanda to feel 'irregular' and see herself as not fitting in. Shame surfaced in fantasies of her pregnancy as a monster, or herself as a monster. Her anger at her personal parents and at the collective adversely influenced her marriage and potential motherhood. Isolation and loneliness often seemed safer than belonging to any group. Wanda's achievement of healthy fertile motherhood became possible after psychic liberation from her captivity by the internal negative mother and negative father imagos. This was frightening at first, her ego lacking strength to combat both inner and outer worlds. Her work in sandplay bypassed her critical nature and defensive rationality, ultimately freeing her deeply sensual, body-intuitive creative self and creative strength.

Wanda's sandplay process according to Weinrib's stages

Stages 1, 2 and 3

The sandworlds done in the first phase of Wanda's therapy illustrate Weinrib's first three stages (see page 120). Her first sandworld presented an immediate realistic goal of mourning her brother and completing her thesis. A primary problem is her struggle with a collective mentality denying individuality, manifesting as fear of being visible and self-responsible. Other offshoots of this are an undifferentiated masculine and feminine and a monstrous disowned central shadow.

Healing potentialities emerge with the initiating innocent Gingi, accompanied by a tiny uroboros. The privacy of therapy became a trusted temenos in which to examine the edicts of communal education. A first milestone was Wanda's individual mourning rite for her brother. Partial resolution was accomplished by overturning the kibbutz walls and escaping over a rainbow wall. Gingi's young individuality was still not equipped to trust an alternate community, nor to alleviate fear of the monster within. Final sandworld images in the first phase seem fragile. In Wanda's use of sandtray space, the center or ego is used tenuously and infrequently. Organization more often occurs in quadrants and corners. For example, the upper right corner is Gingi's refuge over the rainbow in sandplay A24 (Plate 8), and again for the shell holding a god and violin in sandworld A29 (Figure 17.10), sailing between mountains of garbage.

Stages 4, 5 and 6

Wanda's first pregnancy ended in terrible loss, guilt and self-questioning remorse. Wanda and I did not know whether the first baby's death could have been prevented or predicted. Failure and grief spread through her, seeming to contaminate any second chance. To maintain hope both Wanda and I needed to identify signs of health and balance in which we could both believe. As an artist I related to her non-verbal language of art and sandplay which was so intuitively authentic and innately honest. Her sensual use of sand and precise organization and choice of objects could only originate from an inner healing source. Her aesthetic creative solutions possessed an instinctual knowledge of wholeness and balance that was often devalued because it was an individual trait. It did not help unravel her critical, pessimistic view of human relations from her indisputable basic life instinct. Psychologically the balance between her wounded self-esteem and sense of being a misfit tipped towards valuing herself as an individual, when a male god kidnapped a baby from the collective in sandworld B7 (Plate 10).

Despite fear and ambivalence, a differentiation of opposites begins with the pointy hill as center. Quadrants are used to differentiate danger from support. A grandparent couple reinstate a beginning positive masculine and feminine. Gingi and the clown continue the male–female coalition in sandplay B11 (Plate 11), confirming the 'emergence of the nascent ego … and an ensuing struggle to differentiate masculine and feminine aspects of the personality' (Weinrib 1983).

Stages 7 and 8

Wanda's ego has strengthened. She is more confident and able to talk about herself and all she has been through. In answering the call to go into the unknown in therapy she has suffered loss and realized the emptiness of collective ritual. She must create a new home within this emptiness. Her journey continues to bring pain before she can identify herself as a mother. Sandworld B13 (Plate 12) presents a god and goddess, in an anima–animus relationship working together on fertility, bringing water to the center. The ego concedes to the transpersonal powers working towards a successful birth in sandworlds B19 (Figure 19.1), B20 (Plate 14) and B21 (Plate 15).

Four months after the birth, a loving couple on a bench defines the male–female relationship. Wanda is an individual, a community member and a mother learning a new set of values. She views the world with a differentiated eye closer to a patriarchal level of consciousness. Her disowned

shadow can be seen as the normal desire of a small child needing warmth, love and protection. Little-cow-Wanda always felt she walked against the communal direction, which rationally dissected families as an ideal. She has listened to nature and instinct and in return has received a sense of divine protection.

Wanda's sandplay images activated processes of awareness, growth and healing. Her final sandworld illustrates three stages of working through the negative aspects of the collective and activating the positive feminine and masculine in the service of motherhood and her own existence.

The myth

Wanda's process contained several dramatic themes, any one of which could constitute a central issue of therapy. To mourn a sibling, mourn a son, struggle with infertility, carry a pregnancy to term successfully while coping with feelings of loneliness, defenselessness and guilt is an extraordinary combination of challenges. These rested on the long shadow cast by the kibbutz children's house. Like the heroine in many a myth or fairytale, Wanda is a sort of orphan, neglected by her competitive witch mother and stepparents, and left unprotected by a weak family structure. Her brother is taken from her and she seeks her fortune in the world alone, unable to return to her collective past and unable to create a safe home outside the kibbutz. Companionship comes from a little snake uroboros and unexpected help arrives from archetypal powers. She battles dragons twice: the kibbutz walls are overthrown and the little god kidnaps and saves a baby from the collective.

Acceptance of the dark shadow of guilt for the death of her first baby opens the possibility of collaboration between Gingi and the witch with help from archetypal forces that exist beyond her control. The home and hearth she seeks to build are preceded by making a place within her own body for a baby. Home becomes an internal space that is realized with full womanhood.

Wanda's personal journey in the real world entailed a rebirth from the ashes of sorrow and loss and individuation from the collective. Her psychological journey progressed from matriarchal diffusion towards the patriarchal in the formation of an individuated ego. Transpersonal powers aided in transcending loss and its debilitating power, towards reconstruction of life. The sandtray was the vehicle of a process that unfolded with an intrinsic sequence and power that meshed with her need for healing and growth.

Wanda's choice of art-making or of sandplay

During Wanda's three-year process, sandplay was the preferred medium of self-expression, except for a period of five months in the latter part of the first pregnancy, when she preferred gouache paint on paper. The first 21 sandworlds consistently reveal the symbolic blue water of the base. The representation of water disappears in five out of the next seven sandplays done preceding and during her first early pregnancy. The second and sixth sandworlds of phase B were also 'dry'. Thereafter, water appeared in various forms in the last 20 sandworlds leading to a successful birth and motherhood.

Concurrent with the 'drying up' of sandworlds at the end of phase A, a tenuous, sad and lonely quality is conveyed by them. Possibly, water was experienced in its role of producing a cohesive mud for forming. This would imply a commitment to being a visible physical body-container, holding together a womb-world for new life. Dry sand cannot cohere or be a container. It scatters, like the sand and flower petals in sandworld A12 (Plate 7), after the parting ceremony from a deceased brother. In a time of hesitancy and ambivalence, Wanda first 'dried up' and then stopped working with sand. She switched to gouache paint on paper, using water with control, allowing the paper to soak it up and refraining from three-dimensional work.

Wanda reviewed her process and her choices of sand or art for this writing. She said that working with sand helped to neutralize her rational and critical inner voices. Her strong self-criticism seemed to disappear as she played and chose a doll such as Gingi. To play was to be a child. In art she remained a critical adult. Yet art was something very personal that she could decide to do by herself, in difficult periods, to get things out onto the paper. But it was not play. Painting in the presence of an observing therapist who would not interfere while she worked left her alone with her conflicts, but with acknowledgment of her difficulty. When she 'played' in sand, she felt accompanied and observed and also enjoyed the joint observation of the sandworld. The possibility of change in play enabled her to find new solutions after viewing together, sometimes by simply turning an object, to find another point of view.

Wanda always painted when she used art, never choosing oil pastels, clay or markers that she felt blocked her. The issues that were worked on – pregnancy, menstruation, ovulation – all needed water, she said. She felt that the gouache would always have flow in itself, even though she might be busy trying to cope with critical inner voices.

Conclusion

Jungian sandplay, as presented in this book, has been viewed through the lens of art and art therapy. Exploration of the artistic vision of sandplay has placed emphasis on tactile and visual experience as a primary stage in the creation of a sandworld. The very nature of sand elicits the formation of universal structures from a sandplayer's hands. This occurs at the beach as an absorbing activity and in therapy as stages in a process determined by the needs of one's psyche. In general, self-created sand form has been given less definition in the sandplay literature, compared to the attention paid to the many meanings of already formed miniature objects. Current sandplay theory has fully encompassed developmental stages, symbolic meanings of miniatures and configurations and Jungian psychological underpinnings of the personal sandplay process within the interactive process.

The dominant presence of self-created sand form observed by the author in sandplay in the art therapy setting did not seem to be proportionately reflected in the literature. In the interest of balance, it may be advantageous to relate to the sandtray as a microcosm of the natural environment of limitless sand, endless ocean and infinite sky. This environment is a place where first experiences in creative forming are made and where play, art, spontaneity and cyclic transience are eternally linked. Playful forming of sand and water observed in beach play and serious self-created form observed in therapeutic sandplay have provided in this text the basis of a classification of forms. These forms have been categorized and linked to their meaningful symbolism and importance in stages of therapy and the client–therapist relationship. Understanding the potential of amorphous, transient sand and water may encourage in some way a more frequent use, and impact on the use of objects in relation to a preformed sand foundation.

The art therapy approach relies on materials, their properties and color in itself as a specific presence. Art materials have possibilities and limitations and may be intuitively used to express different strata in the psyche. So also

does use of sand, water and the substances of which objects are made express a distribution of psychic energy between nature and culture. This contributes an additional reference to understanding a sandplay. An artist often does not try to understand the artistic images that one needs to create, nor question why they are chosen. Making art necessitates moving beyond awareness of deficiencies, blind spots and criticisms that could prevent continuation of the process. It is essential to trust one's images and find for them forms to match internal sensations of their intent, opening one's consciousness to the flashes that ease the brain and hand into movement.

A reservoir of intuitive knowing is amassed through familiarity with the language of materials, colors, lines, shapes, directions, proportions and placement. The artmaker, whether artist or art therapy client, has paid time and attention to making images without expectations, alert for a form or configuration that feels right, to flow into the picture. Then, minimal verbal phrases such as cobalt blue, Naples yellow, burnt sienna, deep cadmium red, square, circle, jagged line, sand, water, stone, wood or plastic become a code for a great store of experienced information, which has become part of one's identity. A brief phrase such as 'a diagonal vermilion jagged line' or 'a large cobalt blue circle' may be intuitively understood as formed expression by an artist, but may sound minimally concrete to those without experiential acquaintance over time with visual creativity. The artist may feel that enough words have been used. The psychologist may feel that nothing has been examined beyond the concrete.

The underlying balance in Jungian sandplay can be seen as the balance between the uncertainty of creation from formless matter and an ability to select and place already formed objects. It is also the balance between one's own natural creative powers and the acceptance of what already exists in the world. A balance of natural materials with manufactured materials or cultural products may subliminally benefit the art therapy client and sandplayer by keeping one in touch with nature, representing natural health and healing.

It has been important to sort out the differences between creating a sandplay image, or creating a drawing or painting in art therapy. Basic precepts of sandplay, such as giving minimal directions, the unintrusiveness of the therapist, delayed interpretation and awareness of the triangular transference between client, therapist and image are fundamental to art therapy as well. The difference lies in the specific pre-ordained framework of blue-bottomed sandtray, sand and water and miniatures, a difference of materials, rather than of visual creative process. Sand and water are natural

substances that remain themselves in the sandtray. Options for their use are not versatile, due to the physical limitations of the material and the specific movements, directions and forms they elicit from the sandplayer.

Work begins when from the dark unconscious psyche, the stage of not-knowing beyond the sandtray's boundaries, a creative flow transports an image into the framed territory of potential consciousness within the sandtray boundaries. In Greek mythology, Charon the ferryman transported souls from the land of the living to the land of the dead and usually not back again (Bulfinch 1981). The sandtray reverses the movement of Charon's boat transporting from darkness into the land of light. But movement in the sandtray also flows outward, back towards the unconscious, mirroring the ebb and flow of tides and other natural cycles.

The visible sandplay journey from sandworld to sandworld may show cyclic flow and recurrent rhythms, sometimes spaced months and years apart. In art imagery, a similar psychic flow seems to move outward onto the paper, each new picture fixed permanently, revealing an aspect of the inner world. Review of series of artworks done over time also show recurrent subjects and patterns that change with their own rhythm. Yet, the sandtray is unique in its dynamic movement and immediate possibility for change. The transience of sand and water leaves the same sandtray open and receptive at the next session.

The rhythms of sand and water in nature are phenomena that may be shared as common knowledge. These substances are closest to the primordial foundations that first supported life forms and still do. Our joint knowledge of sand and water in our inherited collective unconscious seems to manifest in the sandtray through the creation of universal forms and in the psyche by common developmental stages. The larger shared natural rhythms, the tides, the seasons, the cycles of the sun, moon and stars, are evidence of different rhythmic cycles working in conjunction within a larger whole, maintaining individuality and commonality.

Intuitive knowledge of these rhythms is simultaneously shared although we are not always aware that our sharing is concurrent. For example, the northern hemisphere and everything in it shares the maturation of the sun's rays at their peak on 21 June, the summer solstice. Minimum light and maximum darkness are shared on 21 December, the winter solstice, as we hope for the sun to increase its light-giving presence. Solstice ceremonies acknowledging our common dependence on the sun as the ultimate source of life no longer unify people in ritual. Religious or secular holidays now

convey messages of commonality. Yet the sun's rhythmic peaks and lows are phenomena that unify people beyond territorial boundaries. Sandplay is a small way of regaining the commonality we have with other beings, as we create similar universal forms and replicate the cyclic rhythms that are natural to a life path.

References

Adamson, E. (1984) *Art as Healing*. Boston and London: Coventure.

Agell, G., Levick, M., Rhyne, J., Robbins, A., Ulman, E., Wang, C.W. and Wilson, L. (1981) 'Transference and countertransference in art therapy.' *American Journal of Art Therapy 21*, 1, 3–24.

Albers, J. (1963) *Interaction of Color*. New Haven and London: Yale University Press.

American Art Therapy Association Newsletter (1998) *31*, 4.

Ammann, R. (1991) *Healing and Transformation in Sandplay: Creative Processes become Visible*. LaSalle: Open Court.

Ammann, R. (1994) 'The sandtray as a garden of the soul.' *Journal of Sandplay Therapy 4*, 1, 46–65.

Anzieu, D. (1989) *The Skin Ego*. New Haven and London: Yale University Press.

Bennett, H.Z. (1993) *Zuni Fetishes*. San Francisco: Harper.

Betensky, M. (1982) 'Media potential: Its use and misuse in art therapy.' *Art Therapy: Still Growing. The Proceedings of the Thirteenth Annual Conference of the American Art Therapy Association*. Philadelphia, Pennsylvania, 20–24 October, 112–113.

Biven, B.M. (1982) 'The role of the skin in normal and abnormal development, with a note on the poet Sylvia Plath.' *International Review of Psycho-Analysis 9*, 205–228.

Bolen, J.S. (1984) *Goddesses in Everywoman*. New York: Harper and Row.

Bolen, J.S. (1989) *Gods in Everyman: A New Psychology of Men's Lives and Loves*. New York: Harper and Row.

Bowyer, L.R. (1970) *The Lowenfeld World Technique*. Oxford: Pergamon Press.

Bowyer, L.R. (1970a) 'A normative study of sand tray worlds.' In L.R. Bowyer *The Lowenfeld World Technique*. Oxford: Pergamon Press.

Bradway, K., Signell, K.A., Spare, G.H., Stewart, C.T., Stewart, L.H., Thompson, C. (1981/1990) (1990) *Sandplay Studies: Origins, Theory and Practice*. Boston: Sigo Press.

Bradway, K. and McCoard, B. (1997) *Sandplay – Silent Workshop of the Psyche.* London: Routledge.

Bulfinch, T. (1981) *Myths of Greece and Rome.* New York: Penguin.

Campbell, J. (1973) *The Hero with a Thousand Faces.* Princeton NJ: Princeton University Press/Bollingen.

Capra, F. (1979) 'Dynamic balance in the subatomic world.' *Parabola: Myth and the Quest for Meaning 4,* 2, 60–65.

Case, C. (1987) 'A search for meaning: Loss and transition in art therapy with children.' In T. Dalley *et al.* (eds) *Images of Art Therapy, New Developments in Theory and Practice.* London: Routledge.

Chilvers, I. (1996) *The Concise Oxford Dictionary of Art and Artists.* Oxford and New York: Oxford University Press.

Chodorow, J. (1997) *Jung on Active Imagination.* London: Routledge.

Clark, L. (1975) *The Ancient Art of Color Therapy.* New York: Pocket Books.

Connelly, D.M. (1979) *Traditional Acupuncture: The Law of the Five Elements.* Columbia MD: Centre for Traditional Acupuncture.

Cooper, J.C. (1978) *An Illustrated Encyclopedia of Traditional Symbols.* London: Thames and Hudson.

Cunningham, L. (1997) 'The therapist's use of self in sandplay: Participation mystique and projective identification.' *Journal of Sandplay Therapy 6,* 2, 121–134.

Dissanayake, E. (1988) *What is Art For?* Seattle: University of Washington Press.

Dissanayake, E. (1992) *Homo Aestheticus: Where Art Comes From and Why.* New York: Basic Books.

Dundas, E. (1978) *Symbols Come Alive in the Sand.* Aptos CA: Aptos Press.

Dundas, E. (1993) 'The development of masculine power in one example of sandplay therapy.' *Journal of Sandplay Therapy 2,* 2, 75–87.

Edinger, E.F. (1968) 'An outline of analytical psychology.' *Quadrant 1,* 1–12.

Edinger, E.F. (1972) *Ego and Archetype: Individuation and the Religious Function of the Psyche.* Boston and London: Shambala.

Edinger, E.F. (1985) *Anatomy of the Psyche: Alchemical Symbolism in Psychotherapy.* LaSalle IL: Open Court.

Eickhoff, L.F.W. (1952) 'Dreams in the sand.' *British Journal of Psychiatry 98,* 235–243.

Eliade, M. (1991) *Images and Symbols.* Princeton: Princeton University Press.

Encyclopedia Britannica (1962) vol. 19. Chicago: William Benton.

Estes, C.P. (1992) *Women who Run with the Wolves.* London: Rider.

Foster, F. (1997) 'Fear of three-dimensionality, clay and plasticine as experimental bodies.' In K. Killick and J. Schaverien (eds) *Art, Psychotherapy and Psychosis*. London: Routledge.

Funk & Wagnall's Standard Dictionary of the English Language (1961) New York: Funk and Wagnall's.

Gallegos, E.S. (1990) *The Personal Totem Pole*. Moon Bear Press.

Gray, E. (1983) 'Review: Images of the self: The sandplay therapy process, by Weinrib, E.' *American Journal of Art Therapy 23*, 1, 35–38.

Grimm, J. and Grimm, W. (1981) *The Complete Brothers Grimm Fairy Tales*. New York: Crown.

Hale, R. (1988) 'Sandplay and background music.' *Journal of Sandplay Therapy 7*, 1, 14–18.

Halliday, D. (1987) 'Peak experiences: The individuation of children.' In T. Dalley *et al.* (eds) *Images of Art Therapy: New Developments in Theory and Practice*. London: Tavistock.

Hammer, E.F. (1980) *The Clinical Application of Projective Drawings*. Illinois: Charles C. Thomas.

Harner, M. (1980) *The Way of the Shaman*. New York: Harper and Row.

Hillman, J. (1979) *The Dream and the Underworld*. New York: Harper and Row.

Jackson-Bashinsky, B. (1995) 'Off on a tangent.' *Journal of Sandplay Therapy 4*, 2, 48–67.

Janson, H.W. (1962) *A History of Art*. London: Thames and Hudson.

Jones, L.E. (1986) 'The development of structure in the world of expression: A cognitive-developmental analysis of children's sand worlds.' Unpublished doctoral dissertation, Pacific Graduate School of Psychology, Menlo Park CA. (University Microfilms no. 83–03178.)

Jung, C.G. (1916/58) 'The transcendent function.' *Collected Works*, vol. 8. Princeton: Princeton University Press.

Jung, C.G. (1917/1961a) On the psychology of the unconscious. Two essays on analytical psychology. *Collected Works*, vol. 7. London: Routledge.

Jung, C.G. (1923) *Psychological Types*. New York: Harcourt, Brace.

Jung, C.G. (1927/1931) The structure of the psyche. The structure and dynamics of the psyche. *Collected Works*, vol. 8. London: Routledge.

Jung, C.G. (1929/1976) Commentary on the secret of the golden flower. *Collected Works*, vol.13. Princeton: Princeton University Press.

Jung, C.G. (1933/50) A study in the process of individuation. *Collected Works*, vol. 9. Princeton University Press, second edition, 1968.

Jung, C.G. (1935/1976) 'The Tavistock lectures: On the theory and practice of analytical psychology.' *Collected Works*, vol. 18. Princeton: Princeton University Press.

Jung, C.G. (1954) 'The development of personality.' *The Collected Works of C.G. Jung*, vol. 17. London: Routledge.

Jung, C.G. (1955) Mysterium coniunctionis. *Collected Works*, vol. 14. Princeton: Princeton University Press.

Jung, C.G. (1956) 'Symbols of transformation.' *The Collected Works of C.G. Jung*, vol. 5. London: Routledge.

Jung, C. G. (1961) *Memories, Dreams, Reflections*. London: Fontana Press. An imprint of HarperCollins Publishers. Reprinted (1995) New York: Pantheon.

Junge, M. and Asawa, P. (1994) *A History of Art Therapy in the United States*. Mundelein: American Art Therapy Association.

Kalff, D.M. (1980) *Sandplay*. Boston: Sigo Press.

Kalff, M. (1993) 'Twenty points to be considered in the interpretation of a sandplay.' *Journal of Sandplay Therapy 2*, 2.

Kandinsky, W. (1977) *Concerning the Spiritual in Art*. New York: Dover Publications Inc.

Kandinsky, W. (1979) *Point and Line to Plane*. New York: Dover Publications Inc.

Kramer, E. (1971) *Art as Therapy with Children*. New York: Schocken.

Kramer, E. (1977) *Art Therapy in a Children's Community*. New York: Schocken.

Landgarten, H. (1987) *Family Art Psychotherapy: A Clinical Guide and Casebook*. New York: Brunner/Mazel.

Levy, F.J. (1988) *Dance Movement Therapy: A Healing Art*. Virginia: American alliance for health, physical education, recreation, and dance.

Lewis, P.P. (1988) 'The transformative process within the imaginal realm.' *The Arts in Psychotherapy 15*, 4, 309–316.

Lowenfeld, M. (1935) *Play in Childhood*. London: Victor Gollancz.

Lowenfeld, M. (1979) *The World Technique*. London: George Allan and Unwin.

Luscher, M. (1969) *The Luscher Color Test*. New York: Random House.

Mack, W.N. and Leistikow, E.A. (1996) 'Sands of the world.' *Scientific American*, August, 62–67.

Margoliash, E. (1998) 'Rebirth through sand.' *Journal of Sandplay Therapy 7*, 1, 63–87.

Markell, M.J. (1994) 'Images of the whale in sandplay by women with issues of molest.' *Journal of Sandplay Therapy 3*, 2, 14–35.

McNiff, S. (1981) *The Arts and Psychotherapy*. Illinois: Charles C. Thomas Publisher Ltd.

McNiff, S. (1986) 'A dialogue with James Hillman.' *Art Therapy: Journal of the American Art Therapy Association 3*, 3, 99–110.

McNiff, S. (1989) *Depth Psychology of Art*. Illinois: Charles C. Thomas.

Mitchell, R.R. and Friedman, H.S. (1994) *Sandplay, Past, Present, and Future*. London: Routledge.

Naumberg, M. (1966) *Dynamically Oriented Art Therapy: Its Principles and Practice*. New York: Grune and Stratton.

Neumann, E. (1954) *The Origins and History of Consciousness*. Princeton: Princeton University Press.

Neumann, E. (1983) *The Great Mother*. Princeton: Princeton University Press.

Neumann, E. (1988) *The Child*. London: Karnac.

New Webster's Encyclopedic Dictionary of the English Language (1997) New York: Gramercy Books.

Oaklander, V. (1978) *Windows to our Children*. Moab UT: Real People Press.

Ouseley, S.G.J. (1949) *Colour Meditations*. Romford: L.N. Fowler and Co. Ltd.

Rhinehart, L.M. and Englehorn, P. (1984) 'The full rainbow-symbol of individuation.' *The Arts in Psychotherapy 11*, 1, 37–43.

Rhyne, J. (1990) 'Gestalt psychology/gestalt therapy: Forms/contexts.' *American Journal of Art Therapy 29*, 1, 2–8.

Rogers, P.J. (1995) 'Sexual abuse and eating disorders: A possible connection indicated through music therapy?' In D. Dokter (ed) *Art Therapies and Clients with Eating Disorders: Fragile Board*. London: Jessica Kingsley Publishers.

Robbins, A. (1994) *A Multi-modal Approach to Creative Art Therapy*. London: Jessica Kingsley Publishers.

Robinson, M. (1984) 'A Jungian approach to art therapy based in a residential setting.' In T. Dalley (ed) *Art as Therapy: An Introduction to the Use of Art as a Therapeutic Technique*. London: Tavistock/Routledge.

Rubin, J.A. (1984) *The Art of Art Therapy*. New York: Brunner/Mazel.

Ryce-Menuhin, J. (1988) *The Self in Early Childhood*. London: Free Association Books.

Ryce-Menuhin, J. (1992) *Jungian Sandplay: The Wonderful Therapy*. London: Routledge.

Sams, J. and Carson, D. (1988) *Medicine Cards: The Discovery of Power through the Ways of Animals*. Santa Fe NM: Bear.

Schaverien, J. (1987) 'The scapegoat and the talisman: Transference in art therapy.' In T. Dalley *et al.* (eds) *Images of Art Therapy: New Developments in Theory and Practice.* London: Tavistock.

Schaverien, J. (1992) *The Revealing Image: Analytical Art Psychotherapy in Theory and Practice.* London: Tavistock/Routledge.

Schaverien, J. (1995) *Desire and the Female Therapist: Engendered Gazes in Psychotherapy and Art Therapy.* London: Routledge.

Shaia, A. (1991) 'Images in the sand: The initial sand worlds of men molested as children.' Unpublished doctoral dissertation, California Institute of Integral Studies, San Francisco.

Signell, K. (1990) 'The use of sandplay with men.' In K. Bradway *et al.* (eds) *Sandplay Studies; Origins, Theory and Practice.* Boston: Sigo Press.

Simon, R.M. (1992) *The Symbolism of Style.* London: Routledge.

Sproul, B.C. (1979) *Primal Myths: Creating the World.* New York: Harper and Row.

Steinhardt, L. (1989) 'Six starting points in art therapy with children.' In H. Wadeson, J. Durkin and D. Perach (eds) *Advances in Art Therapy.* New York: Wiley.

Steinhardt, L. (1989) 'Creating the autonomous image through puppet theatre and art therapy.' *The Arts in Psychotherapy.* Illinois: Charles C. Thomas.

Steinhardt, L. (1995) 'The base and the mark: A primary dialogue in artmaking behavior.' *Art Therapy: Journal of the American Art Therapy Association 12,* 3, 191–192.

Steinhardt, L. (1997) 'Beyond blue: The implications of blue as the color of the inner surface of the sandtray in sandplay.' *The Arts in Psychotherapy 24,* 5, 455–469.

Steinhardt, L. (1998) 'Sand, water and universal form in sandplay and art therapy.' *Art Therapy: Journal of the American Art Therapy Association 15,* 4, 252–260.

Stewart, C.T. (1990) 'The developmental psychology of sandplay.' In K. Bradway *et al.* (eds) *Sandplay Studies: Origins, Theory and Practice.* Boston: Sigo Press.

Stewart, L.H. (1977) 'Sandplay therapy: Jungian technique.' In B.B. Wolman (ed) *International Encyclopedia of Psychiatry, Psychology, Psychoanalysis and Neurology,* vol. 10. New York: Aesculapius Publishers, pp.9–11.

Stewart, L.H. (1990) 'Play and sandplay.' In K. Bradway *et al. Sandplay Studies: Origins, Theory and Practice.* Boston: Sigo Press.

Storr, A. (1983) *The Essential Jung.* London: Fontana Press.

Thompson, C. (1990) 'Variations on a theme by Lowenfeld: Sandplay in focus.' In K. Bradway *et al.* (eds) *Sandplay Studies: Origins, Theory and Practice.* Boston: Sigo Press.

Toscani, F. (1998) 'Sandrama: Psychodramatic sandtray with a trauma survivor.' *The Arts in Psychotherapy 25*, 1, 21–29.

Ulman, E. (1965) 'A new use of art in psychiatric diagnosis.' *Bulletin of Art Therapy 4*, 91–116.

Walker, M. (1991) *The Power of Color.* New York: Avery.

Waller, D. (1984) 'A consideration of the similarities and differences between art teaching and art therapy.' In T. Dalley (ed) *Art as Therapy. An Introduction to the Use of Art as a Therapeutic Technique.* London: Tavistock/Routledge.

Waller, D. (1991) *Becoming a Profession, the History of Art Therapy in Britain 1940–1992.* London: Routledge.

Weinrib, E.L. (1983) *Images of the Self.* Boston: Sigo Press.

Whitmont, E.C. (1991) *The Symbolic Quest: Basic Concepts of Analytical Psychology.* Princeton: Princeton University Press.

Wildenstein, D. (1996) *Monet, or the Triumph of Impressionism.* Benedikt Taschen Verlag.

Wilhelm, R. (trans.) (1951) *I Ching or Book of Changes.* London: Routledge.

Winn, L. (1995) 'Experiential training for staff working with eating disorders.' In D. Dokter (ed) *Art Therapies and Clients with Eating Disorders: Fragile Board.* London: Jessica Kingsley Publishers.

Winnicott, D.W. (1971) *Playing and Reality.* London: Penguin.

Wood, C. (1997) 'The history of art therapy and psychosis 1938–95.' In K. Killick and J. Schaverien (eds) *Art, Psychotherapy and Psychosis.* London: Routledge.

Wood, L. (1981) *Mazes and Mandalas.* Englewood Cliffs NJ: Prentice Hall.

Subject Index

abundance 193, 206
active imagination 16, 21, 33–4, 60, 79, 81
 in case example 180–81
African male god 191, 196, 199–200, 201, 208, 216
American, Native 10
 fetish and totem pole 91
analysis: of art 17
 verbal 15, 17, 41
analytic process and sandplay 41
angel, in case examples 174, 176, 178–9
anima and animus 120
 animus 191, 204
animals: the collective unconscious 21
 as sandplay objects 94, in case examples 178
 bear 204
 rabbit 178
 snake 178–9, 181–4
apple, in case examples 173, 203, 207–8, 210–13
April 180, 188, 190, 205, 214
archetypal imagery 21–2, 206, 220
archetype 21–2
 of the 'way', 130
armadillo 178
art: action painting 151
 Bauhaus 57
 environmental 80
 Kandinsky 57, 102, 104
art making 9, 57–8, 61–2
 fear of, 82

media 18
artists 17, 57, 62, 113
 and art therapy 56
art therapy,
 history of 17, 53–4, 56–60
 materials 54, 64–74
 and sandplay 17, 48–9, 54, 60
 and verbalization, 18
assemblage, and collage 54, 62

babies 175, 195–7, 211, 216
base, and marks 19
 83–6
basket 187
beach, and beach play 84–5, 222
bears, white 204–5
bird 121, 209
birth, in case examples 148, 189–90, 211, 214
black 104, 208, 210–13
blood 199, 206, 208
blue 39, 100, 104, 111, 199–200, 203
 egg 196–8, 214
 blue pigments 101–2
 color in sandplay 17
 the sandtray's blue interior 38–9
blue fairy 179–80 203, 210
boat 194–5, 197–98
body 220
 earth 214
 movement 151
Bolgar, Hedda 44
bones 98
bread 216–17
bridge 174
brown 105

buddha 206, 208–10, 212–13
Buhler, Charlotte 44
burying and unburying in sandplay 44, 132

cactus 176
camel 178
cave 25, 143
 and tunnels 144
 case example 146
 cave-womb 172,
 cave in whale's belly 175
center 119
 in case examples 135, 138, 192, 201–3, 205, 206
chain 189–90, 209–10
chairs, in case examples 176, 184, 217
chakras 91
Child, Eternal 24
children: first environmental art 80
 and sandplay therapy
 in case examples 173, 208
church 205
circle, and mandala, 110–11
 concentric 138, 200–2
 squared circle 204, 207
classification: of art therapy materials 75–8
 of sand forms 17, 24, 126
 of sandplay materials 96–8
clay 64, 76, 81
clock 135, 174
clown 197–8, 203, 219
collage, and assemblage 54, 62

233

Author Index

CPSIA information can be obtained at www.ICGtesting.com
Printed in the USA
BVOW09s2046091214

378226BV00003B/44/P